THE ART
OF
DRAWING

THE ART OF DRAWING

From the dawn of history to the era of the Impressionists

by Richard Kenin

PADDINGTON
PRESS LTD

THE TWO CONTINENTS
PUBLISHING GROUP

ISBN 0-8467-0019-0
LIBRARY OF CONGRESS CATALOG CARD NUMBER 73-15023
© copyright reproductions: Trustees of the British Museum
© copyright text: Richard Kenin, 1974
Printed in the United States of America
The text is set in 12 point Bembo

Designed by Richard Browner

IN THE UNITED STATES

PADDINGTON PRESS LTD
TWO CONTINENTS PUBLISHING GROUP
30 East 42nd Street
New York City, N.Y. 10017

IN THE UNITED KINGDOM

PADDINGTON PRESS LTD
1 Wardour Street
London, W.1
England

IN CANADA

PADDINGTON PRESS LTD
distributed by
RANDOM HOUSE OF CANADA LTD
370 Alliance Avenue
Toronto, Ontario

Table of Contents

Introduction

THERE IS NO FORM of creative expression that is more spontaneous than the art of drawing. The innermost visions of the mind flow clearly and directly through the hands of the draughtsman, and all that the imagination can conjure is represented in this most fragile and transitory of artistic media.

In a great drawing one can see the creative process at work. Here is the font of artistic expression. Unlike many styles of painting which are designed to conceal artistic technique, the drawing lays all bare and enables the observer to see exactly how certain effects are produced. The great masters of drawing use their gifts to penetrate and describe the fundamental organization of natural processes and forms. And through their imagination and technical analyses the very construction of objects and natural phenomena are celebrated and dramatized in a manner that is both unique and uncompromising.

In the making of a drawing subjectivity naturally plays a part. Things are prescribed according to the limits of size and volume, and objects are assigned particular positions in space. If one attempts to trace the origin of draughtsmanship in any culture the road inevitably leads to the discovery of the bonds that join man's imagination to his physical position in the universal order of things. And it is from this position that his own perspective is fundamentally conditioned.

In the Orient there is no break between the creation of an idea and its execution. While in the West the use of drawing takes on a dual role both as a preparation for other representational arts, and as an autonomous form. It is this particular duality in the West that has greatly influenced both artistic technique and style in the chronological development of all European cultures and schools.

Line, even though it does not objectively exist in nature, is the basis of most drawing. Some artists have found the use of line sufficient for their purpose. Others have found it necessary and desirable to employ 'form drawing' which, through shading, hatching, chiaroscuro, and wash, adds the impact of contrasting light and darkness. Color too has played a significant role in the creative output of certain

draughtsmen. And it has been argued that the watercolor, because of its autonomy, is the most important type of drawing.

The variety of media available to the draughtsman has constantly increased over the centuries. To watercolor can be added gouache—usually less subtle because it lacks watercolor's delicate transparency. Renaissance artists often used metalpoint and silverpoint on prepared paper. The soft modulating tones of charcoal, colored chalk, and crayon appear in countless drawings. In skilled hands the precise clarity of pencil and graphite, together with pen and ink, can delineate even the most minute details of nature or the imagination. Great drawings have been executed in one or combinations of all these media and the result has been a body of creative work dating back thousands of years.

In 1972 the British Museum staged a monumental exhibition of the draughts-man's art drawn almost exclusively from its own collection and covering the entire chronological development of the art of drawing. Every piece of work exhibited was a masterpiece. As a whole the exhibition, which was acclaimed by critical opinion and enjoyed an attendance numbering tens of thousands, demonstrated conclusively the range, depth, and international importance of the British Museum's collection; a fact that was well known to scholars but less appreciated by the general public.

All the illustrations included in this volume have been drawn from that collection. Inevitably, such a course has limitations, and comprehensiveness either of subject or artist cannot be claimed. Yet because of the scope of the British Museum's collection each work stands out as a prime example of creative sensitivity and technical virtuosity. So much of our art, in all cultures, relies fundamentally on the imagination and skill of drawing. It is one of the most essential methods by which man describes both himself and the environment in which he exists. For such an all-inclusive means of expression there cannot be an over-abundance of praise or celebration, for without drawing our cultural heritage would be inestimably poorer and our creative horizons severely limited.

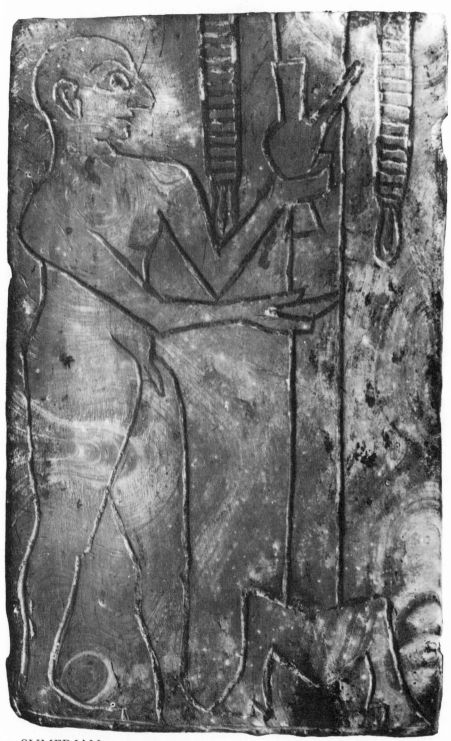

1 SUMERIAN *c* 2500 BC
A Naked Priest with Offering Vessels
Tool-incised drawing on a shell plaque.
From Ur, Babylonia.

I

The Ancient World

IN THE ANCIENT WORLD of the Fertile Crescent drawings were rarely made as ends in themselves. Draughtsmanship was generally a preparatory step to other art forms and as such was often destroyed or covered up during the creative process. Of all the ancient peoples only those of Egypt and the Aegean have left graphic works of great distinction, and it can be argued that it is from these two disparate traditions that the art of drawing, as we know it today, descends.

Following the unification of the Nile valley *c* 3100 BC, a characteristic Egyptian graphic style appeared that was to last almost unchanged throughout the epoch of the Pharaohs. New Kingdom *ostraca* (*c* 1500–1000 BC), or sketches on limestone and pottery, are highly descriptive in character and aim at a precise but conventional form of two dimensional representation. There was never a conscious attempt to use perspective to achieve a third dimension, and Egyptian reliefs are usually little more than a strengthened and more emphatic version of this two dimensional expression. A closely similar style of drawing can be found in the magical Books of the Dead, written and illustrated on papyrus.

To the ancient Egyptian artist all thoughts of emotive interpretations were completely foreign. Indeed, his language included no word for art—handicraft was the closest approximation in his vocabulary. This is not to say that Egyptian drawings are lacking in spiritual content. On the contrary, the labors of the draughtsman were directed toward facilitating the magical dynamism of the Gods which directed the universal order of things. It was believed that whatever the artist drew in the service of his religion was actually brought into reality. In essence, his craft bore the burden of creating the recognizable environment that would bridge the chasm between death and reincarnation. Consequently, nothing of an unhappy nature was to be reproduced lest it creep into the world of the living as a reality to be

confronted.

With such an overpowering faith in the effectiveness of art it is readily comprehensible why Egyptian drawings are always absolutely explicit. Truthful rendition was an optimal objective, but could be achieved most successfully free from the hybrid permutations and shortcomings of nature. In the artist's mind what was ideally real was translated graphically. Any abstract thought of great importance was symbolically treated. For example, men of great dignity and distinction were always shown in much larger size than those of lesser rank. This was the artist's way of ensuring the continued status of his subject in the after-life.

The technical skill of the Egyptian draughtsman was quite advanced. Once the surface to be drawn on had been prepared the subject matter was sketched in section by section. Freehand drawing was not unknown to the Egyptians, but more frequently a grid was used. This was not just for the sake of convenience but rather to insure that the preconceived correct proportions of figure and object were accurately depicted. In addition to guide lines, horizontal strips were laid out as registers with a common base line. Chronological sequence was achieved by reading the registers from bottom to top and thus the story was conveyed.

After the preliminary sketch had been made, a string dipped in a kind of dye or pigment was laid on the soon to be decorated surface to mark out the guide lines. Then the actual task of laying in the design began. The artist's tool was a fibrous brush also used commonly by the scribes of the New Kingdom. Red was the initial primary color of such work, while black was employed for any subsequent correction that might have to be done.

Once the figures and objects had been placed within the chosen area a formal, highly decorative border was provided to avoid the implication that action extended beyond the limits defined by the artist. Such an implication, for obvious religious reasons, was undesirable.

The artist as an individual is almost unknown in ancient Egypt. He was for all practical purposes an anonymous artisan who worked as a highly trained member of a team assigned a task in a tomb or in making a statue. Only on papyrus rolls was there a significant element of individual approach. Egyptian artists were sufficiently versatile to apply their skills to all the art forms—sculpture, architecture, handicraft, as well as drawing. And it is to these creators that one must look for the first true masterpieces of the art of drawing in the ancient world.

<p style="text-align:center">★ ★ ★</p>

Of everything that survives from ancient Greece it is the decorated ceramic vase, in a variety of shapes and sizes, that best illustrates the draughtsman's art in the centuries before the birth of Christ. From the literature of the Aegean we know of painted works by several celebrated Greek artists such as Polygnotus, Parrhasios, Apelles, and Zeuxis, but nothing survives. All that does remain are the vases decorated

by men who were thought of as mere artisans in their own time.

Once fired, a terracotta vase is almost indestructible. Rediscovered in the ruins of sanctuaries and tombs as well as in the remains of private dwellings, these vases provide a continuous picture of Greek artistic life from the earliest geometric designs to the fluid illustrations of Hellenistic times.

Greek drawing, in the meaningful sense of the term, begins about 1000 BC. On Attic Dipylon vases of the ninth century BC Greek draughtsmen display a highly geometric style. There were dozens of variations on the style, according to locality. All geometric style drawing had one thing in common, it was ideographic. Human figures and animals were depicted thus, not through lack of technical skill, but as part of a preconceived decorative scheme. Memory-images were both idealized and schematized, to fit the pattern and its rhythms.

In the following three hundred years this conventionalized style gradually changed. As communications improved artistic influences from Phoenicia, Egypt, Mesopotamia, and Syria began to make their presence felt in Greece. The result was the introduction of oriental decorative motifs such as monsters, floral patterns, and animals such as panthers and lions.

Technically this was also an important period for it witnessed the introduction of the so called black-figure style. Artists turned away from the use of outline and adopted black silhouettes with incised details, usually on a red background. The shape of an individual vessel was always of great importance in determining the type of decoration used. But with the emergence of the full black-figure style in the sixth century BC, the shape of the vase became paramount in determining what was drawn as decoration. Draughtsmanship was delighted in for its own sake and the human figure emerged as the dominant motif, uncluttered by decorative triangles and other space-filling devices. A greater range of color was used, such as white for the flesh of women. In essence, once the human figure began to be drawn as a thing of beauty, rather than just as an element in a geometric pattern, the world of Greek art opened itself to the possibilities of narrative interpretation. There was now scope to examine man's relationship to his environment, and movement and action introduced a new sense of immediacy and realism to what was still a primarily decorative art form.

It was at Corinth, the most politically and commercially powerful of the Greek City States in the seventh and sixth centuries BC, that the black-figure style had its first phase of development. The Corinthians spread their knowledge throughout the known world and consequently their manner of drawing and painting was copied in many countries bordering the Mediterranean.

The Corinthian style was characterized by a general bilateral symmetry of design which produced a rich patterned effect especially in drapery which was outlined in a series of finely etched lines. But there were limits to Corinthian technique. The human figure, for example, achieved no more than a repetitious flat quality in silhouette and seemed brittle and generally unsatisfactory.

If Corinth was moderately successful at cultural penetration, she was far over

THE ANCIENT WORLD

shadowed by the accomplishments of the artists and artisans of Athens who around 550 BC, with the decline of Corinthian power, embarked on their own road to cultural dominance. For over 150 years Athens remained the ceramic center of the world. Not only were her wares carried throughout the Greek mainland and islands of the Aegean, but also into North Africa, Asia Minor, Italy, the Crimea, and even Spain and France. Much of this success was dependent on the commercial might of the Athenian empire, but also to the high level of technical skill and artistic merit of Athenian ceramic products.

The fifth century was the golden age of Greece. On the military front the expanding might of the Persian Empire was defeated at Marathon, Salamis, and Plataea, and thus the future of Europe was temporarily secured against the expansion of oriental despotism. In Athens, under the leadership of Pericles, the great monuments of the Acropolis—the Parthenon, the Erechtheum, and the Propylaea—were erected as symbols of the city's wealth and majesty. The tragedies of Aeschylus, Sophicles and Euripides; the comedies of Aristophanes; the odes of Pindar and Hesiod; the histories of Thucydides and Herodotus; the philosophical writings of Socrates, Plato and Aristotle; were all products of the Athenian spirit.

The period from 450 BC until the death of Alexander the Great in 323 BC was the age of mature Greek classicism. It was a time when all branches of knowledge were interdependent and a bond of cultural unity knit the free society of Athens into a closely homogenous group. In the representational arts one could see evidence of the philosophy, history, science, and aesthetics of the time. And as archaic mannerisms gave way to more refined ideal conceptions of beauty, significant steps were taken that conditioned the development of Western art for over 2300 years.

The Athenians reversed the black-figure style so that their pottery showed red figures first on a black, and later sometimes on a white background. Foreshortening was introduced along with a rudimentary treatment of perspective. Colors were mixed and forms were modelled either by the line itself or by internal details. There was greater interpretative freedom in Athenian vase drawings, and this was combined with an increased knowledge of anatomy which also found expression in the contemporary sculpture of the period.

The Athenian draughtsman presented his figures in three-quarter view with drapery depicted naturally by oblique lines and zig-zag edges. Spatial considerations became increasingly important as contours suggested realistic depth with greater fluidity. Minute details like hair were given great attention not as a mass but as a series of individually delineated strands. In his drawings the Athenian artist employed a plethora of flowing lines to suggest the rounded forms of the human figure. And in the early stages of the red-figure style incision was occasionally employed to accentuate this type of contour.

The variety of available media also increased in Athens, and the artist now found it possible to distinguish more important lines from those that were less crucial. This was done by painting the latter in thinner glazes which resulted in a sharp

contrast of color between the full black or red of important lines and the golden brown of less significant contours. This principle of contrast between painted and unpainted areas of the vase, and between various colors, was constant throughout the history of Greek vase decoration, but it was in Athens that this particular achievement reached its zenith.

When Athens fell to foreign invaders in 404 BC the red-figure style of vase painting was checked in its development. There was a rapid decline of skill and decadent versions of Athenian art proliferated at a rapid pace throughout the Aegean. The Greece of the fourth and third centuries BC witnessed a decentralization of power that affected the arts by scattering craftsmen throughout North Africa, the Crimea, and Southern Italy, where colonies of expatriates carried on, albeit in weakened form, the styles and practices of their predecessors. Eventually these colonies, particularly in Southern Italy, were to become the centers for artistic production in the Mediterranean world.

These transplanted schools of art never improved on the ability of the Athenians to achieve linear perspective in drawing. That feat was left to artists of a much later era. Even in Athens, the compositional space was never conceived of as a unitary whole looked at from a single viewpoint. Neither form nor shadow, nor even modelled figures, occupied a single space illuminated by a single source of light. The development of linear perspective was to be the task of the artists of the Italian Renaissance who took up the torch of classical inspiration.

Drawing as a medium steadily declined in importance once the classical age ended. Outline and detail were muted in favor of a coloristic approach which depicted objects and forms and their general spatial relationships in terms of light. This can most clearly be seen in the mosaics of the late antique period which emerged as a major area of artistic effect in place of the decorated vessel.

It was only with the development of the Byzantine style that drawing regained its importance. The Byzantine draughtsman was no longer dedicated to the idealized realism of the ancient Greeks, but rather sought to transpose the human figure into a world of unreality governed by new canons of aesthetic appreciation. Here was an approach to the art of drawing based on quite different precepts of consciousness, knowledge and faith, which was to prove a significant influence on much of the graphic art of the European medieval era.

2 PHOENICIAN *c* 700–500 BC
A Sphinx emerging from a Thicket
Tool-incised drawing on a shell fragment.
From Nineveh, Assyria.

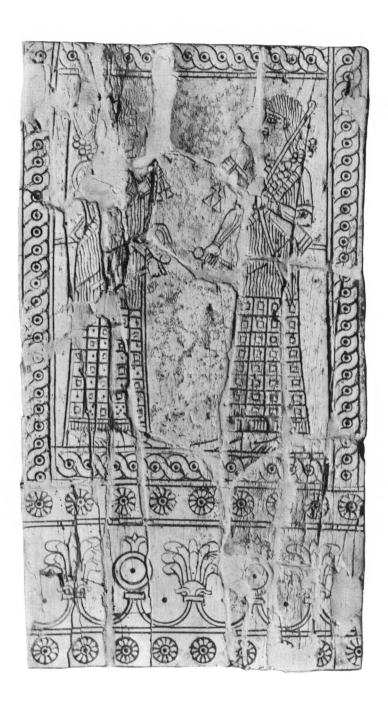

3 ASSYRIAN *c* 800–700 BC
Two Men carrying Bows, Quivers, and Maces
Tool-incised drawing on ivory.
From Nimrud, Assyria.

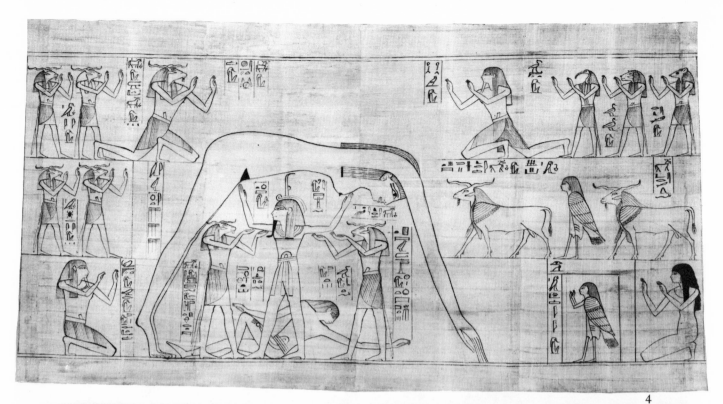

4

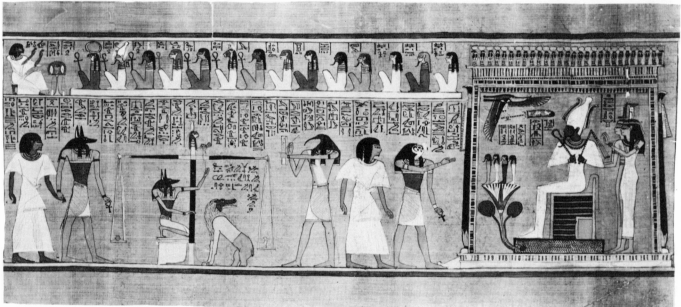

5

4 ANCIENT EGYPTIAN, TWENTY FIRST DYNASTY *c* 1000 BC
Separation of the Sky from the Earth
Brush drawing, in red and black, on papyrus.
From a *Book of the Dead*, from the Tomb of Inhapi, Western Thebes.

5 ANCIENT EGYPTIAN, NINETEENTH DYNASTY *c* 1300 BC
Weighing of the Heart of Hunefer
Brush drawing in red and black outline, with watercolor on papyrus.
From a *Book of the Dead*, from Thebes.

6 NEAR EASTERN, PREHISTORIC PERIOD 5000–4000 BC
A Coiled Snake showing its Fangs
Reed-brush drawing, in plum-colored pigment, on a pottery vessel.
From Tall-i Bakun, Iran.

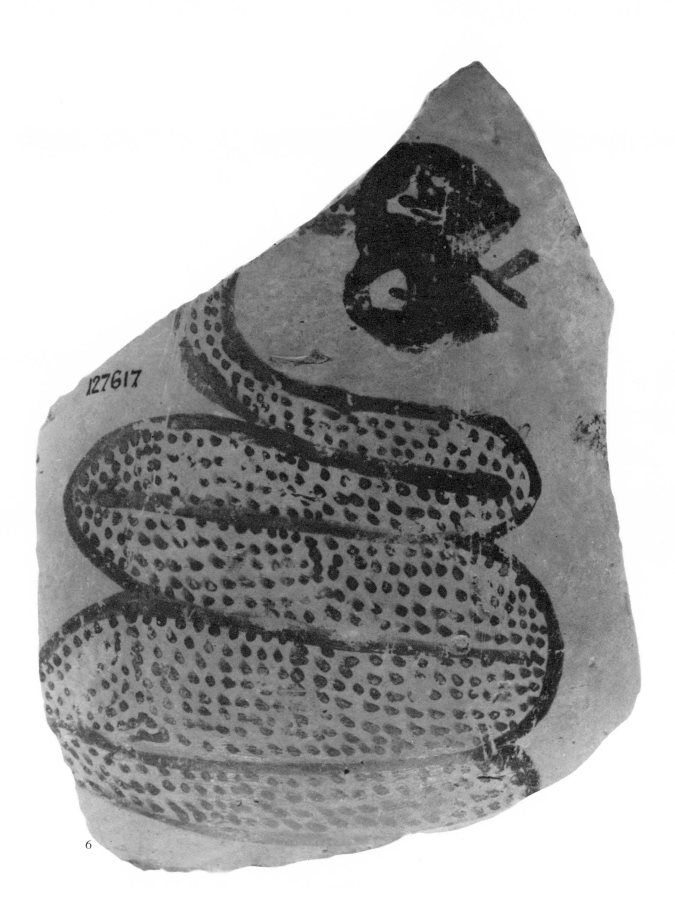

127617

6

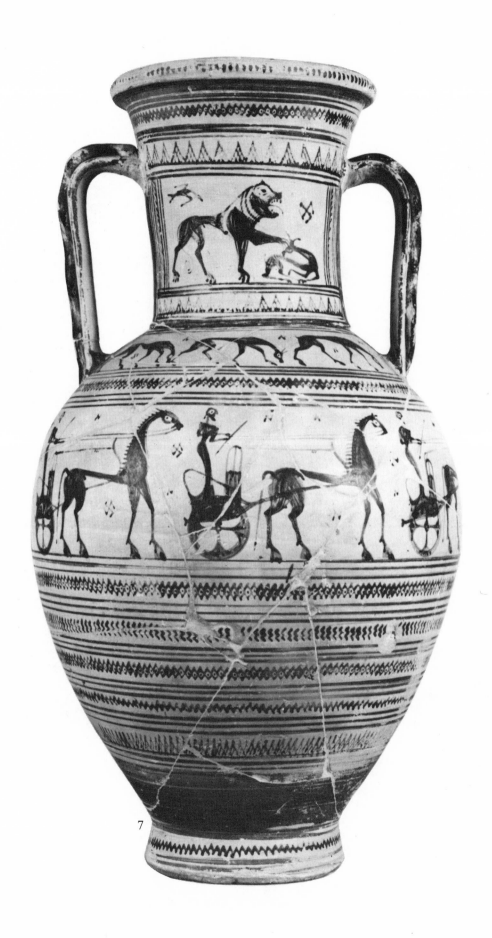

7

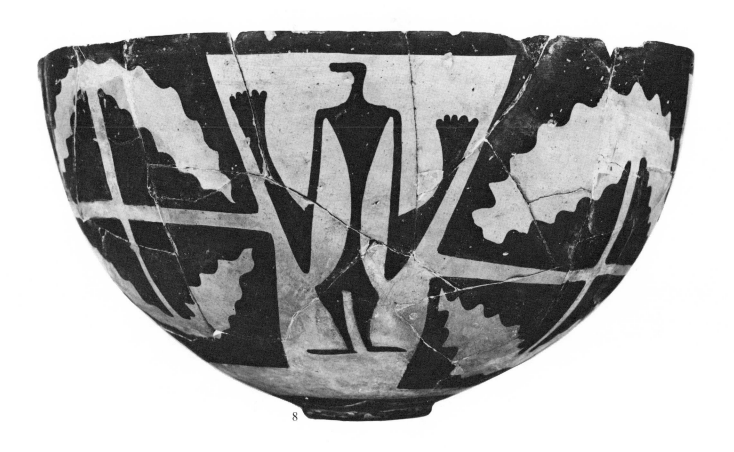

8

7 ATTIC GEOMETRIC *c* 720–700 BC
Charioteers: Lion and Deer
Brush drawing on a pottery storage-jar (*amphora*).

8 CORINTHIAN *c* 620–600 BC
A Winged Man
Brush drawing on a pottery perfume-flask (*alabastron*).

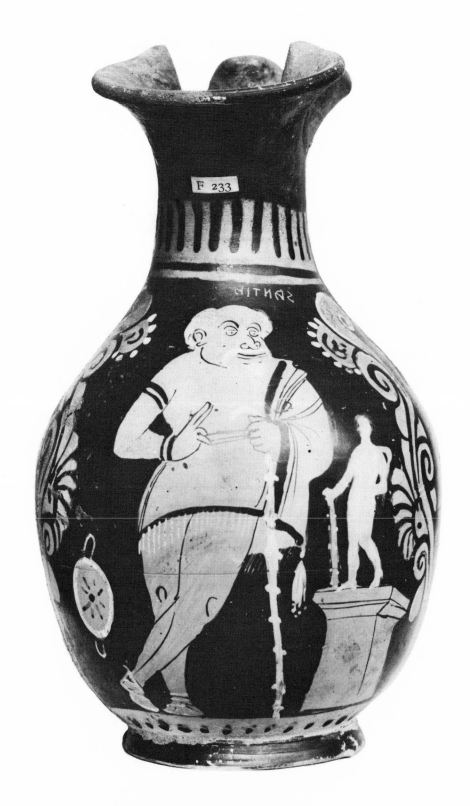

9 THE 'SEATED NIKE PAINTER' *fl c* 350 BC
Greek Colonial (South Italy (Campania))
Xanthias by a Statue of Herakles
Brush drawing on a pottery jug (oenochoe).

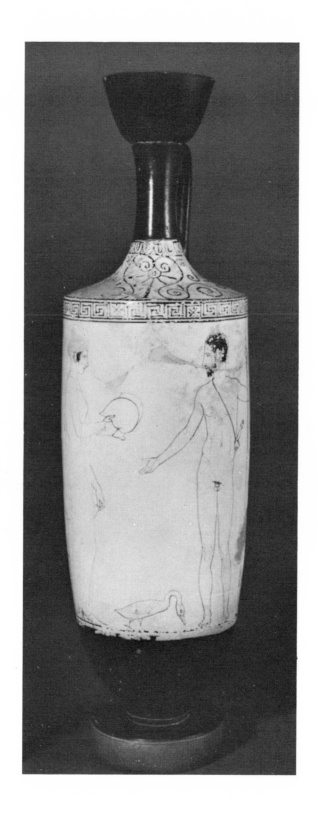

10 THE 'ACHILLES PAINTER' *fl c* 460–430 BC
Attic (Athens)
A Woman and a Warrior arming
Brush drawing on a pottery oil-flask (lekythos).

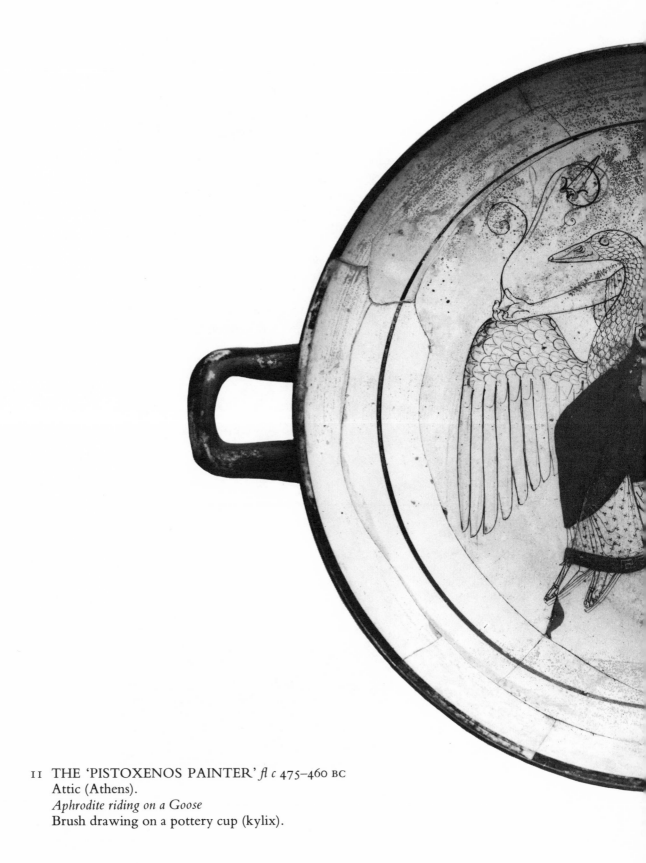

11 THE 'PISTOXENOS PAINTER' *fl c* 475–460 BC
Attic (Athens).
Aphrodite riding on a Goose
Brush drawing on a pottery cup (kylix).

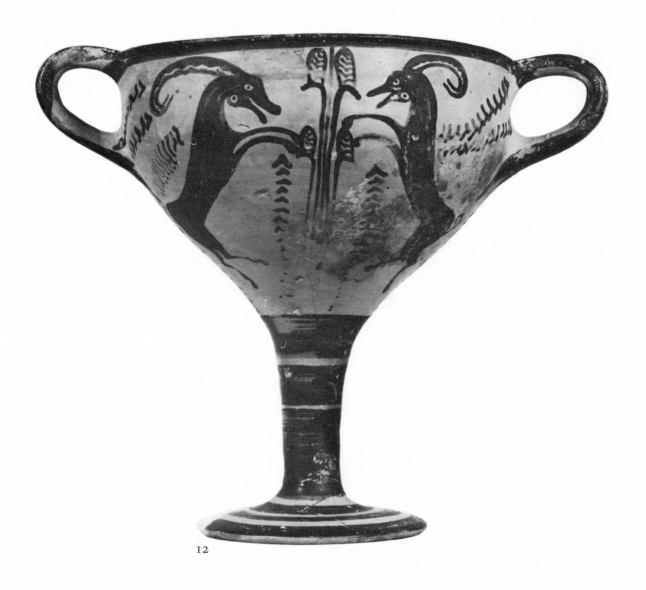

12

12 MINOAN *c* 1400 BC
Two Goats
Brush drawing on a pottery goblet.

13 THE 'AMASIS PAINTER' *fl c* 550–530 BC
Attic (Athens)
Perseus slaying the Gorgon Medusa
Brush drawing on a pottery jug (*olpe*).

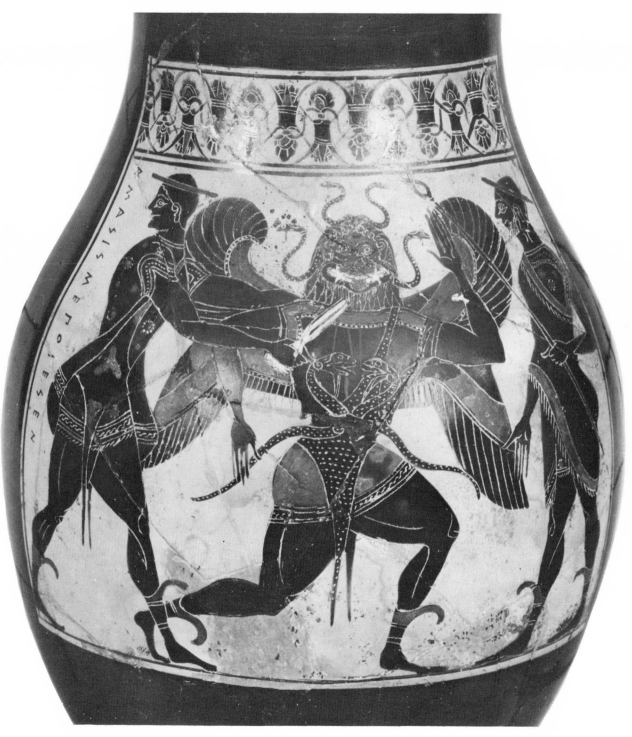

13

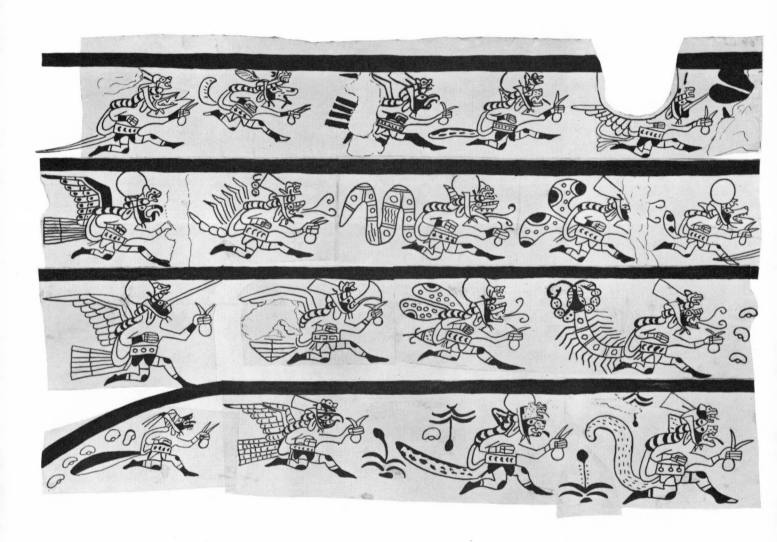

14 MOCHE (MOCHICA) CULTURE *c* AD 300–850
Peru
A Series of Monsters
Brush drawing on pottery.

2
Drawings of Pre-Columbian Peru

WHEN APPROACHING THE SUBJECT of ancient drawing it is natural that one should turn first to the fertile crescent of the Middle East and subsequently to the classical achievements of Greece and Rome, of China and Japan. In these areas there is so much to delight the eye and occupy the mind that one can easily overlook the contribution of New World civilizations, yet it would be wrong to do so.

For example, in the verdant valleys of Peru there evolved civilizations which produced impressive works of art as early as the empire of Alexander the Great, and which flourished continuously up to the age of Charlemagne. Of these various Peruvian Indian cultures predominance artistically must be given to the tribes who occupied, and whose names are taken from the Moche valleys of the north coast and from the south central coastal valleys of Nazca and Ica.

There city states were formed which erected monoliths of stone, which developed complex political organizations, and whose wealth was legendary throughout South America. The Mochica and Nazca tribes were only part of a continuous cultural evolution, but their achievements marked the height of artistic development on the continent, and the artifacts that survive from their cultures are highly prized today by collectors of pre-Columbian art.

As in Greece, the Mochicas adopted ceramics as the ideal medium for their drawings. Theirs' was a very complex theocracy which assigned great importance to the art of war, and many of their decorative motifs are related to this topic. Religious and military ritual were carefully re-enacted in Mochica drawings. Zoomorphic deities, the taking of trophy heads, ceremonies of human sacrifice, and the ballet of battle are all portrayed in great detail. Likewise are the activities of a paramount class of priests who administered a network of sacred shrines, temples, and

altars for the Mochica people. Much of their ceramic work was funerary, and so preoccupied were their artists with the rituals of death and burial that it seems likely that both ancestor worship and a belief in reincarnation were essential tenets of their religion.

At the same time the Mochicas were an agricultural people who raised a variety of food crops, and whose gigantic systems of irrigation involved aqueducts, canals, and reservoirs. Indeed, the valley areas they cultivated were far larger in size than those placed under the plough in modern times. They lived in cities of adobe houses with thatched roofs and built as symbols of their might both fortresses and pyramidal platform temples like Huaca del Sol, made of millions of sun dried bricks. They were doctors and engineers; builders of roads and transmitters of messages. The Mochicas perfected many social institutions that were later to appear among the Incas. All these themes, together with a feeling for the erotic, are to be found in the drawings that decorate Mochica ceramics.

Pottery ranked with metalwork and textiles as one of the three major art forms of the Mochicas. From the beginning of their cultural ascendancy *c* 300 AD Mochica artists produced true masterpieces of decorated ceramics. Thanks to their durability these objects have survived in great numbers to tell of the creative talent of their makers.

Mochica art was oriented toward accurate representation rather than symbolic abstraction. They were the makers of the great portrait vessels that rival similar works made in fifteenth century Europe. But their drawings on ceramics are their greatest achievement. Reddish brown figures were drawn with a fine brush on an off-white base.

Unfortunately, there is not sufficient difference in brushwork to identify individual workshops in the Moche valleys, and the identity of particular artists remains a mystery as is generally the case in Egypt.

The Mochicas delighted in examining the world about them. Consequently, even the monsters they chose to depict have comprehensible animal-like qualities consistent with their creators' own experience. Thus, the mythical figures of 'Owl-man', 'Fox-man', and 'Crab-man' are well within the framework of their own religious and social experience. From their point of view such beings were at least plausible and not totally the product of imagination.

Color was limited to two tones by the Mochicas. Polychrome decoration was rejected in favor of the pure power of movement in their drawings. Lines are penned in red and there is no variation in width. Figures are generally in profile and suggestions of depth through perspective do not go beyond a rudimentary over-lapping of forms. Spatial composition, in short, was less important than the clear depiction of movement. Everything available to the Mochica draughtsman was used to convey a restless agitated dynamism. Their subject matter, particularly military and religious themes, was especially suitable to such an approach. Force, power, and physical combat are seen everywhere. All the schematic formulae

available to the Mochica draughtsman were employed to capture the essence of action, and whatever peripheral decoration was used, also contributed through design to the feeling of agitated movement.

No other American Indian drawings, except those found on ceramics in West Mexico, bear any similarity to the draughtsmanship of the Mochicas. Theirs' are works of art appealing directly to the sensory powers of the eye and are based on the human ability to perceive instantaneously how reality changes from moment to moment. Such an aesthetic endowed Mochica art with an aura of modernity which survived, albeit in altered and weakened form, once their culture was assimilated first by the Tiahuanaco c 850 AD, and then by the Chimu style which held sway until the arrival of the *conquistadores*.

In sharp contrast to the graphic art of the Mochicas are the drawings of the Nazcas who flourished in the south central coastal valleys of Peru between c 150 BC and 850 AD. As with Mochica art, so little is known of the Nazcas that their ceramic objects can only be dated between these two polar extremes of a thousand years. Some art historians do speak of Nazca A and Nazca B drawings, but these are only rough approximations carrying no positive chronological orientation.

The Nazca were skilled at weaving and ceramics like the Mochicas. They constructed conical adobe huts but never attempted large architectural structures like Huaca del Sol. The most puzzling relic of Nazca culture is the vast intersecting network of rectangles and squares etched into the sand and gravel of the hillsides bordering their valleys. These enormous outlines take a variety of forms ranging from birds and spiders to whales and strange surrealistic figures. They run for miles in length and because of the dry state of the climate have been well preserved in the 1,500 years that have elapsed since their execution.

The Nazcas rarely produced modelled portrait pottery of equal quality to that found in the valleys of the Mochicas. But their decorated bowls and vases are of an equal and often higher caliber. They were fond of polychrome decoration in up to eight colors, and tended to separate each shade through linear division rather than attempt a mixing of tones. From the outset the Nazcas relied on line, whether incised or drawn, to create a passive quality in their work. Their designs are generally symbolic, though realistic representation is not unknown. However, the Nazca draughtsmen were not generally interested in scenes from everyday life. Instead they concentrated both on visions of the macabre and on a surrealism which did not conform to human perceptions. Like the Mochicas, the Nazcas too had a preoccupation with the circumstances and rituals surrounding death.

As a tool for drawing the Nazcas used a quill or thorn stylus and consistently avoided a variation in width in their contours and demarcations. Their compositions usually reflected an arrangement of imagery based on a preconceived order. Yet they found no difficulty in adjusting their subject matter to the spherical or cylindrical shapes of their vessels.

Nazca drawing is always consistent within its own canons. As has been noted,

action or movement are not stressed; neither are landscapes or individual dwellings the subject of many drawings. The bolder the system of patterning the more successful the composition. Naturally, such a formulaic approach precludes the linear refinements found in Mochica art. The strength of the Nazca style is its control of complex color-relationships.

The style and the quality of both Mochica and Nazca draughtsmanship remained constant for over five hundred years. When military reversals finally resulted in the defeat and assimilation of both peoples by their aggressive neighbors, the art forms of Peru grew decadent and never again achieved a similar level of skill and interpretive technique prior to European colonization. What we know today of these art forms is still very vague and unclear. Yet the decorated objects produced by these civilizations do at least survive as reminders of the universality of the draughtsman's art and the spontaneity of his creative genius regardless of both time and geographical location.

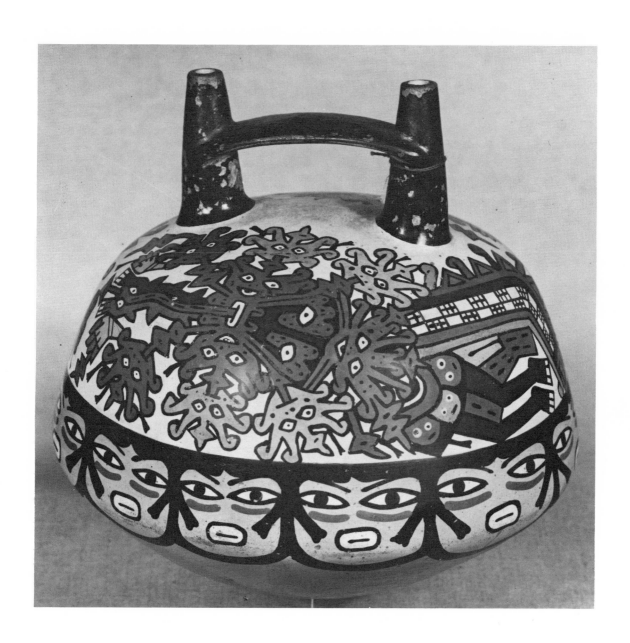

15 NAZCA CULTURE *c* 150 BC–AD 850
Peru
Decorative Faces Both Human and Imaginary
Brush drawing on a double spout globular pottery
vase.

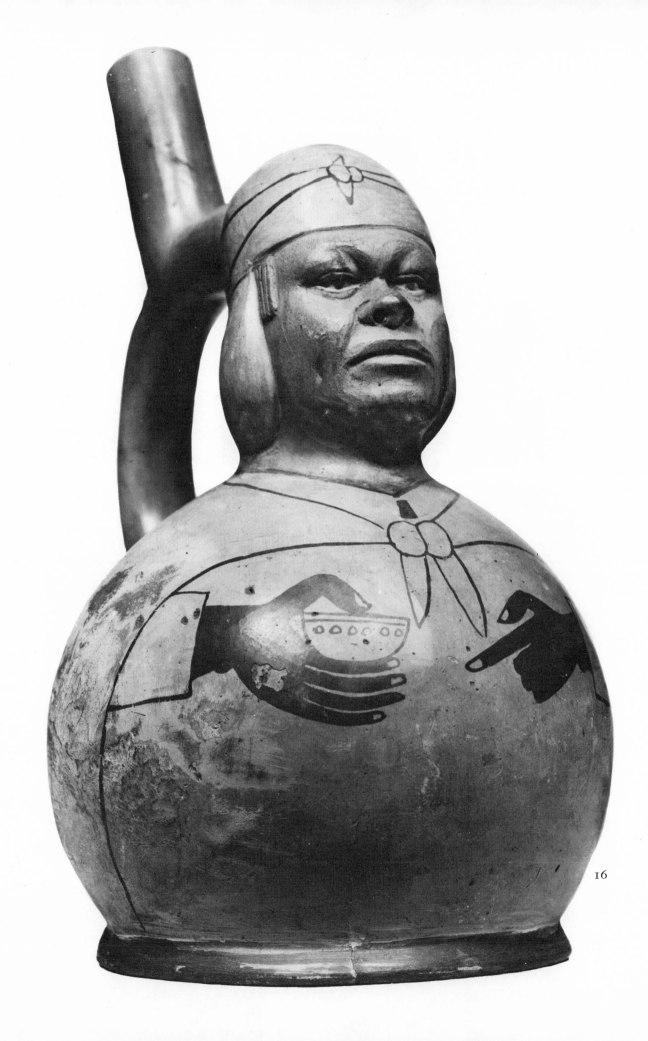

16

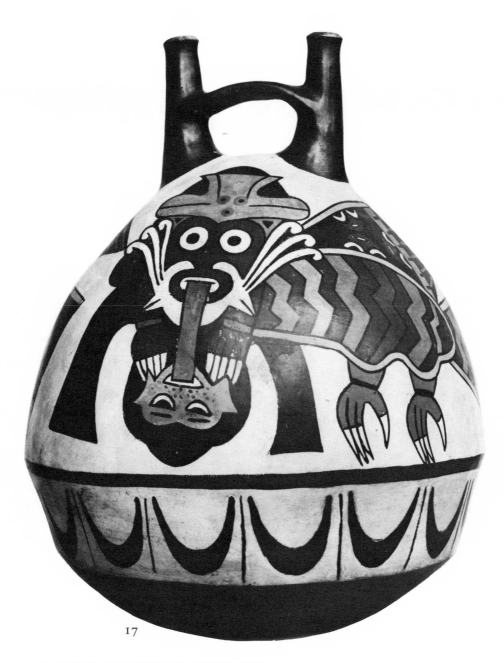

17

16 MOCHE (MOCHICA) CULTURE *c* AD 300–850
Peru
*Brush Drawn Details on a Modelled Single Spout
Portrait Vase*
Brush drawing on pottery.

17 NAZCA CULTURE *c* 150 BC–AD 850
Peru
A Winged Monster Attacking a Supine Figure
Brush drawing on a globular pottery vase.

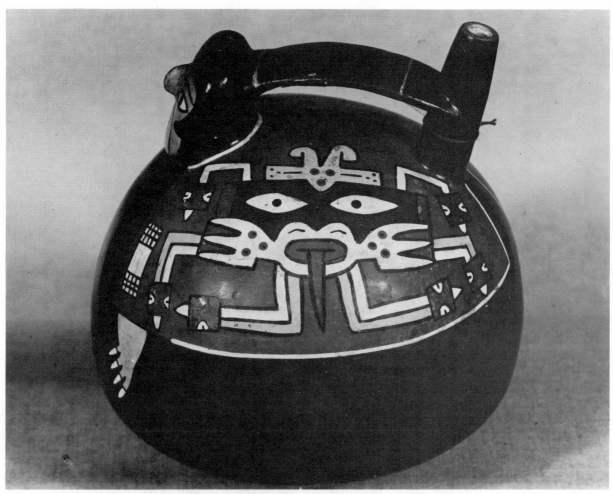

18

18 NAZCA CULTURE *c* 150 BC–AD 850
Peru
A Monster
Brush drawing on a single spout globular vase
with additional modelling.

19 MOCHE (MOCHICA) CULTURE *c* AD 300–850
Peru
Two Intertwined Birds
Brush drawing together with modelling on a
single spout pottery vase.

20 NAZCA CULTURE *c* 150 BC–AD 850
Peru
Decorated Modelled Figure Vases
Brush Drawings on single spout
modelled globular vases (OVERLEAF).

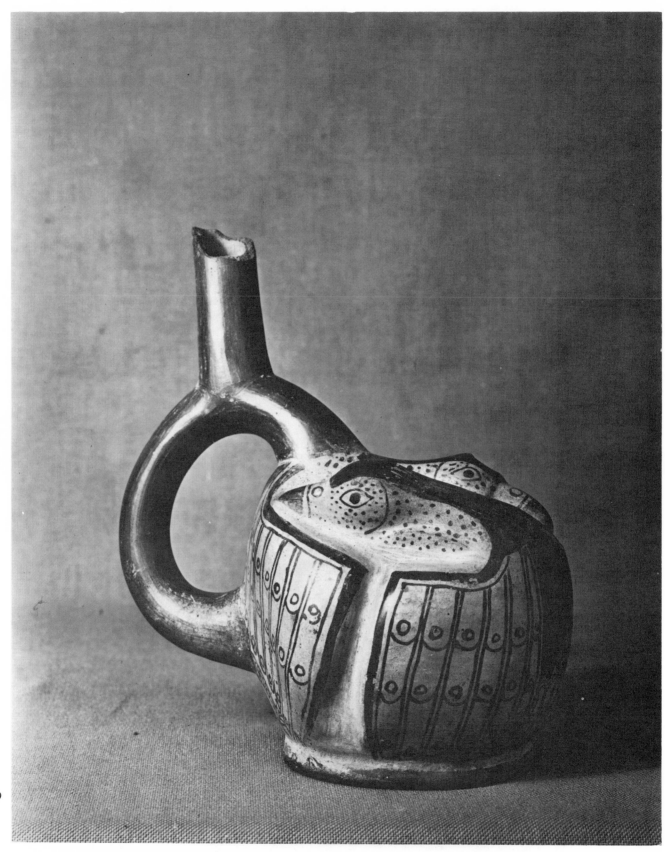

19

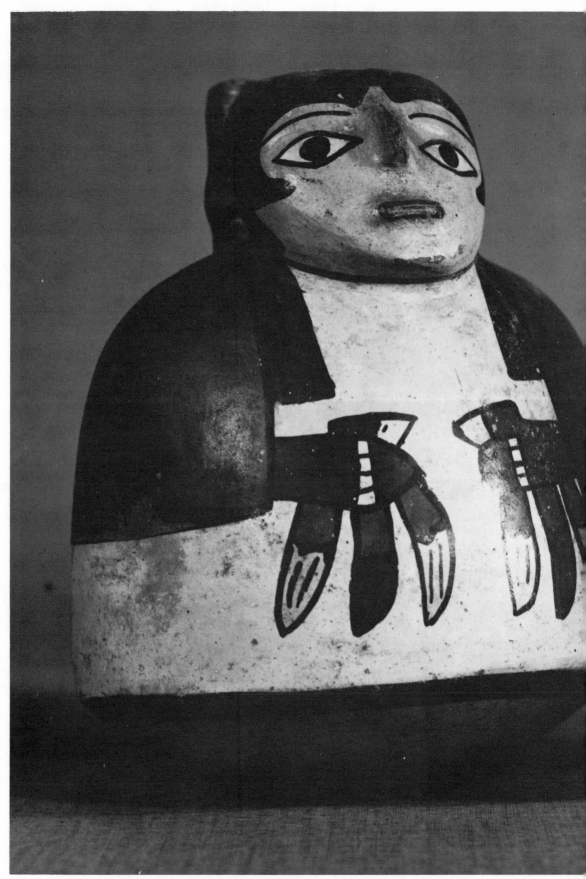

20

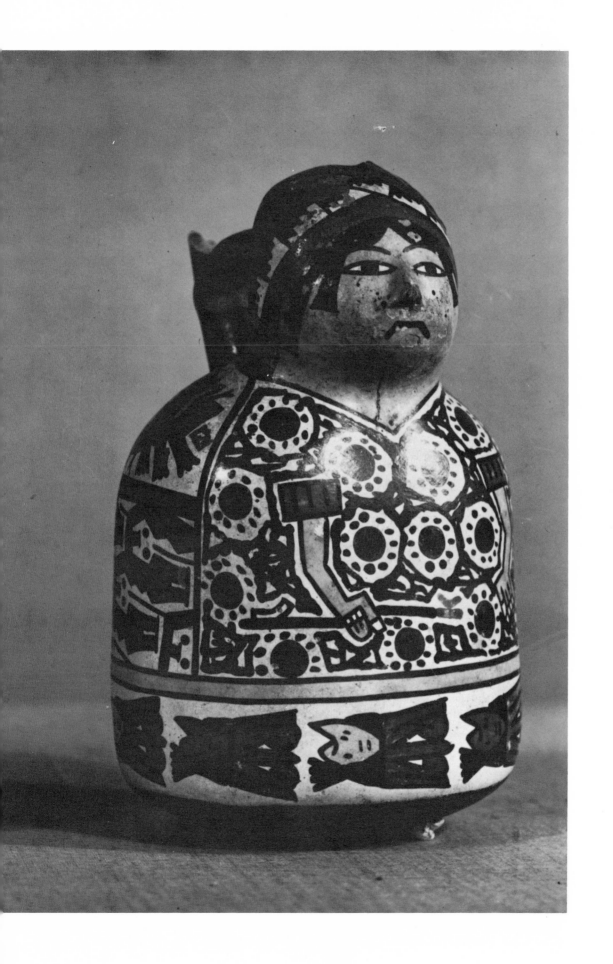

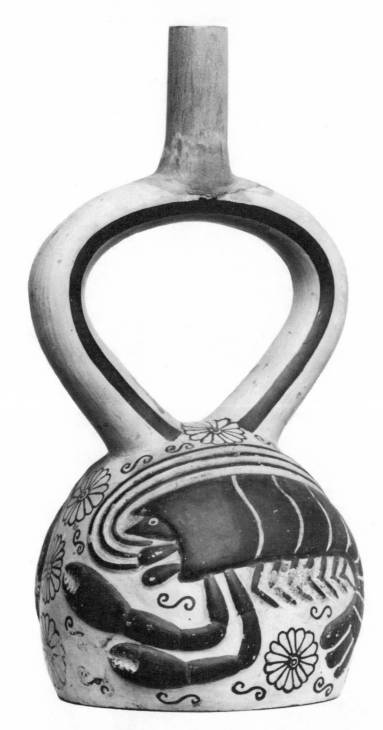

21 MOCHE (MOCHICA) CULTURE *c* AD 300–850
Peru
Crustaceans With Floral Decorations
Incised and partially modelled brush drawings on single
spout pottery vases.

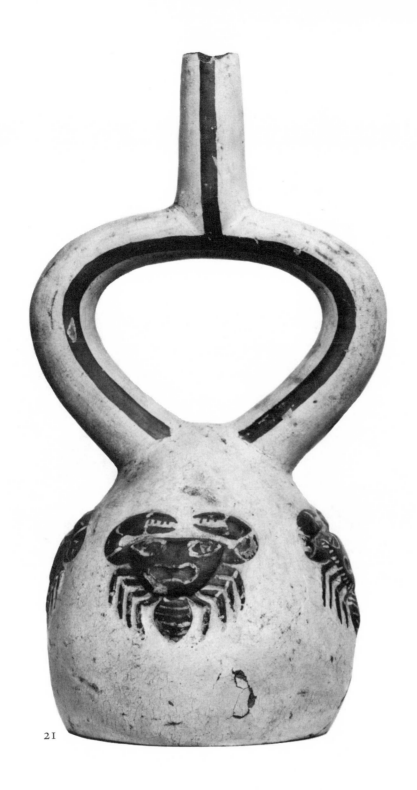

21

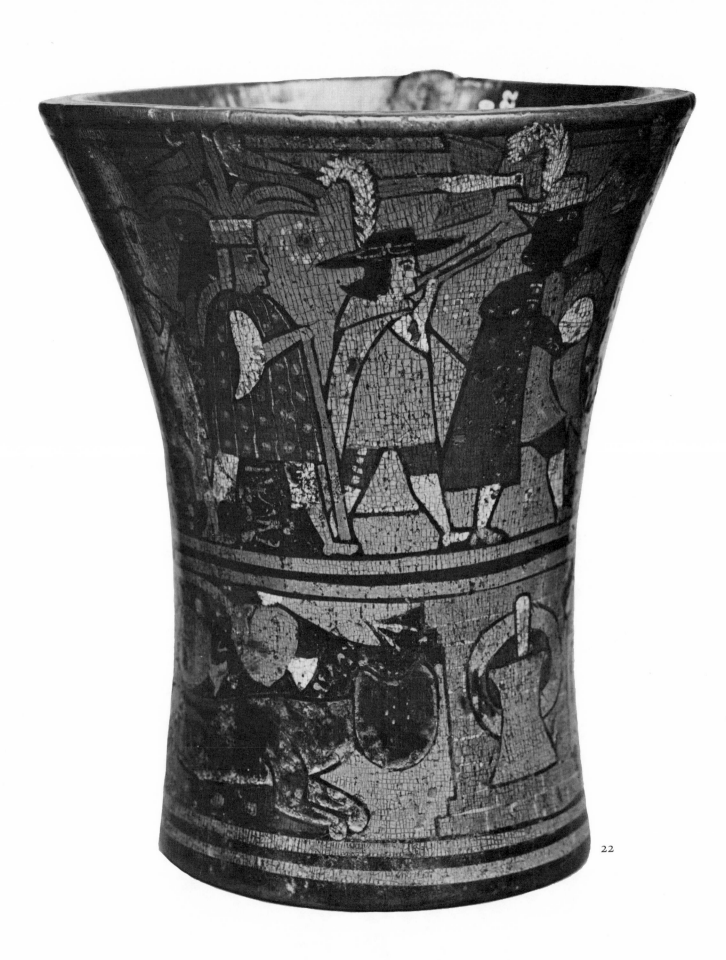

22

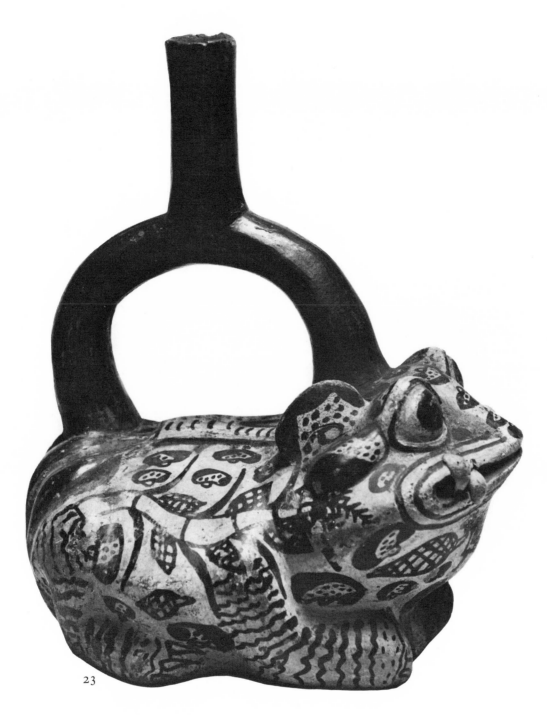

23

22 INCA CULTURE probably seventeenth century
Peru
Beaker (kero) with Two Spanish and Seven Peruvian Figures
Polychrome lacquer, over an incised outline, on a wood beaker—
illustrated for comparison with Mochica and Nazca decorated vases.

23 NAZCA CULTURE *c* 150 BC–AD 850
Peru
Decorated Animal Form
Brush drawing on a single spout modelled pottery vase.

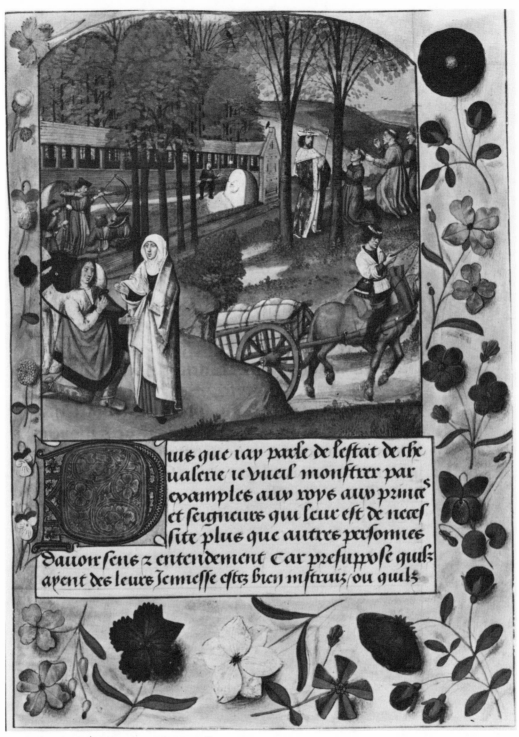

ius que iay parle de leftat de che
ualerie ie vueil monftrer par
eramples auw roys auw prmces
et feigneurs qui leur eft de necef
site plus que autres perfonnes
dauoir fens z entendement car prefuppofe quilz
ayent des leurs ieunesse eftez bien inftruiz, ou quilz

24 THE MASTER OF SHEEN *fl* 1496
Anglo-Flemish (Sheen (or Richmond) Surrey)
Imagination and the Knight in a walled Garden, with Crossbowmen practising at the Butts
Bodycolor, heightened with gold, on vellum.

3

Romanesque and Gothic Draughtsmanship

ART IS VALID only if it is dedicated to the glory of God, the majesty of His Church, and the power of Christendom. Such was the over-riding aesthetic of medieval thought, and in no medium was this more apparent than in the art of drawing.

The draughtsman's creative ability was primarily directed toward the maintenance of a continuous religious tradition. Greater importance was attached to a faithful reproduction of iconography than to the development of a personal style. This is not to say that medieval artists were expressly forbidden to attempt all personal interpretation, but it was true that their canons of aesthetic judgment were both rigorous and explicit in their conceptual vision.

Medieval intellectual theory was at one with itself. The architect, painter, draughtsman, and sculptor understood and accepted the precepts found in the philosophy, literature, and science of the time. Indeed, all the art forms were interdependent, and consequently similar characteristics appear in the drawing, embroidery, enamelling, and carving of a given location and period. In essence, medieval art expressed an abiding confidence in its interpretation of the universal scheme of things as created by God and promulgated by His Church.

It could be said that the very universality of medieval art was so all-encompassing as to be encyclopedic. Man was shown as a whole being. He was a creature whose emotional visions and ecstasies carried him to God, but whose component parts were not subject to individual analysis, as they were in the Renaissance, because he was seen as a single, spiritually complete unit. The essential grandeur of man's relationship with God, as expressed artistically, never placed the human element in isolation. Instead, every man was surrounded by the mysteries, pleasures, and sorrows of his environment, and was directed to find his own particular place

as assigned by divine ordinance.

In essence, the medieval artist was confronted with a continuing need to depict the interaction of transitory man with an eternal God. This relationship manifested itself artistically as a representation of 'time operating in an envelope of timelessness'. There was no straightforward chronology but rather a static continuum of 'now and later' or 'before and after'.

It must be remembered that the preliminary drawing or sketch had a very insecure place in the aesthetics of medieval Europe. It was never valued as highly as in the Renaissance, and consequently few such items survive today. Medieval man valued the draughtsman's art only when a finished product was presented, and this was natural given the medieval perchant for synthesis rather than analysis; for wholes rather than parts of things.

The artist was submerged in the craftsman. Scholars were trained to regard any occupation which involved manual work as somewhat degrading and unfortunately all the representational and mechanical arts fell within this range. Catholic dogma reinforced this prejudice by emphasizing contemplation over action and thinking over performing. The artificer was not considered as worthy as the artifact he produced, and even the object had to fit prescribed purposes by revealing some aspect of the eternal world and the nature of God. Clearly this was not an environment conductive to the development of an individual genius which could assert itself openly.

Certainly the most important surviving examples of early medieval draughtsmanship are the line drawings executed by monastic scriptoria. The art of drawing found its initial home in these rich foundations endowed by princes and nobles seeking a means of saving their immortal souls. The artist-monks conceived the drawing as a necessary part of the hand-written manuscripts, Bibles, psalters, breviaries, and bestiaries used by the Church as instruments of its teachings. Through such work draughtsmanship gradually evolved new forms. Individual objects were treated according to rigidly patterned master-plans in which everything from architecture to drapery to faces was constructed within a formula whose details had already been carefully outlined and composed. No copying from nature was necessary. Instead schematic 'exempla' were used to portray life in terms of geometry and calligraphy rather than texture and plasticity. In other words, naturalism was spurned and everything was represented according to its inner non-visual properties, since proportions based on divine canons were considered more beautiful than anything created by the accidents of nature.

Medieval drawings, particularly those of Celtic origin, convey a kind of supernatural and magical distortion of reality. They evince a neo-platonic emphasis on the spiritual nature of form based on concepts rather than perceptions. Draughtsmanship had become a central art governed by the composition and distribution of forms based on preconceived thought. Symmetries and repetitions were so arranged that a music of symbolic structure is what emerges to the modern eye. The world

ROMANESQUE AND GOTHIC DRAUGHTSMANSHIP

portrayed by the medieval draughtsman was one without space in which even human figures are phantom-like, surface ornaments devoid both of plasticity and a profound exultation of the beauty of the body. These traits are evident not just in drawings but also in paintings, stained glass, enamels, metalwork, and tapestry; in short, in all those areas where two dimensional representation was appropriate.

In medieval drawing we find the draughtsman carried away by the decorative potentialities of his penmanship. There is often such a complete coherence in the staccato zigzag of the pen that an extraordinary sensation of energy, turbulence, and movement is created within the realm of divine composition. Figures which are brittle, insubstantial, and apparently frail achieve a degree of agitation and attenuation which generates fantastic dynamism. This is particularly true of the English drawings of the eleventh century where Byzantine influences are noticeably strong. It is also apparent in many other schools of early medieval draughtsmanship which reduce all descriptive elements into the complex and convoluted embroidery of magical cosmology.

The history of medieval drawing can be roughly divided into two periods—the Romanesque and the Gothic. After the Carolingian, Ottonian, and Salian empires exhausted themselves, and Europe generally, an artistic revival took place in Europe but most particularly in France. There the great feudal lords of Normandy, Aquitaine, Burgundy, Gascony, Anjou, and Brittany, together with the young Capetian monarchy, attempted to restore order, peace, and security to the people of their territories. Papal supremacy also strengthened and with it arts and letters revived in the great abbeys and pilgrimage centers. When peace was at last restored it was in these places that art executed in the *more romano*—the Romanesque style—flourished throughout the eleventh and twelfth centuries.

A characteristic style of draughtsmanship emerged at this time, particularly in manuscript illustration. One finds firm, smooth lines indicating clearly and precisely the boundaries of color and the dynamism of movement. Romanesque draughtsmanship of the twelfth century adopted a particular drapery convention called the damp-fold style. The drawing is executed with a double series of sensuous lines covering limbs in such a way as to suggest their solidity. This gradual hardening of both color and line at length produced a highly conventionalized type of art which in turn has made attribution of a given work to a particular artist extremely difficult for the modern historian of art.

The iconographic drawing of Romanesque draughtsmen provided society with moral and doctrinal lessons together with illustrations of historical and religious precepts. These drawings appear as the products of deep meditation rather than as spontaneous expressions of joy or hope. This is comprehensive when one considers the early monkish draughtsman who viewed his work as an essential tool in the creation of literary and artistic documents.

Romanesque illustrated manuscripts were also an experimental laboratory for those who worked in allied media. Parchment and reed pen were more ductile

than gold, ivory, or stone, and in illuminated manuscripts images were born and new forms created that later found logical expression in the buildings and sculpture of the period. Form was reduced to pattern and pattern could express movement in a never-ending panorama of variation.

The growth of universities all over Europe in the twelfth and thirteenth centuries increased the demand for texts. Since book illustration was a prime source of employment for the draughtsman it was natural that the art of drawing was commercialized and professionalized by workshops and guilds such as those located in Paris' *Rue de la Parcheminerie* (Parchment Street). These guilds were unconnected with the monastic scriptoria which had previously held a monopoly over such activities. As workshops established their partial independence of the Church, so too did the draughtsman's art attain a new independence.

Private patronage played a significant role in the development of secular drawing. Perhaps most notable among late medieval patrons in France were four princely brothers; King Charles V, the Dukes of Berry and Burgundy, and Louis d'Anjou, at whose courts dozens of draughtsmen flourished, opening new paths of creative energy and sophistication. Patronage was further augmented by members of the newly rich merchant classes who were sufficiently enlighted to appreciate the gifts of the artist, and who commissioned works demanding a type of social reality that differed markedly from that required by the Church or the court.

Romanesque art reached its pinnacle in twelfth century France, having already shone brightly in England one hundred years earlier. It was to continue as a dominant style in Germany well into the thirteenth century, and was still to be seen in isolated pockets of Italy and Spain at a much later date. But the conclusion is unavoidable, regardless of venue, that Romanesque art was in many ways simply an incomplete expression of the style that became known as Gothic.

We no longer attach a pejorative connotation to the word Gothic as did Renaissance aestheticians. Time has revealed the Gothic world of the thirteenth and fourteenth centuries as a milieu of romance, courtesy, and idealistic chivalry. The traditional view is that Gothic art emerged under the patronage of Abbot Suger at St Denis between 1122 and 1151. Regardless of the accuracy of such a date, it is clear that by the year 1250, fully one hundred years after Suger, European art in a variety of media had been significantly transformed. A distinctive Gothic style had been born which lasted over two hundred years, and had enormous impact on the intellectual and spiritual life of the entire European community.

Gothic draughtsmanship began to develop in a fresh direction when it attempted to do what was more traditionally appropriate for sculpture, tapestry, or enamel. The Italians were the first people of the Mediterranean to abandon the Byzantine style and adopt instead the conventions of decorative naturalism popularized in transalpine Europe. Gradually a theory of representational art evolved which commanded the draughtsman to recreate the impact of immediate sense-perception. Gothic drawings began to integrate figures with architectural and

landscape motifs. Emotive gestures were introduced and three-dimensionality began to make itself felt. Individuals were portrayed as if on stage, and a background was introduced to cut off the supernatural space which floated behind each figure. Modelling appeared and turned images into personalities made up of definable and recognizable parts. By the fourteenth century figure studies were executed in a delicate grisaille chiaroscuro contrasting with washed lines of surrounding areas. Men turned to the task of self-examination as humanism challenged scholasticism and as the symbol was replaced by the picture.

At the end of the fourteenth century elegant drawings were produced which show a careful attention to naturalistic detail. This approach is now known as the International Gothic style. So popular did it become that the remnants of International Gothic influence are found in certain parts of Europe well into the sixteenth century. This influence can be readily seen in the otherwise disparate work of Rogier van der Weyden, Gerard David, Albrecht Dürer, and Hieronymus Bosch, men who bridged the gap between the styles of medieval and Renaissance Europe, and carried the Gothic vision well into the modern era.

In Italy, International Gothicism was evinced in the drawings of Pisanello and his followers who combined a profound sense of imagination and color with elegant linearity and a rigorous analysis of forms. The result was true virtuoso draughtsmanship that created in the spectator a heightened sensitivity to artistic fantasy while at the same time drawing his attention to the virtues of realism.

An enlightened and sophisticated aristocracy, together with the increasing patronage and interest of the city bourgeoisie, helped set the stage for the last great period of Gothic art. Slowly both draughtsmen and painters were becoming aware of the expanded horizons of their art. As modelling in drawings became stronger so too did the single line lose some of its expressive force. However, this had a positive connotation in a new world of vision based on an appreciation of antiquity. There was an awakening to nature which found expression, not in endless symbolic repetition, but in a systematic method of draughtsmanship based on direct observation. In many ways the drawings of the International Gothic style convey a new language to the viewer, and there is much in the draughtsmanship of the period that is reminiscent of the *dolce stil nuovo* of Dante's *Divine Comedy*.

Drawings, particularly in Italy, attained a more organic sense of construction. New qualities of drama and emotion conveyed the fervor of religious experience more directly than the abstractions of earlier generations. New goals and intentions were proclaimed as artists achieved aesthetic autonomy. The draughtsman came to value the essential dignity of physical excellence and strength of character. The fourteenth century was the time of the proto-Renaissance which opened the way for a true classical revival in which drawing occupied a seminal and central artistic position. Man was discovering a new role for himself in the cosmos, and for the draughtsman great vistas began to unfold as the modern world of artistic expression came into being.

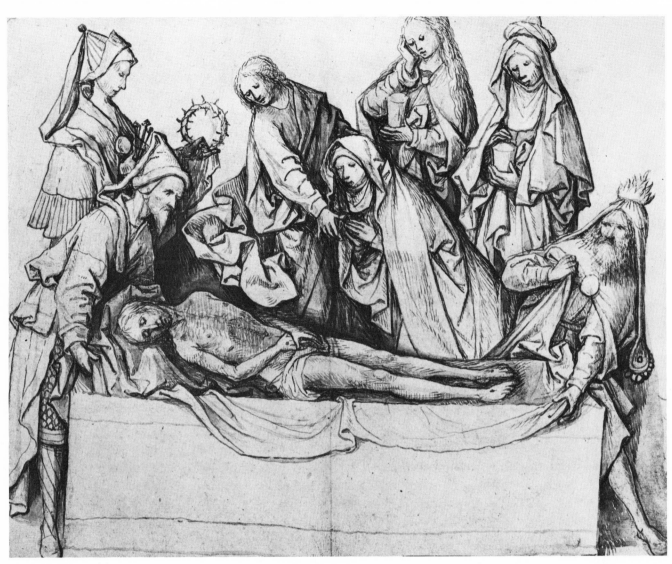

25

25 HIERONYMUS BOSCH b. 1450 or 60, d. 1516
Flemish (Brabant)
Entombment
Brush drawing in grey wash, over black chalk.

26 THE EGERTON MASTER *c* 1405
French
The Visitation
Bodycolor, heightened with gold, on vellum.

27 BROTHER WILLIAM THE ENGLISHMAN *fl* 1239
English
The Apocalyptic Christ
Plummet, partly strengthened in pen and ink, with light
yellow wash, on vellum (OVERLEAF).

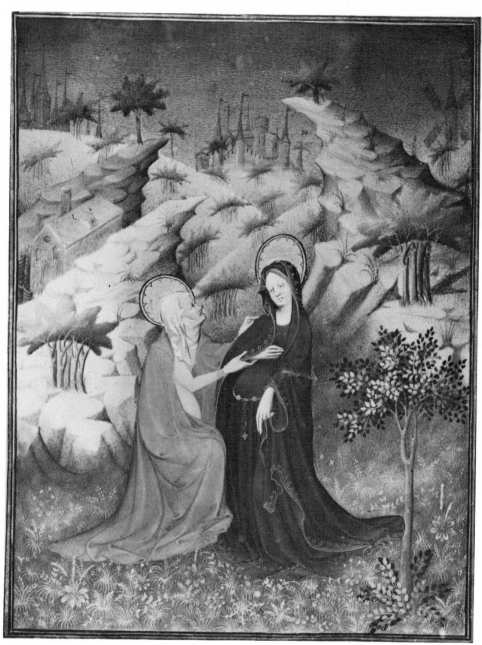

26

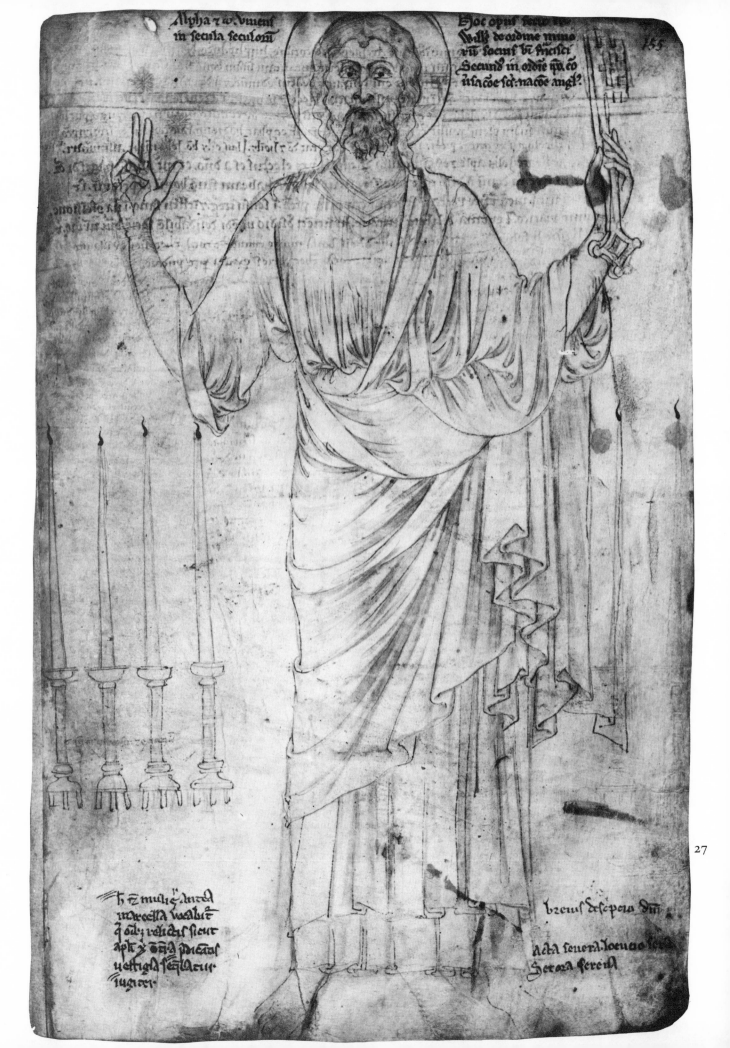

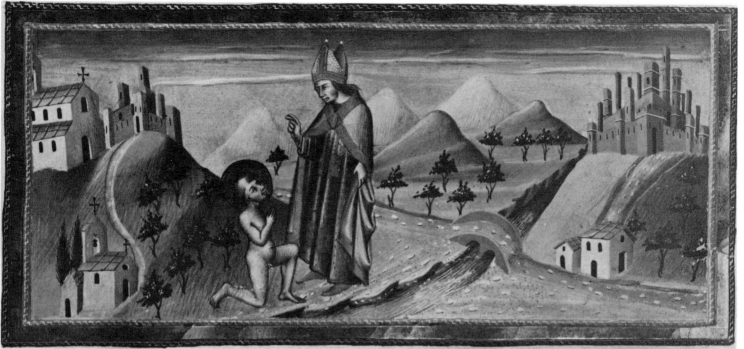

28

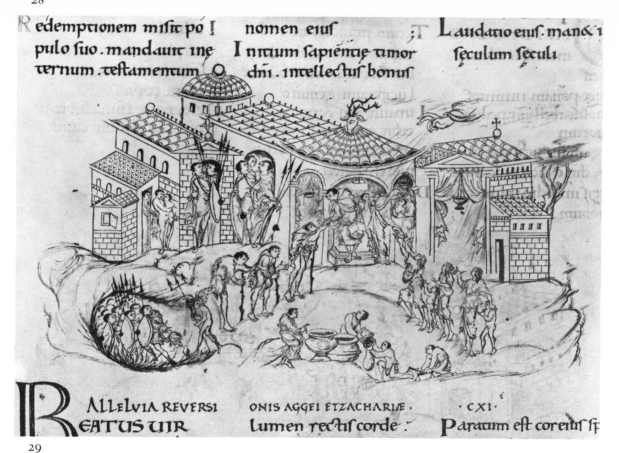

29

28 GIOVANNI DI PAOLO b. 1403 d. c 1482
Italian (Siena)
*St Francis, having taken the Vow of Poverty, kneeling naked
before the Bishop of Assisi: and in the Background, the Cities
of Assisi (left) and Gubbio (right) c 1400*
Bodycolor, heightened with gold, on vellum.

29 ANON. ENGLISH c AD 1000
St Augustine's Monastery,
Canterbury
Illustration to Psalm CXI
Pen and ink, with blue and
brown washes on vellum.

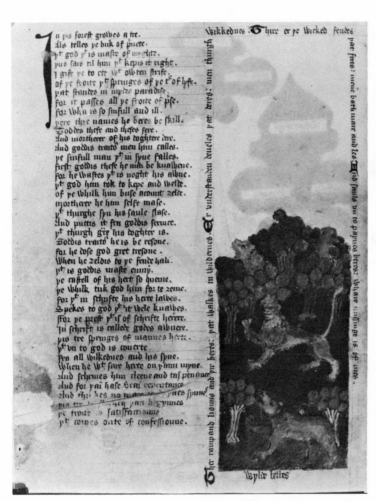

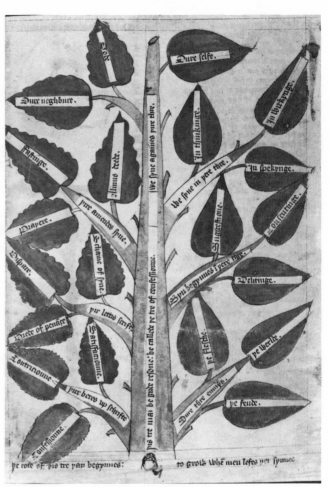

30

30 ANON. ENGLISH (?) UNDER DUTCH INFLUENCE *c* 1425–50
(Left) *'Wylde bestes' in a Forest*;
(Right) *The Tree of Confession*
Watercolor and bodycolor on vellum.

31 THE MASTER OF THE STORY OF TOBIT *fl c* 1500
Flemish
Two Kneeling Ladies
Pen and dark brown ink, over black chalk.

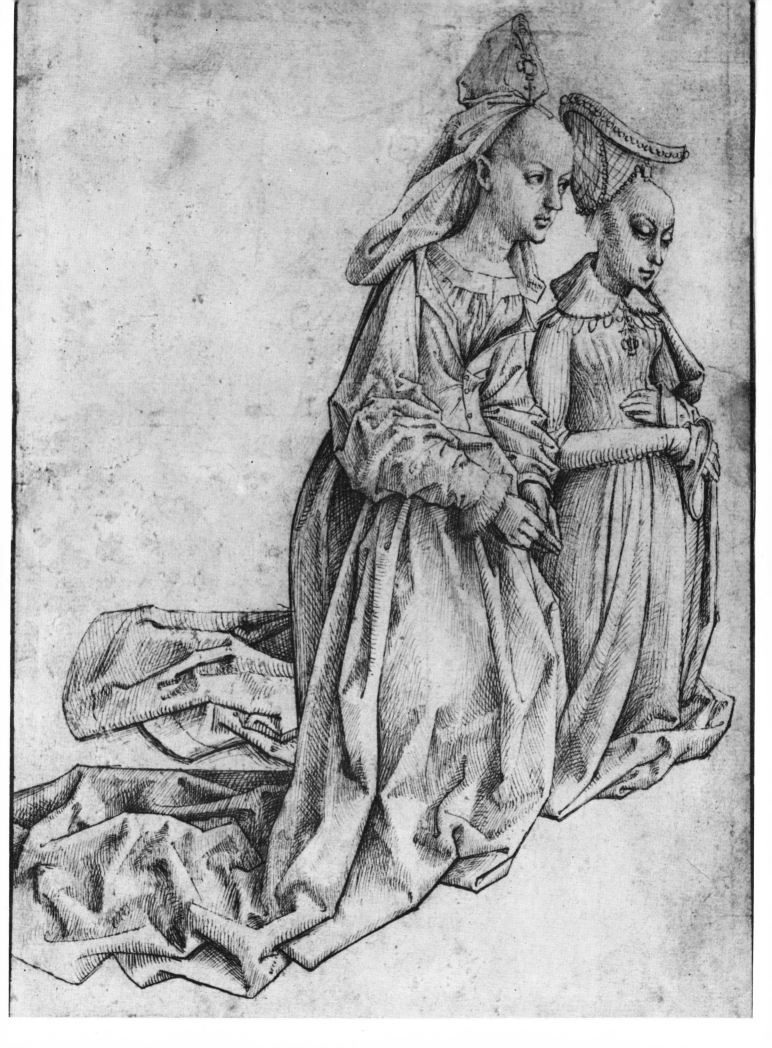

Kl

1	10	K	KS	Kl	d	Omniū scōrum		cl
2	18	23	8	e	e	Comemoracio aīaʒ Eustachy m̄r.		k
3	Λ	6	293		f	Pirminy epi		y
4	14	18	222		g			h
5			Nōs	A	felius et Euseby			i
6			8	b	Leonhardi confessoris			k
Λ	4	2	1Λ	Λ	c	Willibrordi epi		l
8	12	2028	6	d	Quatuor coronatorū			m
9			4	e	Theodori m̄rs			n
10	1	16	1Λ	4	f	Martini pape		o
11	9	23	42	3	g	Martini epi thuronen		p
12			2	A	Gumberti epi			q
13	1Λ	6	42	9b	Briccy epi			r
14	6	22	2Λ	8	c			z
15			1Λ	d	Secundini m̄rs			ſ
16	14	14	24	16	e	Othmari confessoris		6

32 ULRICH FUNK (?) *fl c* 1515
German (North Tyrol)
A Boar Hunt
Bodycolor, heightened with gold, on vellum.

33 ANON. ENGLISH *c* 1450
(Buty St Edmunds (?))
*John Lydgate offering his poem 'The Pilgrim' to Thomas
Montacute, Earl of Salisbury*
Pen and brown ink on vellum.

34 A

34 ANON. FRANCO-JEWISH *c* AD 1280
Northern France
a) *Aaron the High Priest in his Vestments wearing the*
Breastplate of Judgment and a Crown inscribed 'Holy unto the
Lord'
b) *Aaron pouring Oil into the Lamps of the Golden Candlestick*
Pen and ink, with bodycolor, heightened with gold, on vellum.

34 B

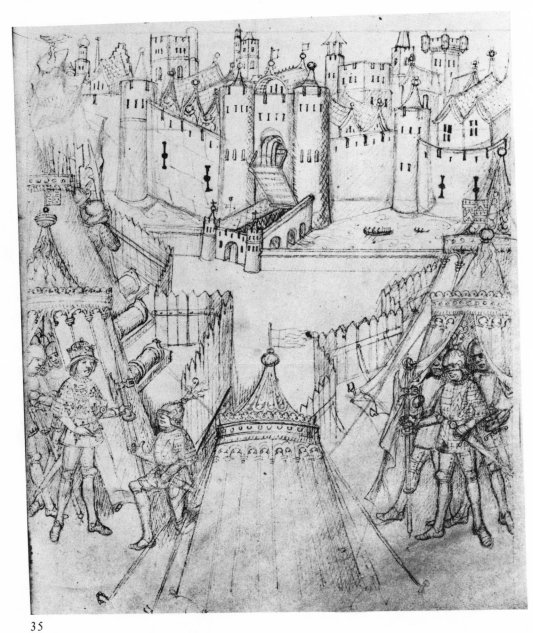

35

35 ANON. ANGLO-FLEMISH before 1493
Rouen 'beseged both by londe and water'
Plummet, finished in pen and brown ink, on vellum.

36 ANON. FRENCH *c* 1500
Cain and Abel
Pen and ink, with watercolor.

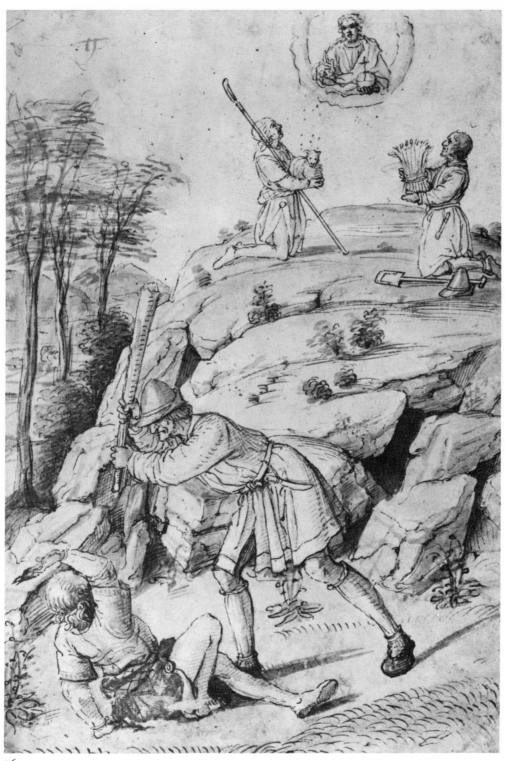

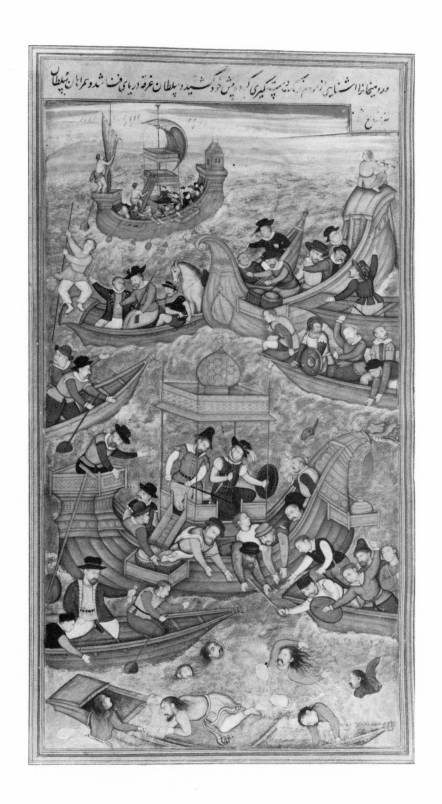

37 LA'L *fl* AD 1603
Mughal (Akbari School)
Sultān Bahādur and Rūmī Khān Leaping into the Sea at Diu,
when surrounded by Portuguese Ships, AD 1537
Bodycolor, over preliminary brush outline, on prepared paper.

4

Persian and Mughal Illustrations

THE PROPHET MUHAMMAD proclaimed himself the messenger of God. His intention was to carry the word of Allah to the people of Islam just as it had been previously carried to the Jews and Christians. The holy Koran was the written instrument of Muhammad's vision, and its veneration fostered a cult of the book in the Middle East similar to that which existed among the adherents to the Judeo-Christian tradition. The worship of God and His teachings through the use of holy books inspired many peoples, whose art forms were highly developed, to turn to the symbols of the divine word as objects suitable for the most sophisticated decoration. Among the Persians, who already valued calligraphy as a supreme art form, the illumination and embellishment of books and miniatures was a natural development and proved to be that nation's major contribution to the art of drawing.

Persia, like Japan, was a prime beneficiary of Chinese influence particularly from the beginning of the thirteenth century. Chinese techniques of drawing, color, and composition were freely adopted by the Persians and then skilfully tailored to suit the particular needs of their culture. Throughout Persian drawings one finds a spirit of romantic childlike perception. They saw the hand of God in all things, and in the greatest of their drawings one can detect an ecstatic sensuous vision which reflects the nature of their creative genius. Technical problems surrounding the use and effect of light were of less interest to the Persians than the simple and unadulterated glory of light and color as an expression of God's handiwork.

Even the strict and often spartan rules of Islam which forbade the depiction of figures as a sacrilege could not destroy the instinctive Persian desire to create beautiful art, and did not diminish the patronage that flowed to artists from the great Timurid and Safavid princes. However, religious prohibitions did prevent

representation in art which was essentially public. Decoration in books was subject to the tastes and whims of the patron, though no outright attack on Islamic principle was ever tolerated.

Three dimensional representation, along with a treatment of atmosphere, light, and shade, was never attempted by Persian draughtsmen. Instead their drawings are predominantly patterned and decorative. Landscape for its own sake was rarely attempted. Man and his activities were the center of all things, and to depict the human world a whole series of conventions were developed.

It is common, for example, to find one group of figures in a scene portrayed on a single level in the foreground. Any additional figures in the background would potentially be obscured by what has already been drawn. But to cope with this problem second and even third levels are constructed on a vertical plane. Thus all characters, however distant, can be seen with equal clarity without relying on the use of Western perspective.

This empirical approach to composition looks somewhat naive to Western eyes. However, it was considered aesthetically satisfying to Persian sensibilities as was their convention of adding decorative floral arrangements which did not conform to natural scale but instead appeared greatly magnified.

Persian drawings also tend to be provided with a decorative border of design endowed with curves, circles, and spirals, but scarcely a single straight line or angle. This was considered harmonious with the calligraphy of Persian books. And it is true that the maze of lines occupying all defined space does seal off the drawing so as to create a marvelous sense of enclosure in which the delights of the master's brush can be fully and securely apprehended.

The Persian sense of values, which reached its most sophisticated level between the fourteenth and seventeenth centuries, demanded that drawing always be light, fast, and mobile, yet at the same time so constructed that the minutest detail was as carefully delineated as those elements of central importance. In great Persian drawings everything is refined to a grace and delicacy which arises primarily out of the slender strength of the brushstroke. All is cool and limpid—nothing suggests monumentality. Any hint of coarseness is banished. The vibrating tones; the endless detail, highlighted with touches of gold, delight both the eye and the mind.

The world of the Persian drawing is bathed in a golden light of happiness and contentment. All women are desirable and comely; all men are robust and handsome. Nature is ripe with fertility and the joy of living abounds. The narrative theme is always clear and explicit. There are few mystical or psychological undertones to the message of these drawings, and because their ultimate aim is to give pleasure the finest materials were always used to complement the perfection of detail.

Unlike the Chinese and Japanese, the Persians never adopted the swirling lines of the broad brush with its strokes of various thickness. Persian line is always as even in its progression as the quiet flow of Renaissance silver-point.

Anything that is overstated or excessive was rejected out of hand by the Persian draughtsman. Nothing was depicted unless it appeared in the eye of the mind, and it is this obedient distinction between the real and the unreal in Persian art that provides perhaps the most essentially entertaining aspect of its performance.

Just as China influenced the art of the Persian miniature and book illustration, so too did the creative genius of the Persians spread from their own lands and flourish at the courts of the great Mughal emperors of India. The migration of artistic influences from one people to another is a never ending process, and among the Mughals the art of drawing achieved a new refinement of all that was creatively vibrant and dynamic in the aesthetic of the oriental mind.

The Mughals traced their ancestry directly to the great central Asians Timur and Tamurlane whose Mongols at Herat and Samarkand made such an enormous impact on the civilization of Persia. While the blood and lineage of the Mughals was Turkish and Mongol, it was the contemporary civilization of Persia, from the sixteenth through the eighteenth centuries, that primarily influenced draughtsmanship at their courts. Indeed, so strong was this influence that some art historians have found it convenient to speak of Mughal drawing as being almost exclusively an Indo-Timurid or Indo-Persian style.

The Mughals settled in North India in the province known as Hindustan and it was there in the sixteenth century that they established the center of their empire under the leadership of the legendary Babur. The chronology of Mughal drawing is brief. The arts of Persia were imported under the second emperor, Humayun, but it was not until the ascension of his son, Akbar the Great, who reigned from 1556 to 1605, that a firm foundation of court patronage was established. With the coronation of the fourth emperor, Jehangir (reigned 1605–27), the art of the Mughals reached its zenith and was maintained at a high level by his successor, Shah Jahan, who built the Taj Mahal. However, with the ascension of the puritanical Emperor Aurangzeb (reigned 1658–1707) artistic excellence began to decline and never recovered its former brilliance, though poetic work in provincial style was produced until the early nineteenth century. Thus, it can be seen that the rise and fall of Mughal art was relatively short, and as political decay and military reversals tore the empire apart an art form that depended entirely upon the court could do nothing but cease to exist.

The outstanding characteristic of Mughal drawings is their ability to catch perfect likenesses in portraiture. It was natural that the secular tastes of princely connoisseurs, ruling an essentially alien nation, should condition this kind of artistic output. Realism was always a primary objective, and subject matter revealed in detail the pastimes and amusements, as well as the achievements and triumphs of the emperors and their nobles.

If an artist was to please his employer, and there were certainly obvious material benefits from doing so, he had first to master the techniques of his profession. As in China and Japan, the secrets of artistic success were passed hereditarily

64

from father to son. If the male line failed then a close relation was sought to carry on the tradition, for it was considered highly desirable that the skills of the master should remain within the family. Yet despite the bond of family the ambitious young artist still had to serve a lengthy apprenticeship, as was common in analagous professions such as carving, metalwork, and sculpture.

Repetition was the key to mastering the art of drawing, and it was from the patterns of his teacher that the young draughtsman learned the essential elements of constructing lines, tracing, pouncing, and stenciling. In essence, the training of the Mughal artist was no different than that required in other cultures. It closely approximates the means by which a child might be taught to read first by learning the alphabet and later the construction of words and sentences.

It was not unusual for a Mughal artist to be asked to produce many copies of a particularly popular work. Consequently, it became common practice for a draughtsman to maintain a stock of working drawings and tracings to facilitate the marketing of his work. These drawings while generally complete in outline also occasionally were colored with suitable pigments or contained minute color notations which assisted in the production of copies. Naturally, many of these drawings also became the instruments by which younger artists were trained.

It has been said that the execution of drawings was initially more a craft than an art at the court of Akbar the Great where Mughal draughtsmanship began to flourish. Artists beginning a commission would first gather in a workshop and have tasks assigned to them by the superintending overseer of the project. One man, usually the chief artist, would lay out the composition that was to be attempted. Mughal art, like that of Persia, was primarily the art of the miniature and small drawing. Once the general outline of work was approved, additional men were required; one to complete the figures, another to deal with the background, and still a third to decorate the border. Such a method of sectional piece-work could not survive in an age of increasing sophistication, and as virtuosi emerged at the court they were given responsibility for the entire execution of a commissioned work. Indeed, so high was the value of a great artist in the eyes of the emperor that Akbar established a state school of the arts wherein all practitioners who were attached to the court were registered, numbered, and ranked according to ability. The great artist at the court of the Mughals enjoyed the same sort of precedence and deference as other officials of the state hierarchy.

However, even though we know both the names and works of art created by many of the court draughtsmen, there is precious little additional evidence concerning their lives and activities. They lived to glorify the existence of others and consequently even portraits of the great artists of the time are objects of some rarity.

It must be noted that the art of the Mughals was primarily masculine in orientation. Few drawings or paintings celebrate either the activities or the physical attributes of women. This is hardly surprising in a society which relegated women

to a place far from the eye of the public. Thus, when ladies of the court are portrayed it must be reasonably assumed that the artist has drawn either from memory or more likely from imagination, since few opportunities would have existed for personal observation of feminine routine.

Although the Mughal miniature descends directly from Persian art there are certain European influences that can be noted. This is particularly true in early works of the school where attempts were made to give a feeling of relief both in the delineation of figures and drapery. Stippling produced an effect of modelled form in these drawings but the general result was unsatisfactory since such imitation was completely alien to both the spirit and the aesthetic of oriental art.

What makes the Mughal miniature unique in Indian art is the creation of outline through the use of calligraphic technique. This more than any other characteristic proclaims the origin of the work. The artists of the Mughal court produced an ideographic brushwork similar to that created in China and Persia and this proved particularly useful when dealing with the two methods of portraiture that developed. These two styles, the first concentrating on rigid profile and the second on a three-quarter view, were contemporaneous. But in the end it was the aristocratic profile of faces and feet, coupled with an angular depiction of shoulders and torso, which became generally acceptable.

It was the Mughals who first brought paper to India—a distinct improvement over the palm-leaf upon which drawings had been previously executed. Working with very fine brushes of squirrel, mongoose, camel, or goat hair, the Mughal draughtsman applied his tempera with devoted attention to detail, so that, despite the obvious limitations arising from the scale of his work, he managed to produce drawings of great charm and beauty.

The various *kalams* or regional and family styles that developed among the Mughals share certain characteristics that remain constant as the hallmarks of all Mughal draughtsmanship. The initial outline on paper was in india red which could in the absence of any adhesive be erased if necessary. Once this preliminary sketch was laid down, black permanent outlines were applied and remained as essential components of the final color scheme. When all outline work was complete the burnished paper was ready for tempera. First a thin coat of white, which did not completely cover the outline, was placed over the entire area of the drawing. Then, using the black outline as a guide, color and gold highlights were applied.

To create human features the color tones were first delicately blended and then applied with precise and never varying brushstrokes. This was the method by which the artist captured both the external and internal reality of his subject's visage, and this skill was also shown in the treatment of the rest of the body, particularly the hands. It has been said frequently that the most exquisite part of a Mughal or Persian drawing lies in the depiction of the palms and fingers of the human hand. While color is certainly the outstanding feature of these miniatures the success in drawing hands is perhaps the truest test of the quality of the work.

Mughal drawing cannot be considered as simply decorative art. A great many autonomous works do exist from this school, created as ends in themselves. They reflect more accurately than any other media the close association between man and nature that existed in the philosophy of the Mughals. When one confronts these miniatures they never seem simply a hazy vision of natural things. The Mughal draughtsman, creating with the imaginative eye of the mind as well as with his senses, tried to depict the essence of a form as well as its physical properties. His goal was the artistic realization of the universal harmony that governs all aspects of nature, and in the very best of his drawings that goal was achieved.

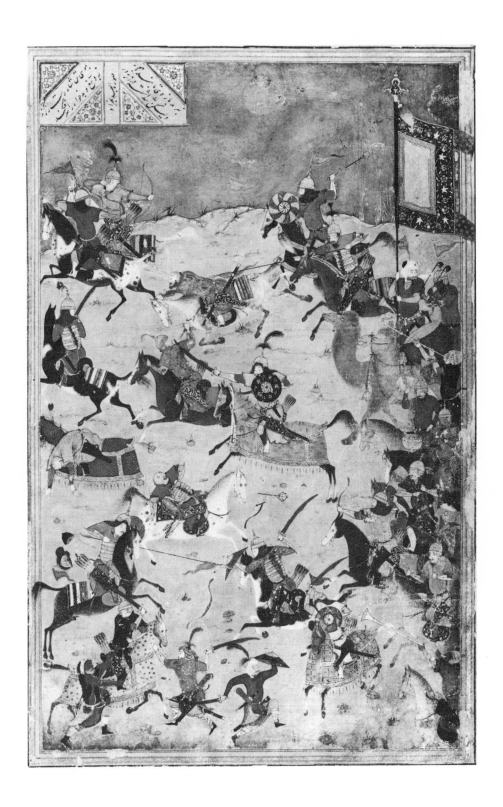

38 BIHZAD b *c* 1450, d *c* 1525
Persian (Herat)
The Battle of the Issus, between Alexander the Great and
Darius III
Brush drawing in black outline, with bodycolor, on prepared paper.

39 ANON. MUGHAL about 1625
A Woodland Scene
Brush drawing, with bodycolor, on prepared paper.

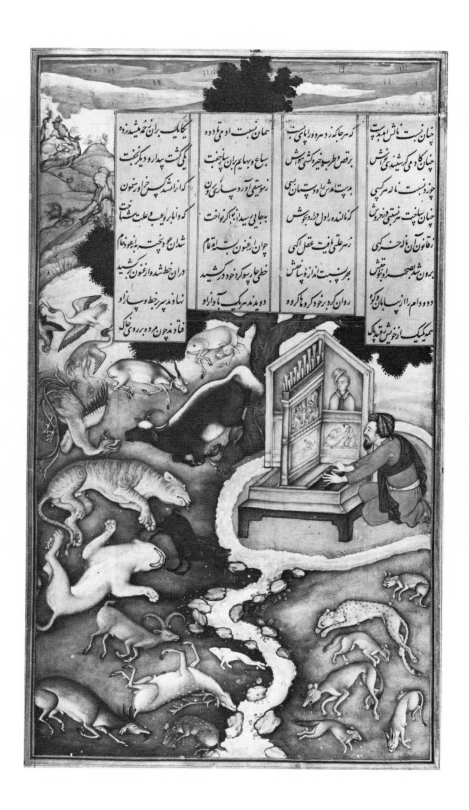

40 MADHU *fl* AD 1595
Mughal (Akbari School)
Plato charming the Animals by playing on an Organ
Bodycolor, over preliminary brush outline, on prepared paper.

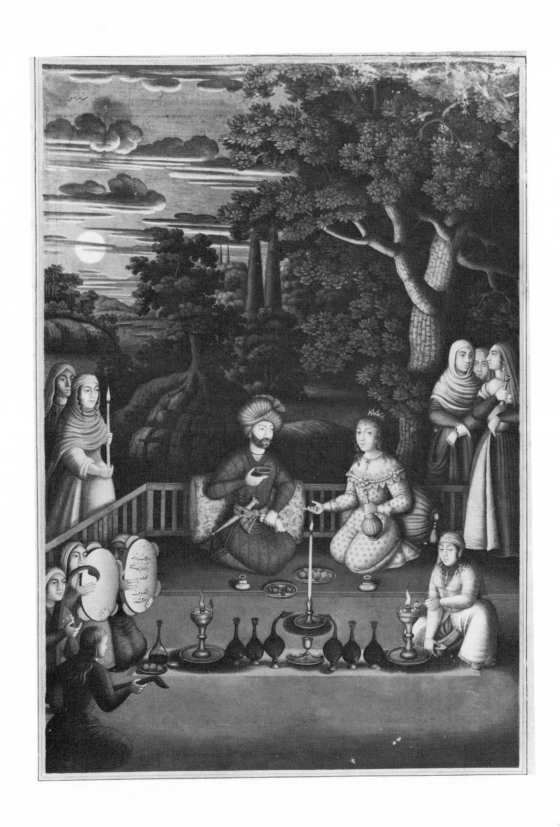

41 MUHAMMAD ZAMĀN (PAOLO ZAMĀN) *fl* 1643–89
Persian (Mazandaran School)
Bahrām Gūr entertained by the Indian Princess
Bodycolor on prepared paper.

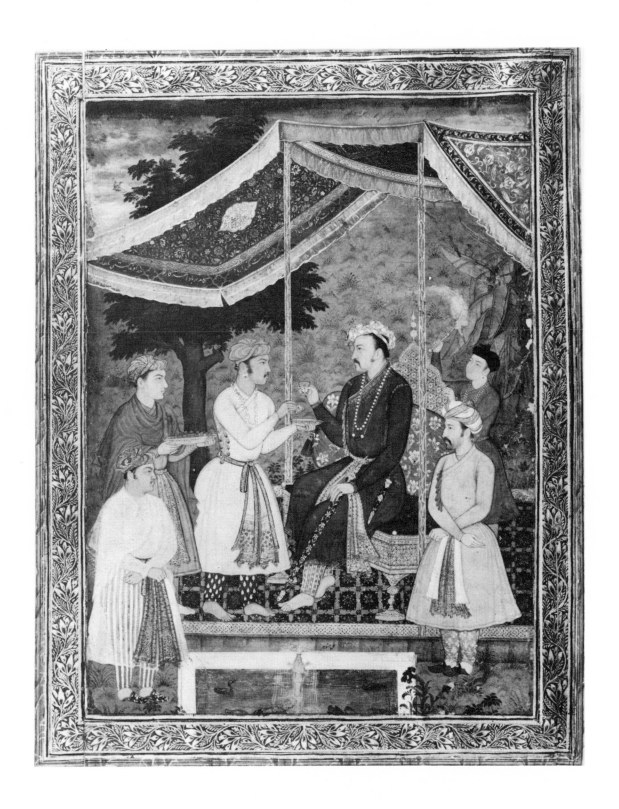

42 MANOHAR *fl* late sixteenth–early seventeenth century
Mughal (Jehangir School)
The Emperor Jehangir in private Audience, c 1610
Bodycolor, heightened with gold, on prepared paper.

43 BASAWAN (?) *fl c* 1600–10
Mughal (Late Akbar–early Jehangir School)
A white Bullock and an Ass drawing a Waterwheel
Bodycolor on prepared paper.

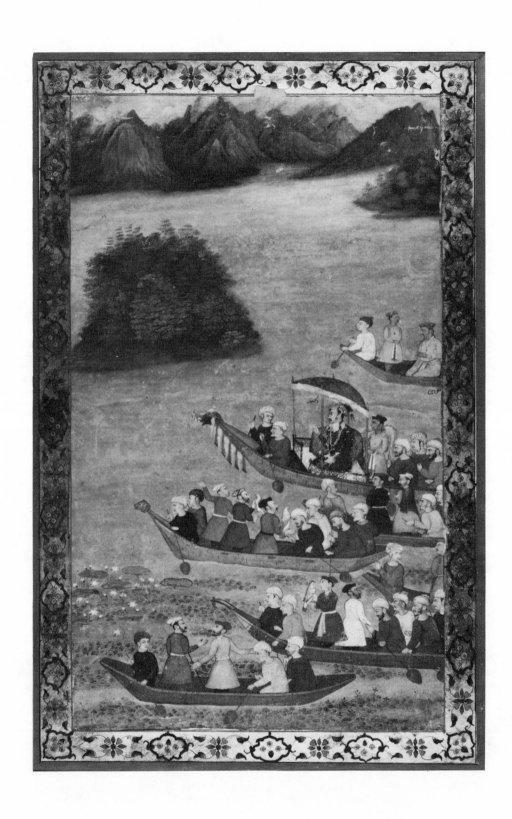

44 ANON. MUGHAL late seventeenth century
A Royal Hawking Party on a Lake
Bodycolor, heightened with gold, on prepared paper.

45 ANON. MUGHAL early seventeenth century
All except (a), Jehangir School
Five Portraits on one Mount: a) The Emperor Babar; b) Darab Khan; c) Prince Parviz (d 1626),
Son of Jehangir; d) The Mullah Shukrullah (d 1629); e) Raja Man Singh (d 1614)
a) Brush drawing in black wash; the remainder in bodycolor,
heightened with gold, on prepared paper.

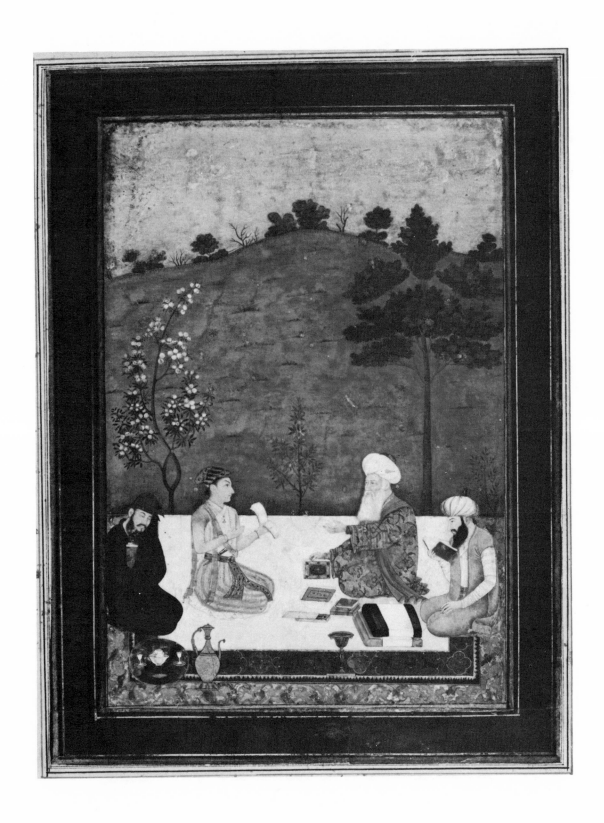

46 DĀL CHAND *fl* 1650
Mughal (Shah Jahan School)
Dara Shikoh, Son of Shah Jahan, with three Sages
Bodycolor, heightened with gold, on prepared paper.

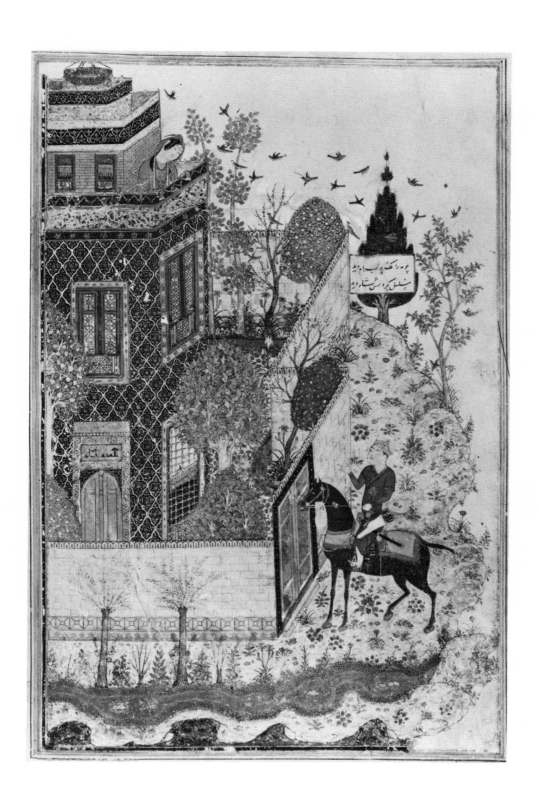

47 JUNAYD *fl* AD 1396
Persian (Baghdad)
Prince Humāy at the Gate of Princess Humāyūn's Castle
Brush drawing in black outline, with bodycolor, on prepared paper.

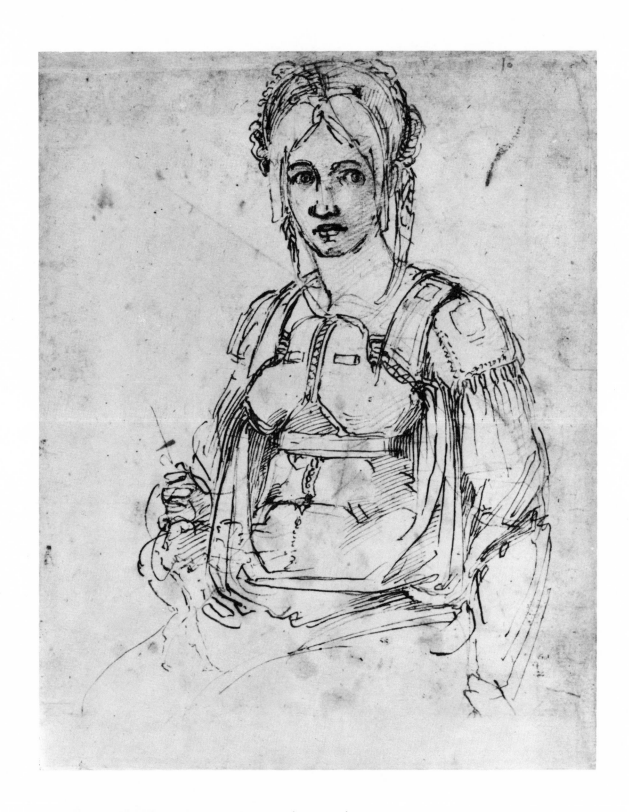

48 MICHELANGELO BUONAROTTI b 1475, d 1564
Italian (Florence; Rome)
Half length of a Woman, c 1525
Pen and brown ink, over red and black chalk.

5

The Italian Renaissance

WHO IS MAN and what is his destiny in the universal scheme of things? This was the central question of the Italian Renaissance that began in Florence at the beginning of the fifteenth century and within a hundred years spread throughout Europe.

The Renaissance was a cultural renewal that moved on many planes. It appeared in different countries at different times with varying intensity. Yet throughout Europe the Renaissance was consistently a celebration of man's achievements in the arts and sciences and, at the same time, an acknowledgment of the debt owed to the glory and majesty of classical antiquity.

The learned men of the Middle Ages had long appreciated the importance of Latin and Hellenic influences and in this context the Renaissance was no more than a developing variation on an old theme. Yet so man-oriented were the doctrines of the Italian humanists who dominated Renaissance thought, that as the movement progressed the medieval canons of scholasticism were seriously questioned and the very walls of Christendom began to shake and crumble.

Florence was the initial center of the classic revival and throughout the fifteenth and most of the sixteenth centuries it was to remain an important focal point for the *studia humanitatis* which advocated humanistic enquiry as the key to both a happy life and a prosperous State. In such a system intelligence rightly used could set man free and allow him to reach the pinnacle of human achievement through the teachings of a new moral order.

The first thirty years of the fifteenth century in Florence were marked by explorations of classical scholarship in a multitude of areas. Nothing was better than the antique and this belief was shown most clearly in the representational arts: architecture, sculpture, and most importantly, painting and drawing. These were

the media that first spread the artistic gospel of the Renaissance beyond Florence and Tuscany to important centers all over Italy and eventually the rest of Europe.

The Florentine master draughtsman in his *bottega* or workshop was surrounded by his family, students, and apprentices. In essence he had two families, the latter of whom stood as his models, ground his colors, sharpened his chisels, and in return were allowed to study their master's work.

The master draughtsman was by no means confined to his studio. It is easy to imagine him out and about armed with a notebook whose leaves had been prepared with a thin layer of ground bone so that a silver stylus could be used in lieu of ink which might run or smear. Thus, a potential patron was allowed to see and comment on an idea at the very moment of its creation. The draughtsman, if ensconced within the confines of his studio, could safely use liquids like ferrous sulphate ink or white zinc or lead which, if applied with a brush or a variety of quills, created a tonal effect suggesting both the illusion of relief and fuller color. Once an idea was approved by a patron sketches were often finalized and then, if necessary, divided into sections for use on a larger scale on a panel or in a fresco.

The Renaissance liberated the draughtsman and allowed him a greater freedom of expression through the multiplicity of media that developed. The artist now experimented with chiaroscuro in chalk or white lead. He could produce single contour line using pastel, watercolor, tempera, metal point, charcoal, ochre, or pen and ink. These media were to have a dramatic effect on artistic output and highly finished drawings bound either in albums or presented as single sheets began to appear. The drawing was becoming more than just a preparatory work.

The wide use of paper for the first time in the fifteenth century brought drawing within the realm of everyone. Previously vellum and parchment were extremely expensive and the advent of paper was an important technological innovation. So, too, the invention of the printing press gave rise to the art of modern engraving and this provided an almost unlimited possibility for the dissemination of artists' drawings. In time, engraving established itself as an important influence on techniques and styles of draughtsmanship as artists found it necessary to conform somewhat to the demands of the etched plate.

During the Renaissance artistic production was controlled by a system of patronage through which the artist, if sufficiently talented, prospered. Merchant princes, guilds, politicians, nobles, and popes vied for the honor of possessing examples of the great masters' finest work. Naturally, certain artists achieved great financial success and consequent social mobility, though admittedly the class which appreciated, understood, and patronized their work was an elite. At no time was the Renaissance a popular experience. But without the sponsorship of the Medici or the Visconti or popes such as Julius II much of the creative insight, power, and magnificence of Renaissance art might have fallen on fallow ground.

Throughout the Italian Renaissance drawing formed the basis of most representational art. The scientific method of Islam had provided a new critical and

empirical way of looking at the world, while medieval manuscript illumination had increasingly encouraged versatility and individuality on the part of the draughtsman. In addition, from the outset of the period the most important critical writings pointed to drawing as the most erudite and loftiest phase of artistic creation. Draughtsmanship was regarded in all the representational arts as a seminal font from which sprang the union of theory and idea with execution. The drawing was the initial and perhaps most important of creative processes, for in it the artist began to execute the details of what would eventually emerge as a total work either in the same or a quite different medium.

Naturally, different artists and schools evinced varying interpretations and styles and because these fell into basically chronological patterns it is fair to speak of the early Renaissance of the fifteenth century and the high and late Renaissance of the sixteenth century.

The Florentines of the early Renaissance were, above all else, draughtsmen rather than colorists. Theirs was an intellectual approach to drawing which placed primary importance on the cumulative effect of lines. When portraying the nature of objects and individuals they emphasized linear content rather than the decorative value which color added to drawings.

The Florentine approach was primarily analytical and scientific. It emphasized the turning of edges or meeting of lines where the strongest points of light and darkness always lie. The Florentines discovered and exploited the use of linear perspective and used this technique, together with a careful analysis of anatomy, to produce figure studies whose liveliness and elegance of stance have never been equalled. These were not drawings which simply emulated antiquity, rather they greatly improved on a foundation already laid.

Artists such as Filippo Lippi (c 1406–1469) and Andrea del Verrocchio (1435–1488) concentrated on the structure and appearance of motion that was often achieved at its best through the use of silhouette. But as the Renaissance spread to other centers such as Padua, Mantua, Bologna, Ferrara, and Milan a tendency developed among draughtsmen to use systematic diagonal shading in conjunction with a consistent contour. Occasionally such work appeared hard and metallic but in the hands of great masters such as Andrea Mantegna (1431–1506), who practised at the court of Mantua, works of almost romantic idealism were produced. Mantegna broke away from the conventions of Gothic art and strove to celebrate the dignity of man in his drawing. His was a major contribution to the art of drawing in Northern Italy and there were few draughtsmen of his generation that could equal Mantegna's thrust and power. Mantegna shifted from the use of a vigorous central perspective to the employment of a new and quite complex treatment of space. Rather than simulating the geometric treatment of Uccello he aimed at compositions which almost appear to be bas-reliefs. Mantegna's drawings express a strong graphic sense through their use of chiaroscuro. They are characterized by a constant use of hatched strokes and lines to give a feeling of drama, and are remi-

niscent of Donatello's sculpture which greatly influenced Mantegna's artistic output both as draughtsman and engraver.

While Mantegna prospered at the court of Mantua, important developments were taking place in other parts of the country. In the remote eastern duchy of Urbino where Duke Federigo Montefeltro encouraged a private classical revival of his own, one of the high points of Renaissance civilization was reached. It was at Urbino that Castiglione wrote his remarkable book of *The Courtier* which served as a definitive guide for all well-bred individuals. Castiglione's book combined the tenets of medieval chivalry with those of neo-platonic love and his precepts became dogma in Renaissance society and therefore in the visual arts.

In this most civilized of courts Raffaello Santi (1483–1520) received his earliest training and in the years that followed his art was to emerge as the ripest synthesis of the Renaissance. Raphael's drawings reflect the strong influence of neo-platonic idealism. This doctrine led draughtsmen to attempt to perfect the superficial appearances of nature. The neo-platonists were so attached to the canons of ideal types and forms that they sought to transcend natural phenomena and create imaginary scenarios of artistic expression.

At Urbino, and later at Florence, Raphael attempted to define a postulate of generalized beauty based upon universal principles. It was an aspiration which looked back to the Middle Ages though the actual bases of his theory was different. When he at last moved to Rome to accept the patronage of the papacy, Raphael transformed the Holy City into a major artistic center—something it had not been for centuries. Although the Roman revival was interrupted by the sack of 1527 this event at least had the effect of scattering Raphael's pupils all over Italy, and with them his influence spread into almost every corner of the peninsula.

Although his origins were Umbrian and his training largely Florentine, Raphael reached the pinnacle of his creative genius in Rome. By using the Umbrian style of Perugino he created a graphic language which relied on easy grace and charm. Later the opposing influences of Leonardo and Michelangelo were both absorbed into the drawings of Raphael, whereas in his paintings of similar subjects these impulses were not always so successfully blended.

Leonardo da Vinci (1452–1519), executing at least half his work in the fifteenth century, can nevertheless, be called the first great draughtsman of the high Renaissance. His vision of the human figure set in a veristic surrounding atmosphere was rooted in the formalism of his master, Verrocchio. However, to Verrocchio's style he added the soft and effective element of chiaroscuro which dimmed all harshness of outline in a haze of multiple hatching. The positive use of light was also an element of Leonardo's method. His colors were subdued, his perspective innovatively aerial, and his figures dispersed in an ideal classic composition of balance and harmony. Leonardo's interests turned in all directions. For him representational art was a medium for experimentation and empirical verification of theory. The scientific element balanced the artistic.

It is a tragedy that the corpus of Leonardo's paintings is small and incomplete. This is due to the use of faulty experimental techniques which have resulted in the rapid deterioration of much of his achievement. It is also due to Leonardo's own hesitations and changes of direction. Fortunately, however, we are given a very accurate indication of the breadth of Leonardo's vision through a much larger corpus of his drawings which survive as the most intimate evidence of his greatness.

With the advent of the high Renaissance around 1500, the intellectual theories so long endorsed by the draughtsmen of Florence began to be challenged. Drawing and painting became less the work of zealous disciples of humanism and more the product of vital individuals who refused to pay absolute homage at the altar of antiquity. High Renaissance draughtsmen attempted to erect their own temples where nature and classical *virtu* were not just emulated in theme but equalled, mastered, and eventually surpassed. From high Renaissance classicism emerged something apparently opposed to it—the new Mannerism which carried artistic expression into heretofore uncharted regions. The smooth *bella maniera* (beautiful style) of Raphael had to compete with the tormented individuality of Michelangelo, Buonarotti (1475–1564) whose constant energy and vitality was the fountainhead of Mannerism, though Michelangelo, unlike Raphael, had no important pupils.

Michelangelo's art was intensely cerebral; it never attempted to imitate nature but rather sought to emulate the creation of nature and concentrated particularly on spiritual rather than corporeal values.

Michelangelo thought of himself primarily as a sculptor and his drawings reflect this attitude. Whether in charcoal, pen and ink, black chalk, or sanguine, his stupendous drawings carry the human form almost out of the paper as figures emerge from the rough stone of his sculpture. Perhaps the most striking thing about Michelangelo's drawings is their timelessness—they could belong to any epoch from the high Renaissance to the age of the great Romantics. The same cannot be said of Raphael whose work combines all that was best of the spirit of the time. Raphael was the supreme synthesizer and harmonizer; as such his works perhaps give us more of the essence of the Renaissance, just as the *Summa Theologica* of St Thomas Aquinas best defines the philosophy of the Middle Ages.

The invasion of Italy in 1494 by King Charles VIII of France produced a steady and growing pessimism in the arts. The once-supreme Italian confidence in the ability of man to control his destiny, and the all-encompassing veneration of rational antiquity, were lost in an increasingly fatalistic conception of society. Renaissance men came to value, for good or evil, the power of historical forces; they felt the attraction of studying the mystical intricacies of the zodiac and revolted against corrupt materialism.

After 1517, when Luther challenged the fundamentals of Catholic dogma, and particularly after the sack of Rome ten years later, artistic production in Italy began to decline in quality. The captive princes and dukes of the Italian city states could not face the realities of their situations and consequently indulged themselves

in wave upon wave of fantasy. Art increasingly moved within the realm of the imagination and, while it was still visually pleasing, much of the power and impact of earlier days was gone. By comparison with what had happened earlier the late Renaissance was somewhat trivial in its conceptions, though Michelangelo and several others were conspicuous exceptions to this rule.

Draughtsmen of the late Renaissance gave up serious efforts to represent human character through emotions and movement. Instead artists chose to illustrate externals; they turned to allegorical representations of ideas such as 'Painting', 'Humility', 'Liberality', and 'Generosity'. It seems true to say that pretentiousness increases as real achievement declines, particularly in the representational arts. Thus, Dante's view of *virtu* as a public and moral attribute of goodness was transformed by the sixteenth century Italian artist into the pursuit of personal self-glorification. The late Renaissance witnessed the emergence of *virtuosi*, such as the unbelievably immodest Benevenuto Celini, who adopted and affected the quality of *virtu* as a personal possession while completely negating its relevance to social values.

Only in the Venetian Republic, safely secluded in its lagoons far from the turmoil of Italian politics, did the art of drawing pursue a different course. Venetian draughtsmen had from the outset of the Renaissance opposed Florentine intellectualism in regard to the use of line as opposed to color. They were preoccupied with the true relationship of objects to color and light and paid less attention to the structure of individual components than did the Florentines. The Venetians approached forms as complete entities rather than as a sum total of various parts. Their drawings rely heavily on the use of flicks of the pen, dots, and hatching to create shadow and contrasting light. Individual lines lose much of their significance in the soft modulating tones of Venetian technique. Chalk was preferred to pen in the poetic statements of the city's draughtsmen, and the Venetian blend of Hellenic subtlety with Latin magnificence provided a unique and lasting source of inspiration for modern artists.

From the work of Lorenzo Lotto right through to that of Tintoretto, Veronese, Giorgione, and Titian, there is a continuous search to find vast unexpected perspectives seen from unusual viewpoints down a flight of stairs or along a plunging curve. For the Venetian draughtsman space was man's link with the divine world of heaven. This theme of religious identification with space was a constant element in the drawings of the Venetian Renaissance and is perhaps its most attractive and powerful characteristic.

In retrospect one can ask what was the Italian Renaissance and what was its significance to the art of drawing? Certainly it was a cultural phenomena that spanned all levels and areas of enquiry in the fifteenth and sixteenth centuries. It was not a complete rejection of medieval tenets and philosophies but was rather a development out of them, particularly in its veneration of classical modes of thinking and enquiry. The civilization of the Italian Renaissance was unapologetically elitist and its general decline can be ascribed in part to the death of the first two generations of humanists who left no one fully capable of carrying on their work. Consequently,

in its later manifestations the Renaissance moved away from the basic values of the classical world and chose instead a divine and superhuman ideal which in turn deteriorated into flights of decorative fancy that bore only a superficial resemblance to what had come before.

Perhaps, most significantly, the Italian Renaissance imposed new values on draughtsmen. New media and greater artistic freedom were put at the service of reason. During the development of the Renaissance man as both the artist and as the subject of art was endowed with a stature that he has seldom reached before or after. For a time it appeared that the mind of man was capable of mastering and absorbing all that nature and God could create. In many ways it was the best of times for the European mind.

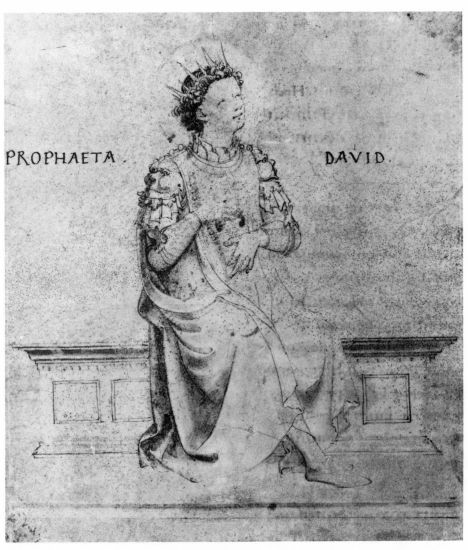

49

49 FRA ANGELO (GIOVANNI DA FIESOLE) b 1387, d 1455
Italian (Florence)
The Prophet David
Pen and brown ink, with purple wash, on vellum.

50 ANON. ITALIAN *c* 1400
(Lombardy)
Two Cheetahs or Hunting Leopards
Brush drawing, with bodycolor, on vellum.

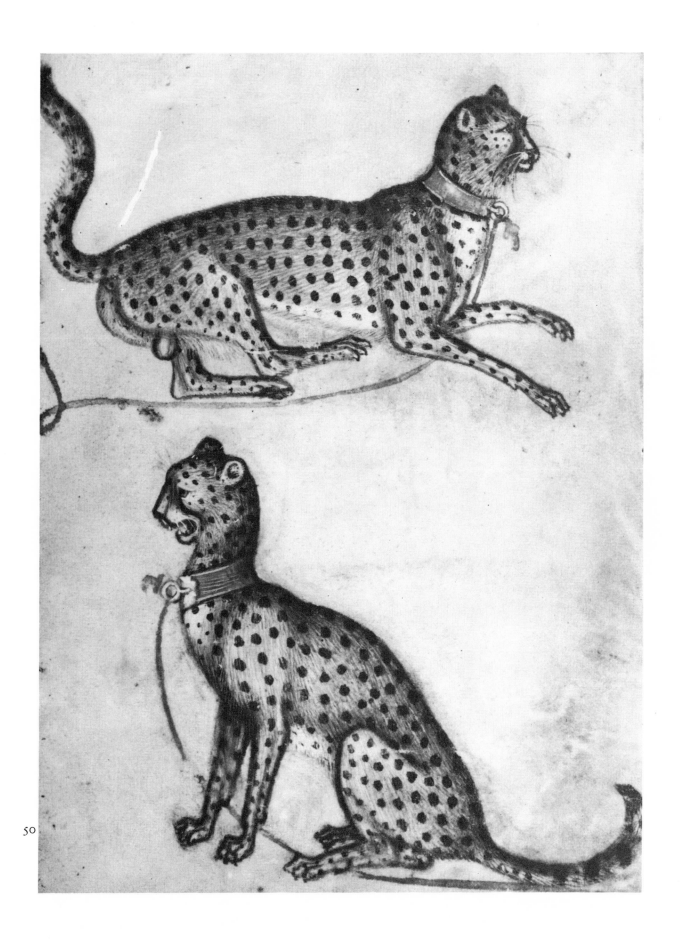

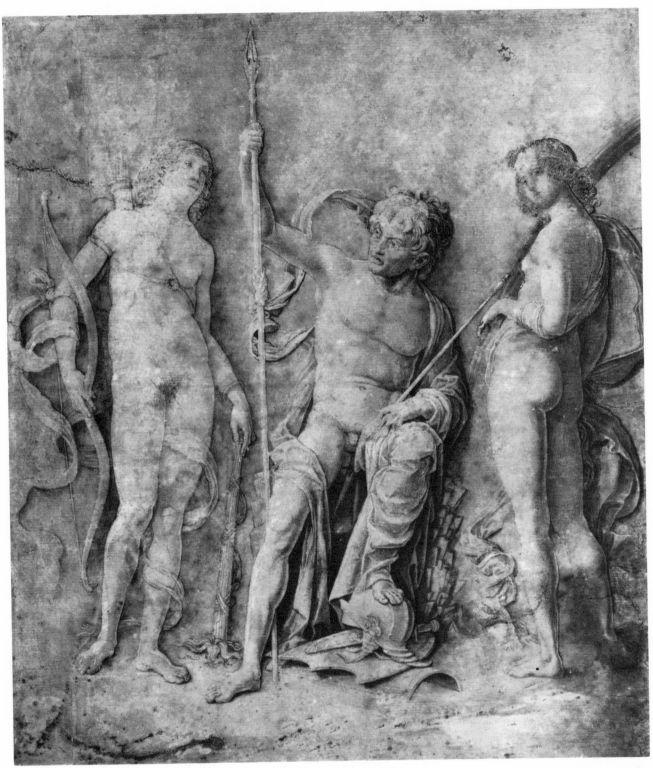

51

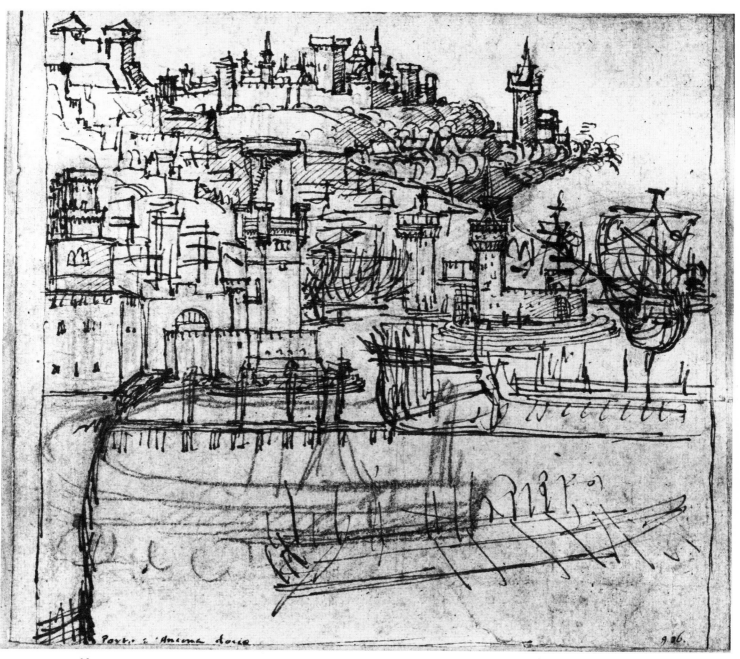

52

51 ANDREA MANTEGNA b 1431, d 1506
Italian (Padua; Mantua)
Mars, Venus and Diana
Pen and brown ink with brown wash, touched with white, the
central figure shaded with the point of the brush in crimson,
and that on the right in blue.

52 VITTORE CARPACCIO b 1472 (?), d 1525/6
Italian (Venice)
Fortified Harbor with Shipping, c 1495
Pen and brown ink, over red chalk.

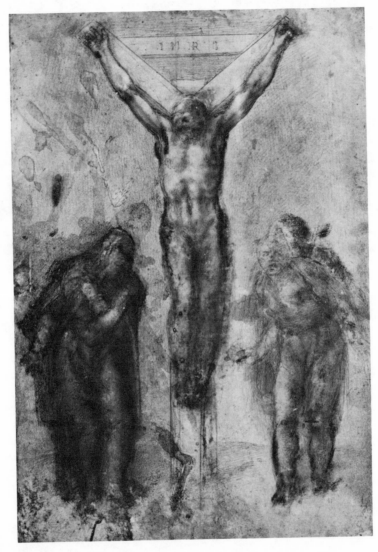

53

53 MICHELANGELO BUONAROTTI b 1475, d 1564
Italian (Florence; Rome)
Christ on the Cross between the Virgin and St John c 1538–1557
Black chalk.

54 RAPHAEL (RAFFAELLO SANTI) b 1483, d 1520
Italian (Urbino; Rome)
Half-length Study of a Young Woman, c 1504–1508
Black chalk.

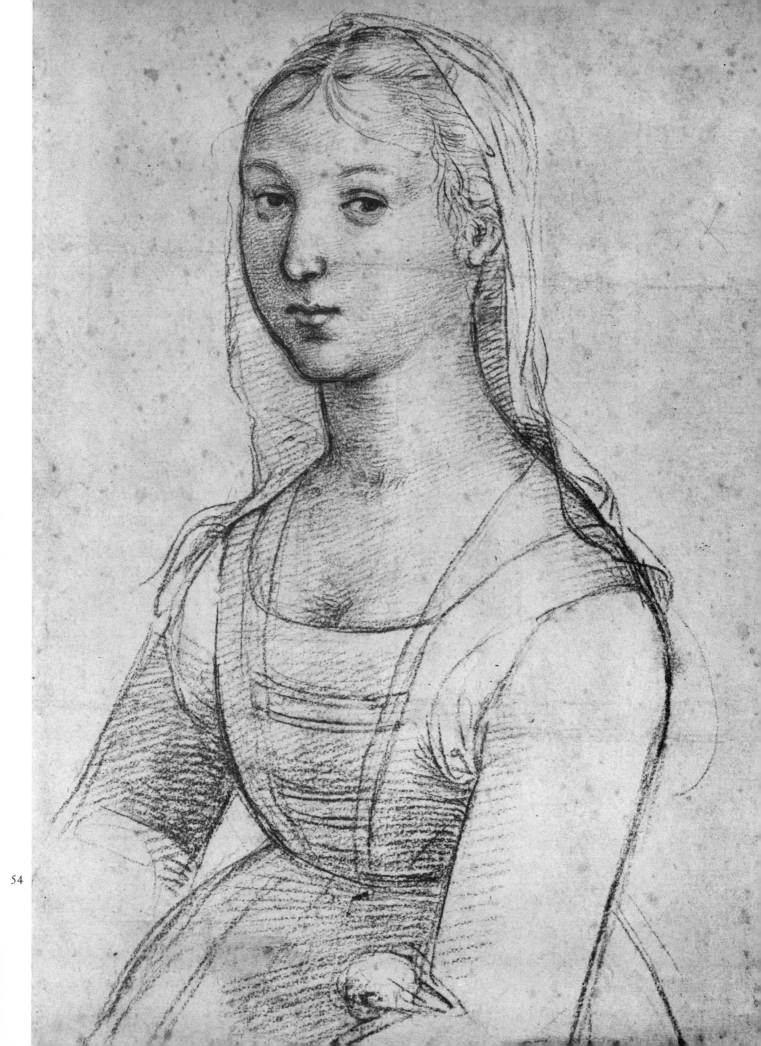

54

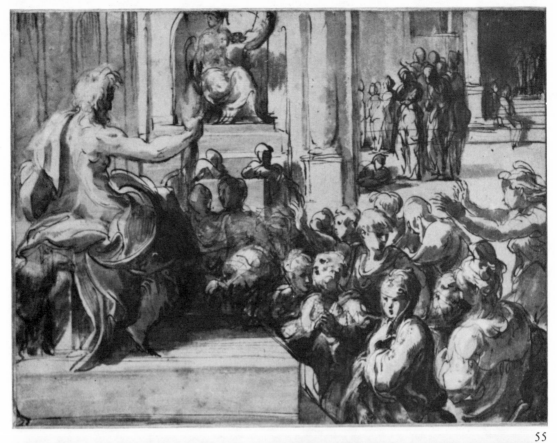

55

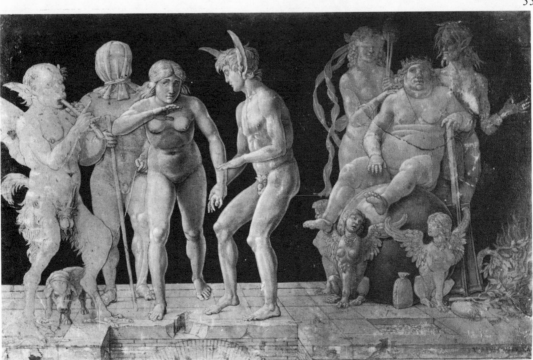

56

55 PARMIGIANINO (GIROLAMO FRANCESCO MARIA MAZZOLA) b 1503,
d 1540
Italian (Parma; Rome; Bologna)
The Worship of Jupiter, c 1524–1527
Pen and brown ink, with brown wash, heightened with white.

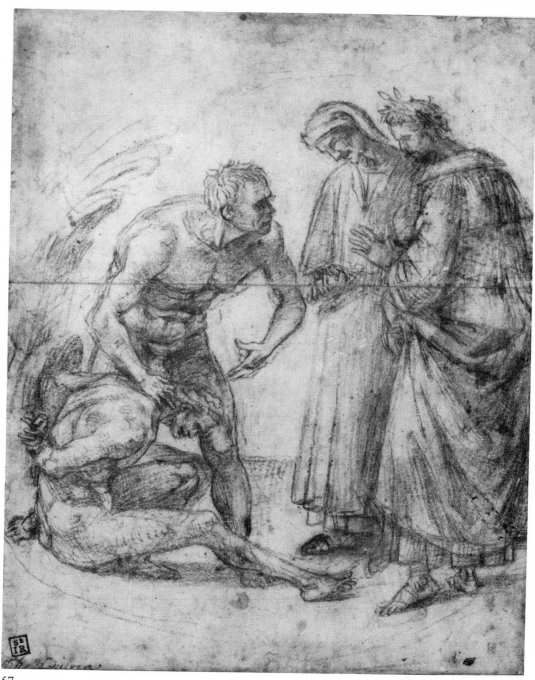

57

56 ANDREA MANTEGNA b 1431, d 1506
 Italian (Padua; Mantua)
 Allegory of Virtue and Vice: 'Virtus Combusta'
 Pen and ink, and the point of the brush in brown wash on a brown ground,
 heightened with white, the background black over red.

57 LUCA SIGNORELLI b c 1441, d 1523
 Italian (Arezzo; Orvieto)
 Dante and Virgil with Count Ugolino
 Black chalk.

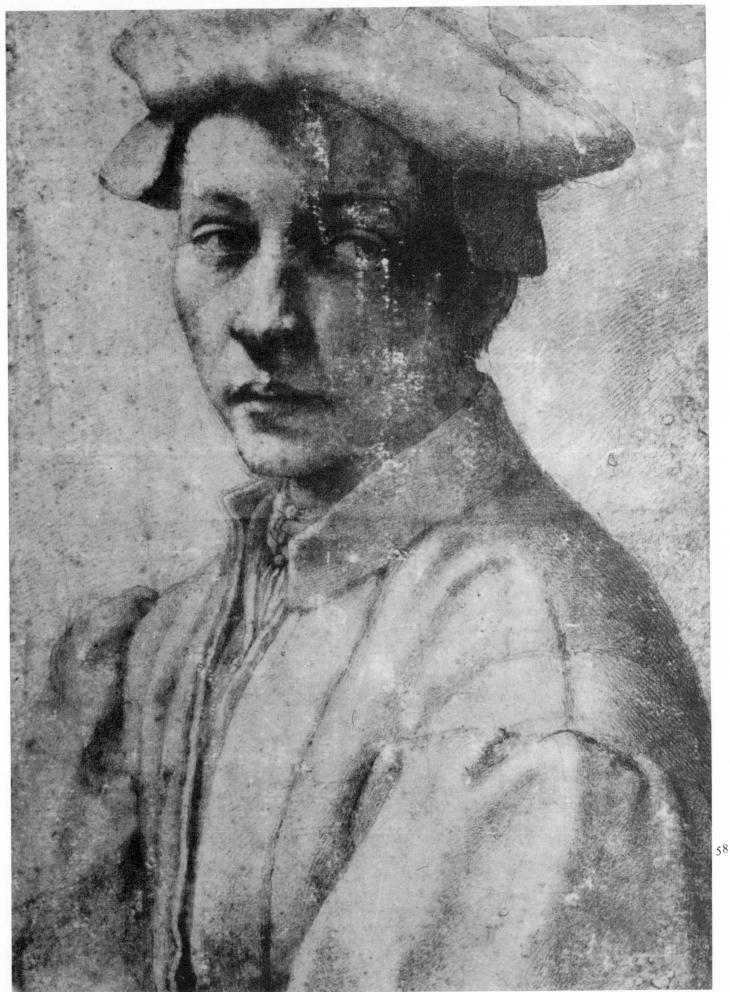

58

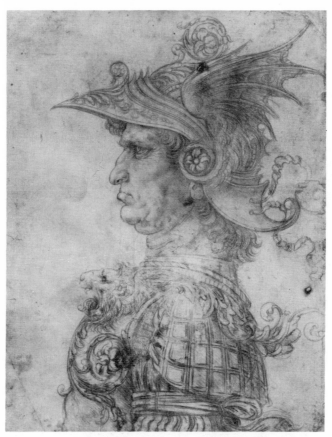

59

58 MICHELANGELO BUONAROTTI b 1475, d 1564
Italian (Florence; Rome)
Portrait of Andrea Quaratesi, c 1530
Black chalk.

59 LEONARDO DA VINCI b 1452, d 1519
Italian (Florence; Milan; France)
Bust of a Warrior in Profile
Metal point on cream-colored prepared paper.

60 RAPHAEL (RAFFAELLO SANTI) b 1483, d 1520
Italian (Urbino; Rome)
Study for the left-hand lower part of the Fresco of the 'Disputa' in the
Stanza della Segnatura in the Vatican, 1509–1511
Pen and brown ink with brown wash, over preliminary
drawing with the stylus, heightened with white (OVERLEAF).

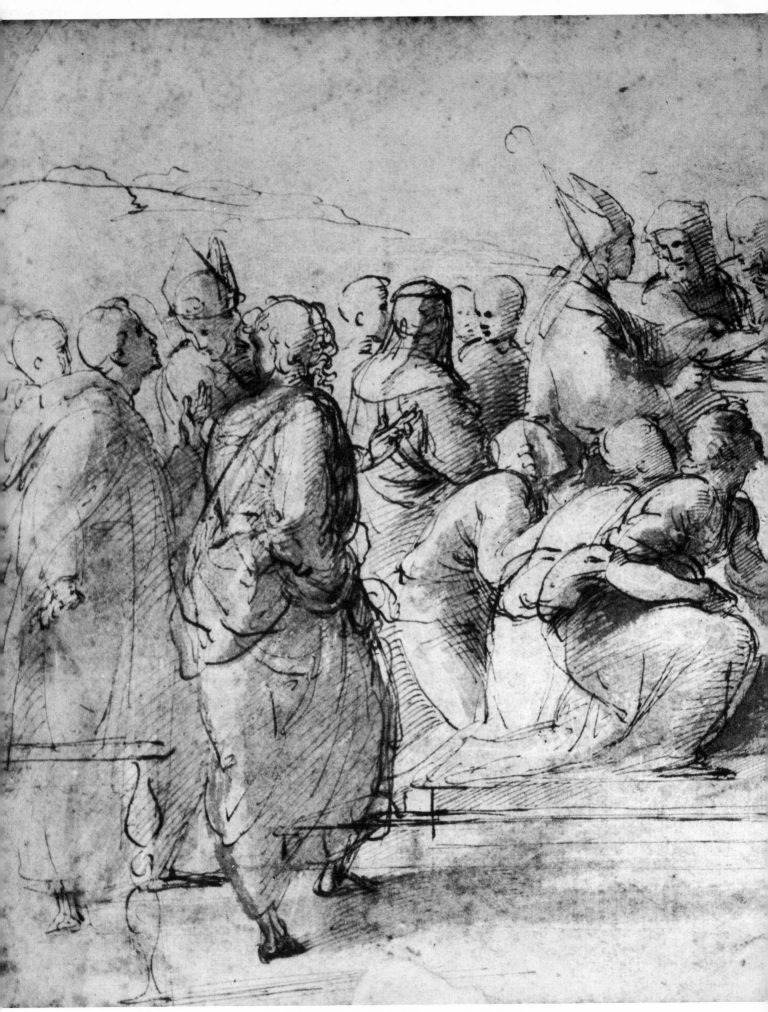

60

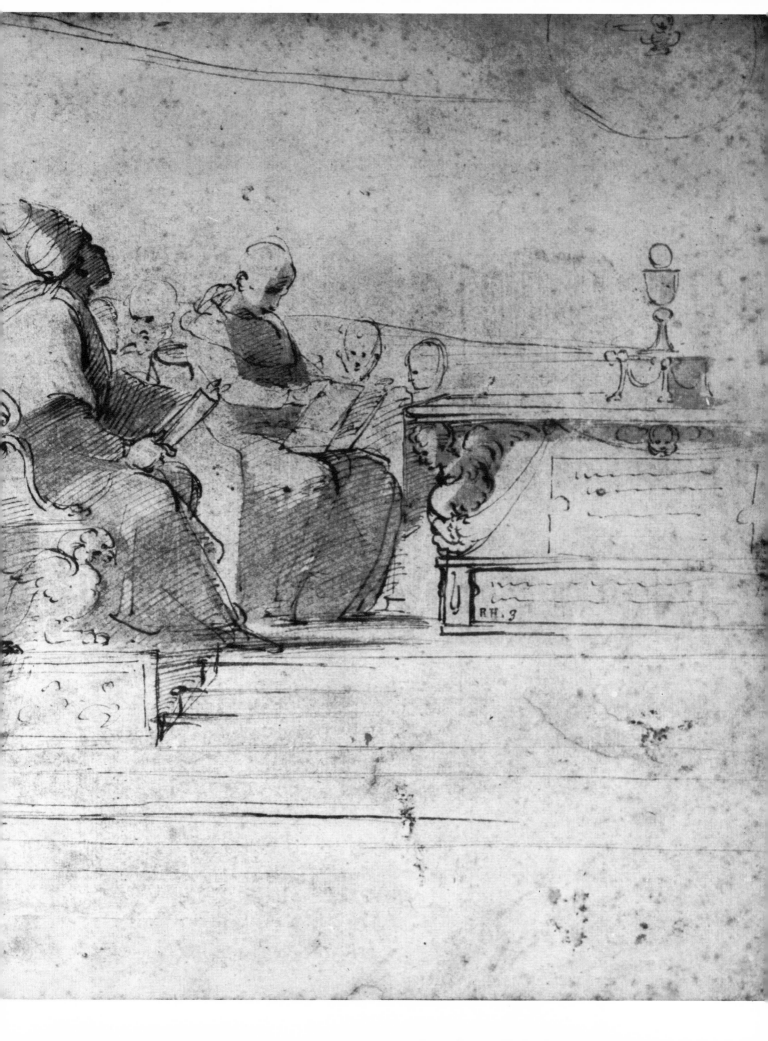

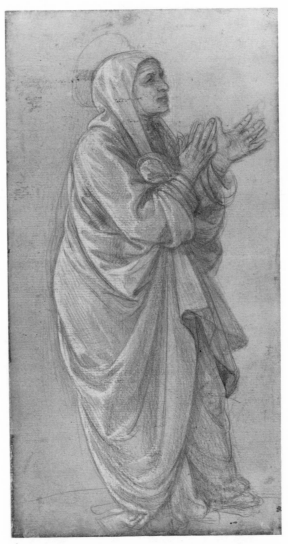

61

62

61 FRA FILIPPO DI TOMASO LIPPI b *c* 1406, d 1469
Italian (Florence)
A Female Saint, standing
Metal point, with brown wash, heightened with white, on
pink-prepared paper.

62 POLIDORO DA CARAVAGGIO b 1492, d 1543
(Italian (Rome)
Landscape with Hermits
Pen and brown ink, with grey wash, heightened with white, on
blue-grey paper

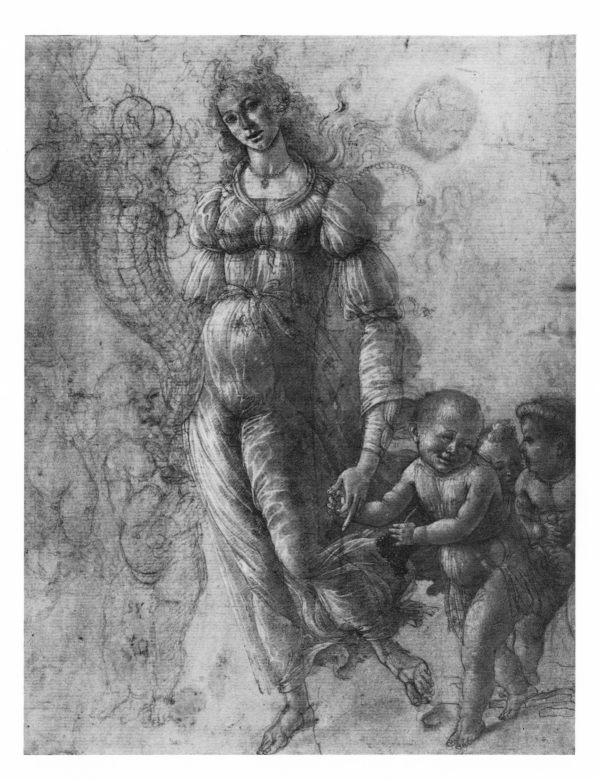

63 SANDRO BOTTICELLI b 1444/5, d 1510
Italian (Florence)
Abundance or Autumn
Pen and brown ink and faint brown wash, heightened with
white, over black chalk on pink-tinted paper.

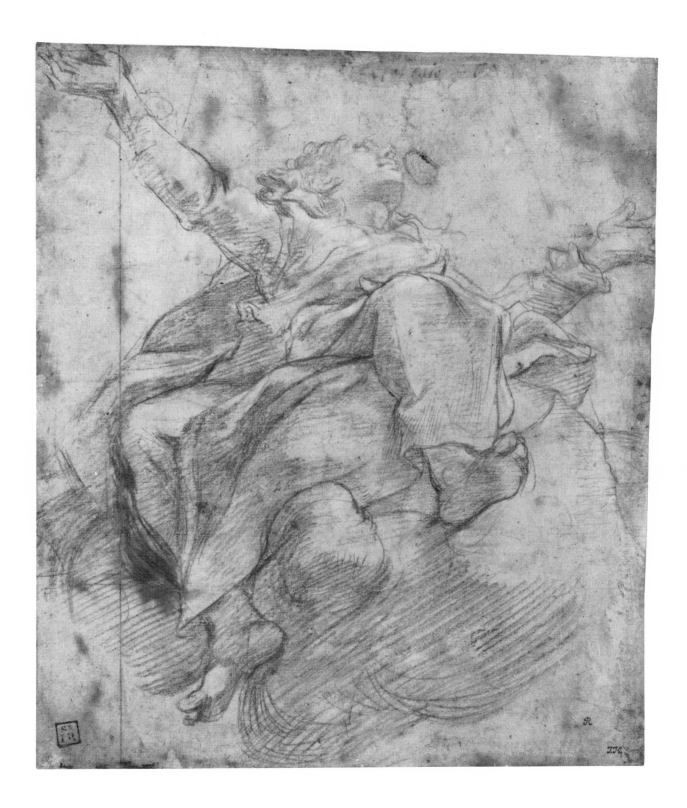

64 CORREGGIO (ANTONIO ALLEGRI) b between 1489 and 1494, d 1534
Italian (Parma; Rome)
The Virgin in an Assumption, c 1520
Red chalk with traces of heightening in white chalk.

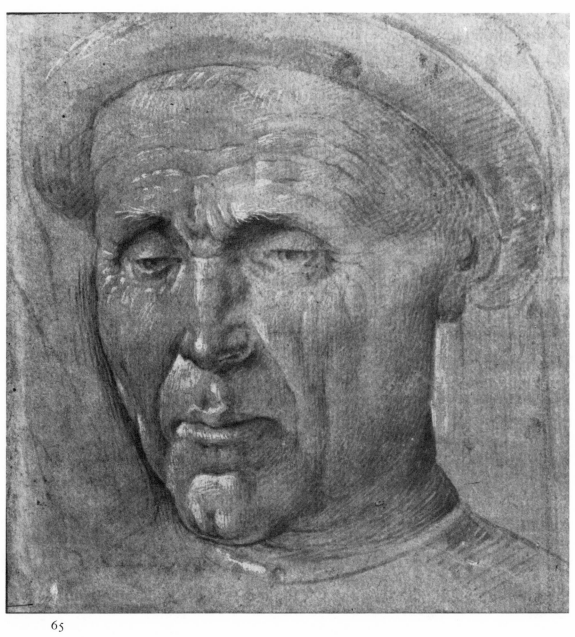

65

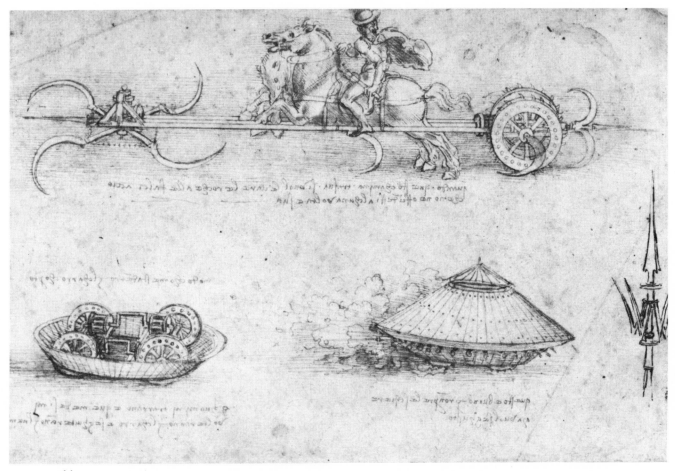

66

65 LORENZO DI CREDI b 1456 or 1459, d 1527
Italian (Florence)
Head of an Elderly Man
Brush drawing in light brown, heightened with white, on
pink-prepared paper.

66 LEONARDO DA VINCI b 1452, d 1519
Italian (Florence; Milan; France)
Military Machines, including an Armored Vehicle
Pen and Brown ink.

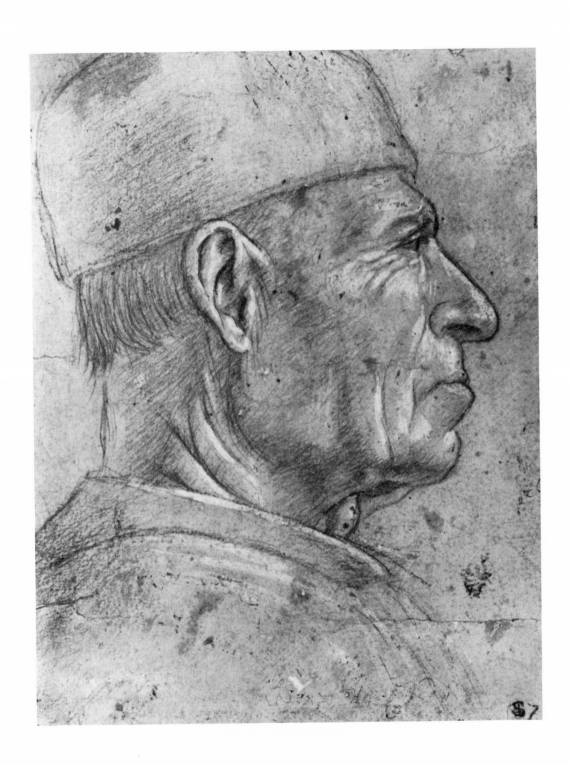

67 DOMENICO GHIRLANDAIO b *c* 1449, d 1494
Italian (Florence)
Head of an Elderly Man
Brush drawing in light brown, heightened with white, on
pink prepared paper.

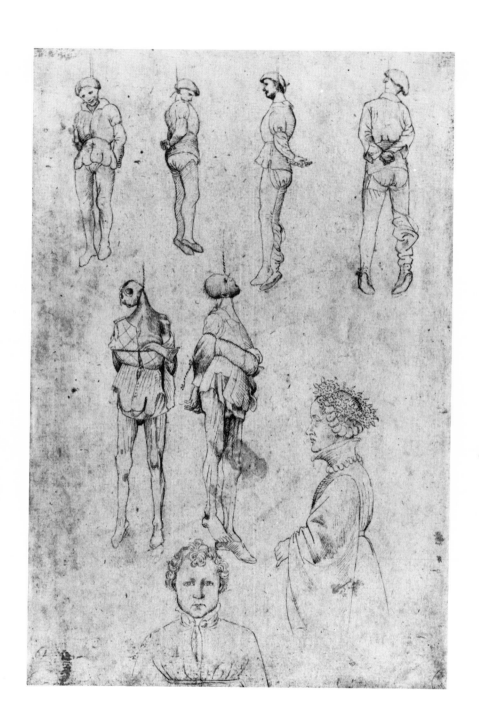

68 ANTONIO PISANELLO b *c* 1395, d 1455
Italian (Pisa; Verona)
Studies of Men hanging, and other figures
Pen and ink over black chalk.

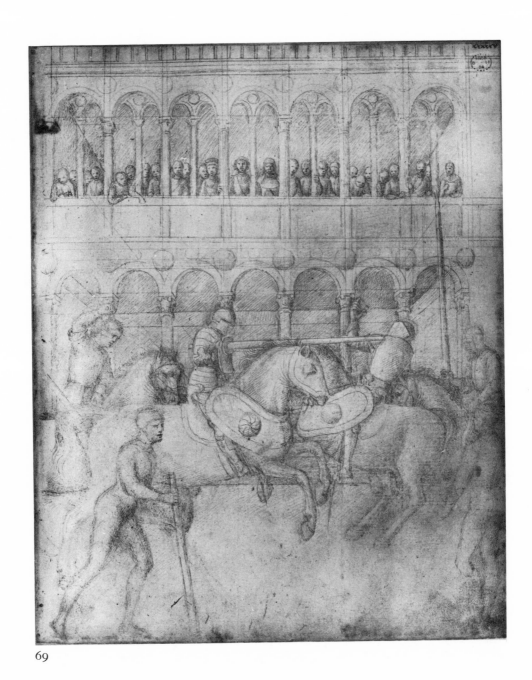

69

69 JACOPO BELLINI b *c* 1400, d 1470
Italian (Venice; Florence)
A Tournament
Lead point on prepared paper.

70 RAPHAEL (RAFFAELLO SANTI) b 1483, d 1520
Italian (Urbino; Rome)
A Female Saint, *c* 1504
Black chalk, over preliminary drawing with the stylus.

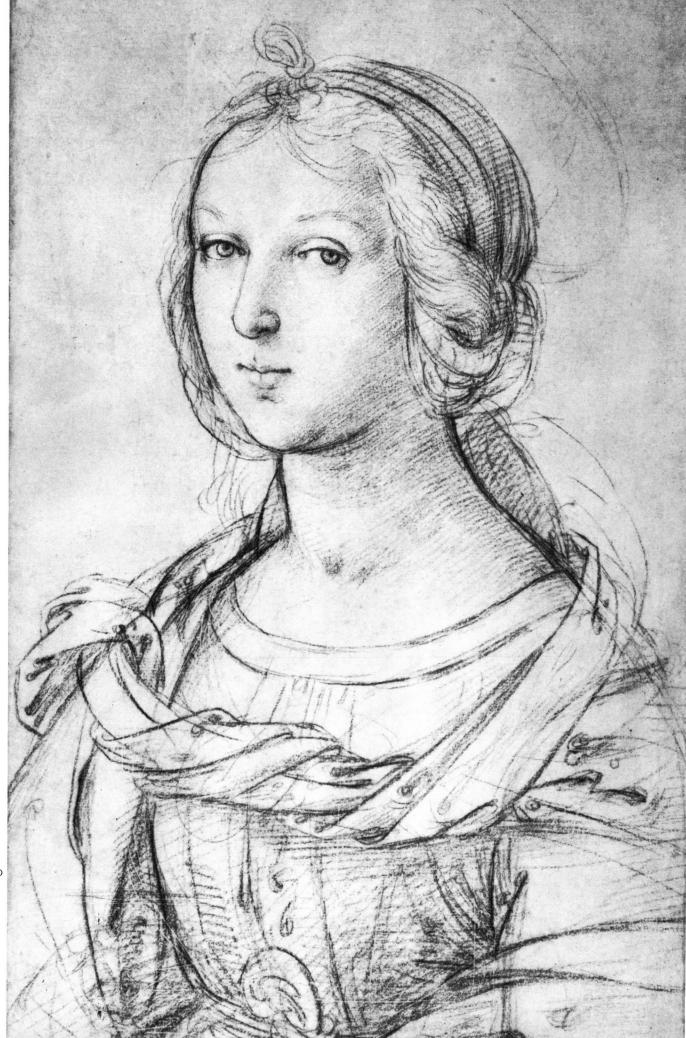

70

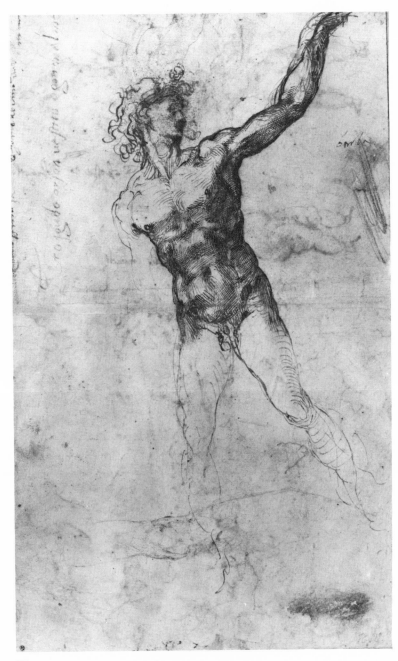

71

71 MICHELANGELO BUONAROTTI b 1475, d 1564
Italian (Florence; Rome)
A Youth beckoning; a Right Leg; Handwriting, c 1504
Pen and brown ink, with black chalk.

72 LEONARDO DA VINCI b 1452, d 1519
Italian (Florence; Milan; France)
*Studies for the Virgin and Child with St Anne and the Infant
St John the Baptist*
Pen and brown ink, with grey wash, heightened with white,
over black chalk.

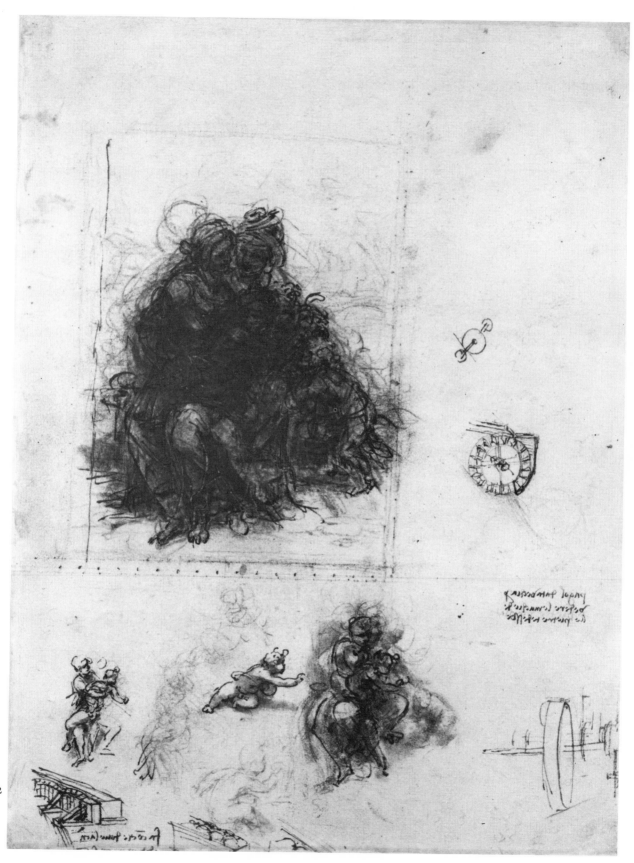

72

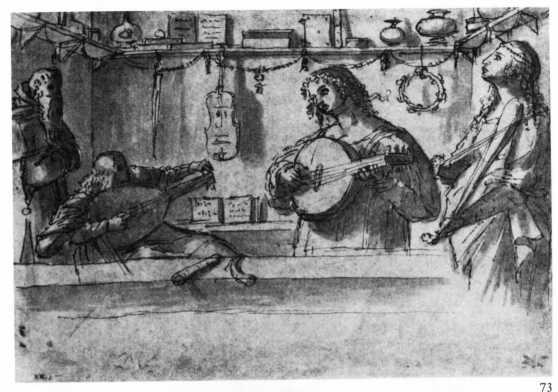

73

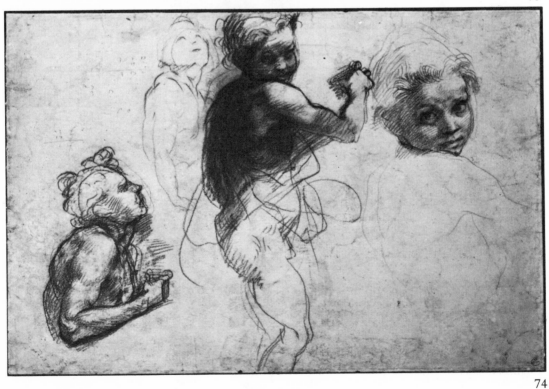

74

73 VITTORE CARPACCIO b 1472 (?), d 1525/6
Italian (Venice)
A Monk and three Musicians, two playing Lutes, the third a Rebec
Pen and brown ink, with brown wash on blue-grey paper.

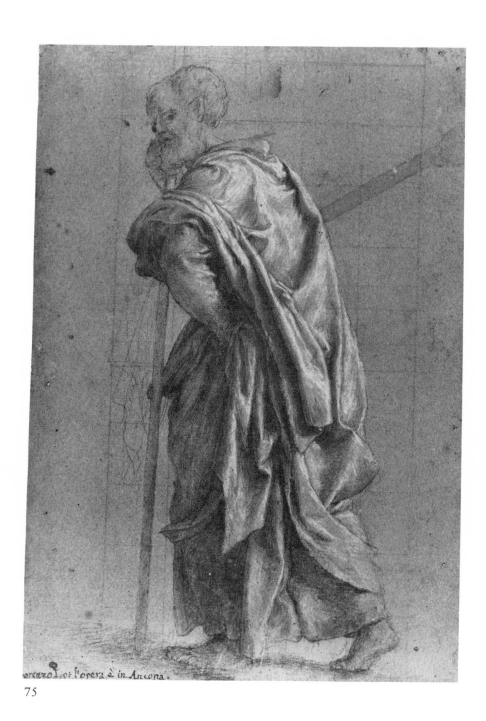

oreuzo L ot l'opera è in Ancona.

75

74 ANDREA DEL SARTO b 1487/8, d 1530
Italian (Florence; Paris)
Study of St John the Baptist in the 'Wallace Madonna', c 1517
Red Chalk.

75 LORENZO LOTTO b 1480, d 1556
Italian (Venice)
Study for the Figure of St Matthias, c 1546
Black chalk, heightened with white, on grey paper.

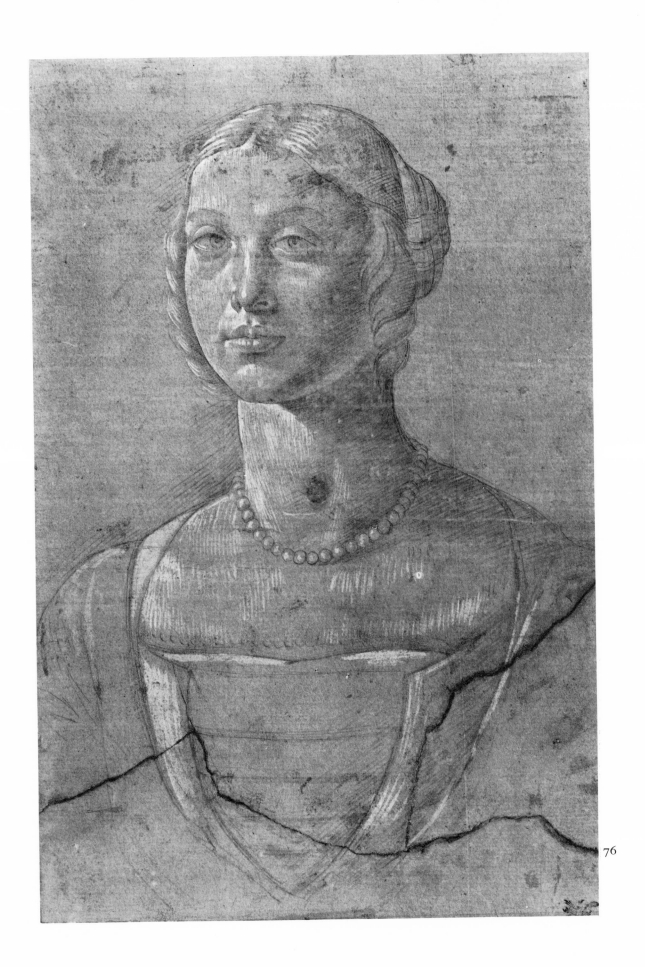

76

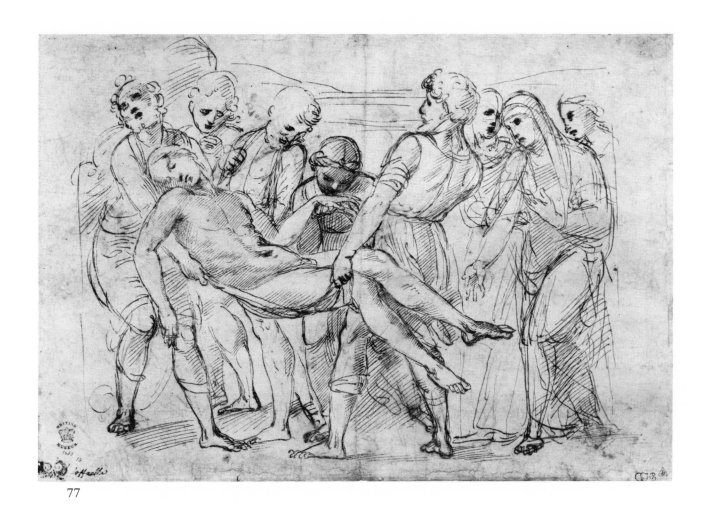

77

76 DOMENICO GHIRLANDAIO b *c* 1449, d 1494
 Italian (Florence)
 Half length Study of a Young Woman
 Metal point with faint wash, heightened with white, on
 grey-prepared paper.

77 RAPHAEL (RAFFAELLO SANTI) b 1483, d 1520
 Italian (Urbino; Rome)
 Composition Study for the Borghese Entombment, 1507
 Pen and brown ink, with traces of underdrawing in black chalk.

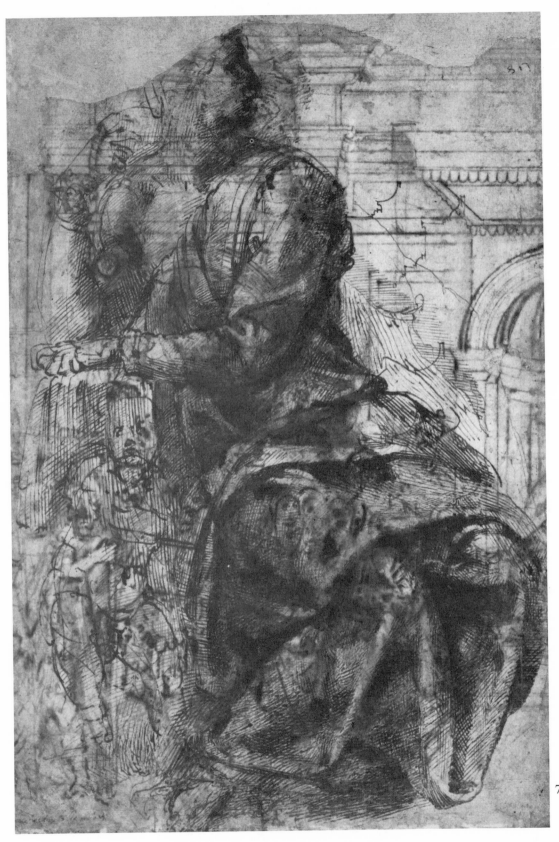

78

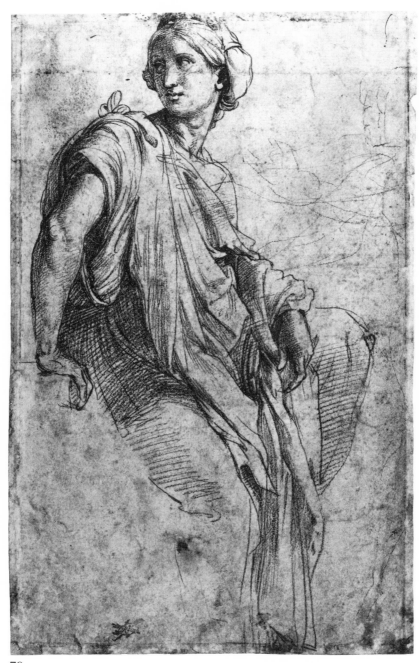

79

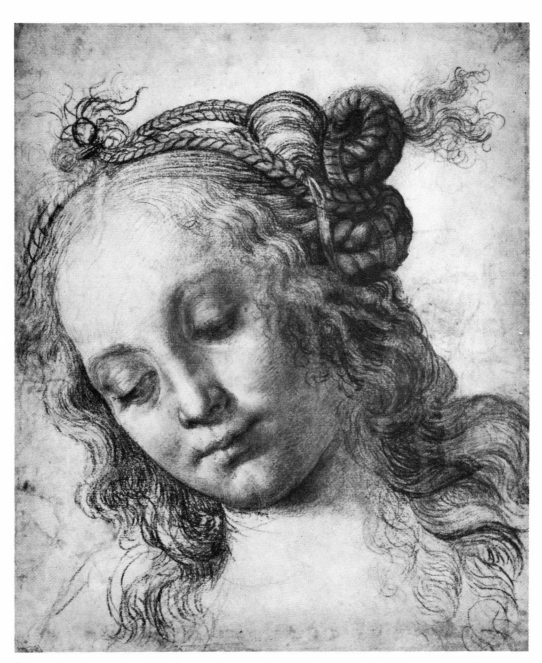

80

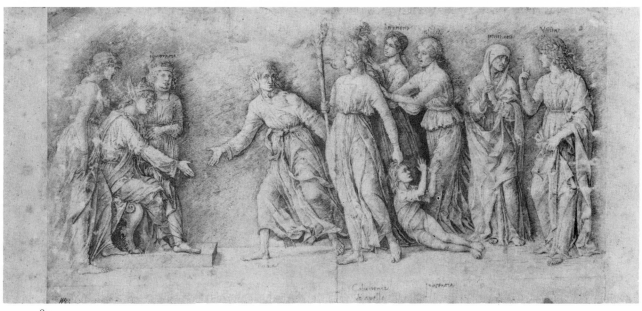

81

80 ANDREA DEL VERROCCHIO b 1436, d 1488
Italian (Florence)
Head of a Woman
Black chalk.

81 ANDREA MANTEGNA b 1431, d 1506
Italian (Padua; Mantua)
The Calumny of Apelles
Pen and three shades of brown ink, with occasional touches of white.

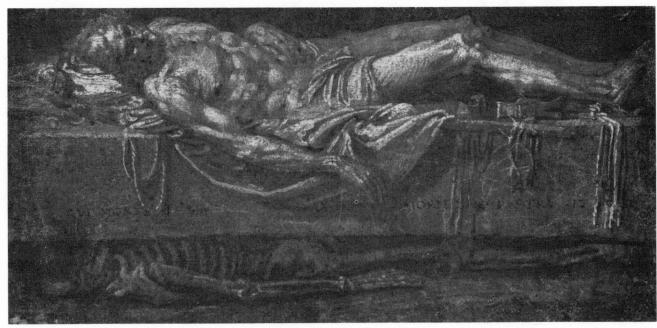

82

82 PAOLO VERONESE b 1528, d 1588
Italian (Venice)
Allegory of the Victory of Christ over Death
Brush drawing in grey wash, heightened with white, on grey paper.

83 JACOPO TINTORETTO b 1518, d 1594
Italian (Venice)
Kneeling Figure
Black chalk, heightened with white on blue-grey paper.

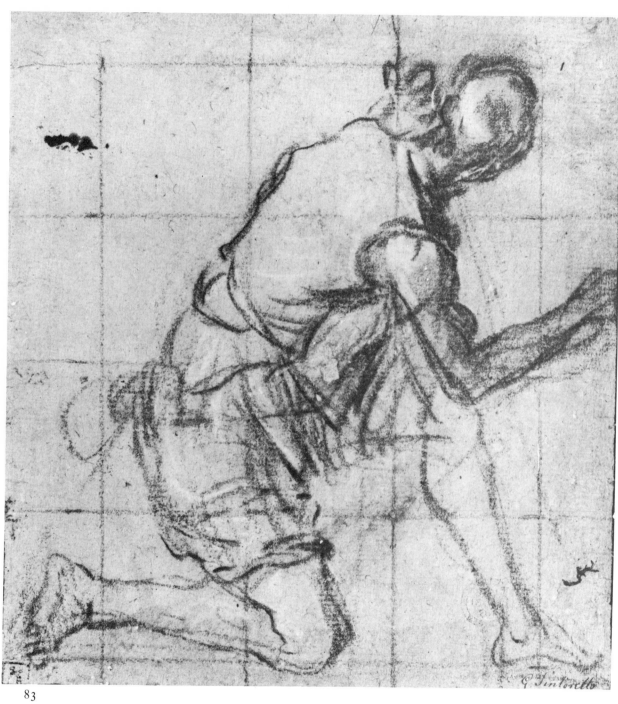

83

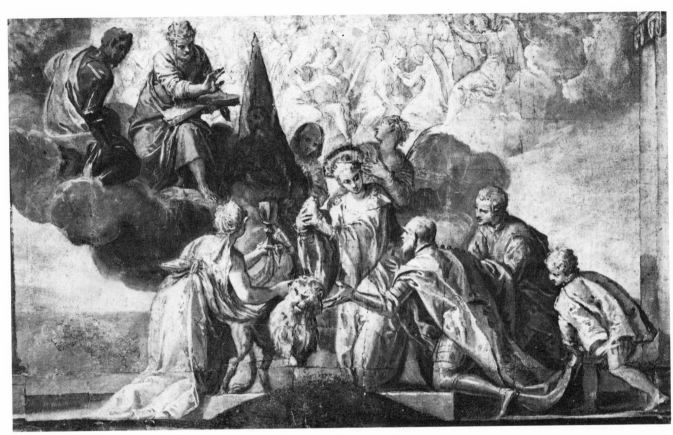

84

84 PAOLO VERONESE b 1528, d 1588
Italian (Venice)
Venice crowning Sebastiano Venier as doge: allegory of the Battle of Lepanto
Brush drawing in grey and white oil-colors on a red-prepared ground.

85 TADDEO ZUCCARO b 1529, d 1566
Italian (Rome)
The Donation of Charlemagne, before 1564
Pen and two shades of brown ink, and brown wash, over black
chalk, heightened with white, on blue paper.

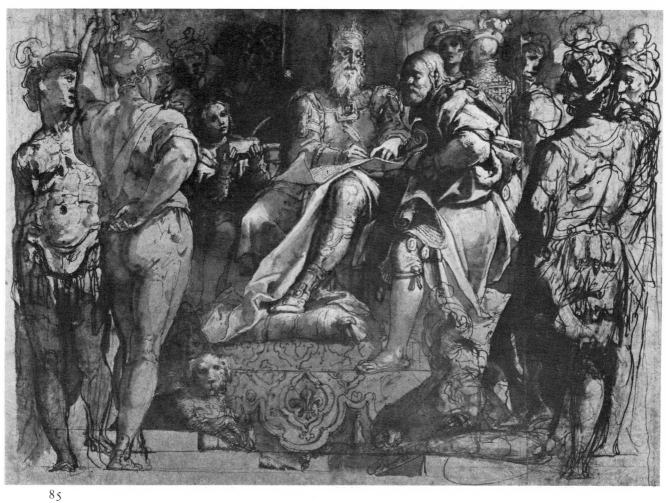

85

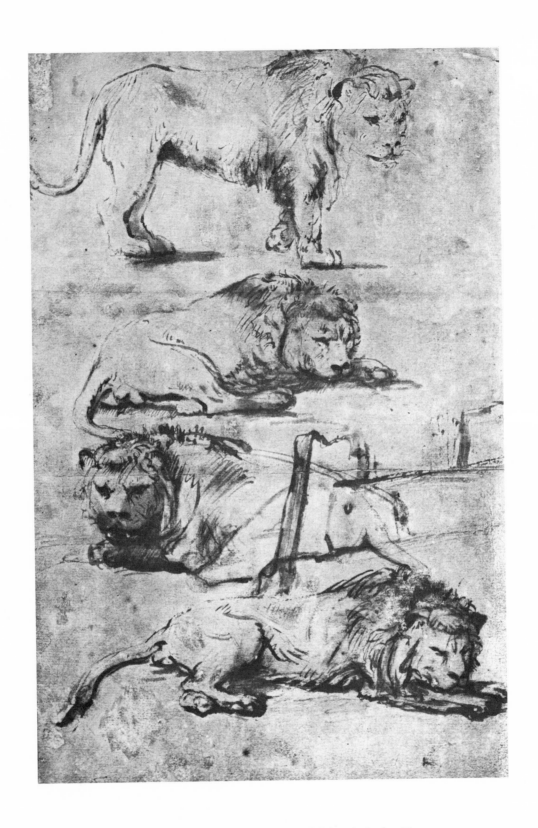

86 REMBRANDT HARMENSZ VAN RIJN b 1606, d 1669
Dutch (Leyden; Amsterdam)
Four Studies of Lions, c 1648 (?)
Pen and brown ink, with brown wash, on brown-toned paper.

6

Masterworks of Rubens, van Dyck, and Rembrandt

T HE HUMANIST DOCTRINES of Renaissance Italy spread north into the rest of Europe carrying a secularist impulse that found willing converts among the Lutheran and Calvinist intelligentsia who spearheaded the Reformation. Everywhere the established Church was under attack by those who dared ask previously unthinkable questions. It was the beginning of a schismatic movement that was to have the most profound effects on the arts, and nowhere were these divisions more clearly seen than in the Low Countries.

In the Southern Netherlands, where traditional piety was strong, the Catholic Counter-Reformation of the seventeenth century made one of its most successful counter-attacks on Protestant 'heresies'. The counties of Flanders, under the Hapsburg regency of the Archduke Albert and Archduchess Isabella, emerged as a bulwark of Catholicism in Northern Europe. The Jesuit order was allowed to grow and prosper, and as a period of economic and political strife came to an end, the door was opened for acceptance of the realist Baroque style of Caravaggio which found many adherents first in Utrecht and later in Antwerp.

Italian artistic ideas were adopted throughout Flanders but always within the context of Flemish traditions and sensibilities. The Counter-Reformation spurred a great deal of new building and restyling of older structures to conform with new tastes and standards. Consequently, there was an appreciable amount of work and patronage available to practitioners in all the decorative arts, from the Church, the State, and the prosperous aristocracy and bourgeoisie.

As this renascence gathered strength and momentum a number of artists emerged to take up the challenge. Without doubt the most important member of this group was Peter Paul Rubens (1577–1640) who quickly established himself as the most authoritative interpreter of the independent Flemish Baroque style.

Rubens' achievement was the last act in an artistic struggle between Northern and Southern Art in the Netherlands that began about 1540. His decorative work in all media preached the doctrine of 'Romanism' and represented the triumph of a self-sufficient Flemish school whose subject matter ranged across the board from the visible to the imaginary world. Religious, mythological, historical, and natural themes were all well represented in the art of Rubens, and in his work a new vital conception of the relationship of heaven and earth was realized on an epic scale. The entire scope of human experience from religious ecstacy to orgasmic eroticism finds ample expression in the fleshy, gleaming, intertwined bodies of Rubens' pictures, and whatever the theme of a particular work one finds constant energy and action.

Artist, courtier, diplomat—Rubens was the fortunate beneficiary of royal patronage in Italy, Spain, England, and Flanders. From his native Antwerp he was able to travel throughout Western Europe, copying the works of all the great masters of the Renaissance and the styles of antiquity.

The technical brilliance of Rubens' pictures is reflected accurately in his countless drawings. It must be remembered at the outset that draughtsmanship for Rubens was almost always a preparatory statement rather than a self-sufficient means of expression, as it was for Dürer and Rembrandt who regarded drawings as ends in themselves. For Rubens the essentials of line and form indicated what was to be realized in subsequent works. His copies of old masters and his original compositions were instructive tools and aids to memory for both himself and his assistants. Yet for the modern observer the drawings of Rubens clearly convey the master's reactions with an unambiguous clarity. There is little absolute abstraction of idea in Rubens' draughtsmanship, but this is entirely consistent with his theory of the role of drawings within the general scheme of his art.

Rubens is one of the greatest of all draughtsmen of the human figure. In most cases he drew on a toned paper of rough texture using either black chalk heightened with white to delineate hair, eyebrows, and eyelashes and costume; or sometimes a combination of red and black chalk when dealing with faces and hands. Chalk was chosen because it suggested plasticity of fabric and flesh, and in Rubens' hands this medium achieved a degree of versatility that had been hitherto unknown.

If a drawing was preparatory to a formal portrait Rubens usually first noted the main outlines of the setting, costume, and pose of the sitter. He then, with great care, studied important elements of expression and position, finishing with reddish tints of diluted sanguine and bistre for maximum visual effect.

On the other hand, if a drawing was destined for the engraver's plate, Rubens adopted a somewhat different technique. He would lay out the design in pen and ink using unencumbered lines accompanied by numerous cross-hatchings which suggested to the engraver the proper directions for his etched grooves. If denser layers of shadow were required Rubens often laid on a number of bistre washes to indicate the depth and character of such shadows.

Whatever tool Rubens employed, be it reed or quill pen, chalk, graphite, wax crayon, or lead pencil, he always began with no more than the barest outlines of his figures. This would be followed by continuous redrawing on top of the original surface until the desired effect was achieved. What is most interesting are the graphic abbreviations developed by the master in order to achieve greater speed of production. Among these abbreviations is his ability to draw eyes and noses with a continuous line which breaks consistently at four right angles, while mouths are barely delineated if at all. One is somewhat surprised to note that an artist such as Rubens, who is mainly thought of for the rounded contours of his painting, regularly employed a majority of straight lines and sharp angles in his preliminary sketches which were only rounded off as the drawing neared completion.

In his earliest graphic work, dating from 1598 to 1610, Rubens was almost exclusively engaged in the production of pen and ink drawings emphasizing outline with only minimal shading produced by parallel cross-hatchings. There is little that is either concrete or textural in his figure studies; drapery clings closely, hands and feet are abbreviated, and there is at this period a general stylistic dryness characterized by stereotyped faces indicating little emotional content.

But in the decade between 1611 and 1620 Rubens begins to show a masterly appreciation of sculptured form in his drawings. His figures are more generously endowed and there is an obvious growth in personal confidence as his lines take on both fluidity and increased precision. Pen strokes now appear combined with chalk underlays in a balanced clear statement emphasizing the dicta of Baroque decorative technique. No longer does Rubens find it necessary to delineate each separate part of the human form. Instead, he finds it possible to rely on a spatial solidity of mass together with the impression of unitary rhythmic movement.

Between 1620 and 1630 Rubens' graphic work decreased markedly as the attraction of oil sketches increased. Yet in the drawings of this period we find Rubens as the complete master of a delicate and fluent pen work which relies primarily on the pressure of the hand alone to suggest light and darkness without using the established technique of formal shading. He ceases to employ his washes in a set and defined way. Instead, he uses them almost impressionistically and combines with them the then experimental technique of gouache.

During this period the number of Rubens' portrait drawings in chalk increased considerably as royal patronage and the duties of diplomacy placed new demands on him. He abandoned the schema he had invented for constructing faces in favor of a new expressiveness. Rubens' drawings of this period occasionally assume the pictorial appearance of his paintings. Linear division is increasingly abandoned in favor of tonal modulation particularly in chalk, and what emerges is a sense of the artist's contentment, happiness, and personal self-assurance.

In the last period of Rubens' drawings, from 1630 until his death ten years later, one finds an appreciable number of female costumed figures. It is only during this last phase of his artistic careeer that Rubens began to delight in drawings for

their own sake. All the sensuality and erotic pleasure so common in his paintings now appears in Rubens' graphic work as well. There is also a greater variety of posing in these drawings which sometimes takes on a nervous harshness unknown in the previous decades of his artistic activity. For the first time Rubens' drawings give up the flamboyance of line. He now finds it possible to express excitement in a quieter way without the use of contrasting depth and sharp foreshortening, and in so doing he creates perhaps the most satisfying of all his drawings.

It has been argued that Rubens' late drawings give a strong indication of the rejuvenating effect of his second marriage, this time to sixteen-year-old Helene Fourment. This may very well be true for it is obvious that the drawings of his last years show a remarkable grace and fluency of touch in which outlines merge into a soft haze. The blackest of chalks can now simulate the shimmery magnificence of silk, lace, and brocade in a manner not too distant from the Rococo lightness of Watteau who learned so much from Rubens' achievement.

In his late landscapes Rubens gives ample evidence of his perceptions of the vitality and potential destructiveness of natural phenomena. In these studies light and air seem to vibrate with expectancy, and, as is true in his figure studies, Rubens softens the outline of his spatial constructions in a way that strongly anticipates the draughtsmanship of Corot.

Rubens rarely sketched domestic or genre scenes. As the eternal courtier he kept himself and his art distant from the world of common experience. Nevertheless, his drawings are of great importance historically and artistically for they demonstrate that an ideal form can be found in shapes that are not entirely perfect. The vitality of motion was of equal importance to Rubens, and he found that in the basic elements of line he could most clearly express his view of life in a statement that representatively stood as the artistic ethos of his time.

The graphic work of Rubens has been an important influence technically on dozens of major artists from Giordano to Fragonard, and from Gainsborough to Constable and even Cézanne. But of all those who immediately came under the influence of Rubens, Anthony van Dyck (1599–1641) most closely approached the excellence of his master's achievement in the graphic arts. So much was this the case that there still survives a body of drawings which art historians are reluctant to assign exclusively either to Rubens or van Dyck. Van Dyck, the son of a well-to-do Antwerp silk mercer, was a child prodigy. By the age of sixteen he was already working independently while living in the same house as Jan Bruegel the Younger. Van Dyck joined Rubens' studio in 1618 and followed in his master's footsteps with journeys to Italy and to England where he enjoyed the patronage of, and was knighted by, King Charles I. Van Dyck only survived Rubens by one year, dying in 1641 at the age of forty two. While he never quite rivalled the artistic power of his master, in his best works there is an individual style which is both sensitive and romantic and harkened to the soft modulating tones of the Venetian school.

Van Dyck produced two distinctive types of drawing. First, there are

predominantly religious figure compositions executed in pen and ink. Second, he produced numerous portrait sketches in a variety of chalks.

There is a nervous restlessness in both types of van Dyck drawing which only rarely appears in Rubens' graphic work. Van Dyck had more capacity for abstraction than Rubens. He often produced elegant figure studies whose sensuousness was illuminated by rapidly applied pen strokes and washes. His draughtsmanship, much more than his painting, conveys a bold incisiveness which was not compatible with the formality of a court portrait in oils.

In essence, van Dyck, though profoundly influenced by Rubens, often moved toward a more abbreviated, elongated, and eventually mannered use of form which lacked the spatial precision and balanced sense of proportion of his teacher. Yet at the same time this very exaggeration of pose together with the use of light creates a passionate expressiveness in van Dyck's drawings which is not found as often in the drawings of Rubens. Rubens was always more careful in his treatment of extremities such as hands and feet. Van Dyck was content with a vague delineation of non-essentials. There is a preference in van Dyck's drawings for continuous undulating lines, for decorative effect, without emphasis on three-dimensionality. Yet in his portrait drawings, executed in chalk, van Dyck regularly manages to prove himself the technical equal of his master.

Van Dyck's drawings can often be identified by his characteristic use of media. He found it possible to create powerful effects of shadow by using a gall-nut ink in his drawings. But this had an unfortunate side-effect in that such ink was highly acidic and ate through the paper of many of his most interesting sketches. Yet the employment of this ink, combined with the graphic device of using rows of small dots in addition to washes and contours, does help ease the difficult task of deciding exactly which drawings actually were the product of van Dyck's hand.

Both Rubens and van Dyck proclaimed in their work the independence, piety and essential grandeur of the Flemish Baroque. Theirs was a monumental achievement that marked an epoch in the pictorial arts, and from their hands emerged some of the truly great masterpieces of modern draughtsmanship. Yet however great Flemish drawings of the period are, they must of necessity share pride of place in Northern Europe with the accomplishments of the contemporary Dutch School.

The emergence of a distinctive Dutch style in the seventeenth century begins officially in 1609 when Spain at last recognized the independence of the 'Seven Provinces of the United Netherlands' as an independent republic. Once politically and religiously separated from Flanders, Dutch art began to respond directly to the ethos of Protestantism that was so firmly entrenched in the land. There was an increasing secularization of painting as ecclesiastical patronage all but disappeared under the new order. It is said that Dutch art of this period absorbed the Calvinist virtues of mental vigor and introspective analysis. This appears to be a justifiable conclusion when one examines the endless still-lifes and technically perfect land-

MASTERWORKS OF RUBENS, VAN DYCK, AND REMBRANDT

scapes produced in Holland during those years. But this does not represent the sum total of the Dutch artistic achievement.

The center of artistic production was Amsterdam, one of the richest and most cosmopolitan of European cities. Her merchants and burghers provided a new source of patronage for the arts, and creative men responded with realistic genre paintings and with the veristic portraiture that soon decorated the walls of banquet halls, inns, hospitals, charitable and public institutions, guildhalls, and homes for the aged, as well as private dwellings. Picture stalls at public fairs did a brisk business in this new age of public patronage, and it is estimated that as many as a thousand painters were active in Amsterdam at the height of the art boom. It is true that much mediocre work was bound to be produced by such a large number of practitioners, but at the same time it cannot be ignored that in the seventeenth century Amsterdam became a center for more artists of truly great skill and quality than any other city on the continent.

Although there was a great deal of work available, many artists still found it difficult to survive financially, and some of the greatest Dutch masters were forced into other professions such as the inn kept by Jan Steen and the wine gauging business of Meindert Hobbema.

Such alien professions were not always distractions to an artist's creativity. In a society that valued realistic pictures devoid of the decoration usually found in Italian Baroque art, all opportunities for observation of everyday life could be considered an asset. Such observation was absolutely essential, for unlike the Italian and Flemish painters, Dutch artists and draughtsmen always endowed the background of their work with detail equal to that traditionally lavished on figures and objects of central importance. Indeed, so developed did this tradition become that occasionally the central figures disappeared altogether and one is left only with what had been the background as the new central stage of contemplation. This trend found expression not only in landscapes but also in seascapes and genre scenes where architecture and furnishings play an equal part with whatever figures are portrayed.

Light is perhaps the most important of all elements in Dutch draughtsmanship. The masters of realism often produced wash drawings with pencil outline. When the outline was drawn, the rest was finished with a brush using a diluted ink which achieved a particularly rich effect of shadow and illumination. The variety of available tints made variation almost endless, and it is fair to point to the almost transparent shades of Dutch drawings as their most attractive and identifiable characteristic.

When one examines Dutch seventeenth century draughtsmanship it becomes apparent that almost all the great artists of the period were specialists. The only universalist of outstanding importance was Rembrandt van Rijn (1606–1669), whose ability to absorb all Holland had to offer without becoming encumbered or limited marks him as one of the great individualists in the history of Dutch art. When looking at his drawings of landscapes, animals, biblical scenes, figure studies, historical

pieces, genre compositions, in fact at any of his masterly achievements, one finds in the work of Rembrandt the synthesis and the symbol of all that was best in Dutch art.

The most common media used in Rembrandt's drawings were sepia and pen occasionally accompanied by wash. In the use of washes Rembrandt is masterfully subtle, and the shading he achieves in his drawings by the application of a single finger tip compares most favorably in atmospheric effect with the lovely use of chiaroscuro in his paintings. Line of course holds a great place in all Rembrandt's graphic work. It is strong, sure, and in most cases applied with constant speed and pressure. An appreciable number of Rembrandt's early drawings, that is those executed before 1640, are done in black or red chalk with a heightening of white body color. These media were also employed with great skill but they somehow lack the emotional content and intellectual commitment of the master so evident in the broad passionate strokes of his reed pen or his brush.

Rembrandt frequently used a grainy white paper as his drawing surface. Sometimes he tinted his paper with a grey or brown hue for added effect, and on occasion he indulged his passion for the silky exotic texture of the fine Japanese paper used in some of his most brilliant etchings.

Although a great individualist, Rembrandt still adopted certain characteristic styles in common to his time. His early work shows the mark both of the Utrecht Caravaggists and the Dutch followers of Callot. Much of his draughtsmanship for the period 1630–1640 shows a use of sweeping Baroque curves and massive forms which when combined tend to produce moments of great tension and dramatic impact. The old people, beggars, and Jews who could be seen in Rembrandt's quarter of Amsterdam appear in these drawings. The number of figure studies show a marked increase during this period as do those drawings whose essential subject matter is religious.

As Rembrandt matured in the 1640's both his themes and technique simplified and his drawings show ever-increasing boldness and confidence. His landscapes became freer and more relaxed. Children, women, and nurses began to assume a greater thematic importance in his draughtsmanship. So too, do animal studies— here Rembrandt revels in nature's variety. Art and life were inseparable for such a master, and the only way he was able to capture the true essence of a subject was to identify with it completely. This is a fundamental characteristic of Rembrandt's approach to his work both as a painter and a draughtsman.

As his style became more monumental so too did it become more economical. Forms are now suggestions on the page rather than being explicitly delineated. Roundness of line gives way to angularity. Light and atmosphere, and the skilful use thereof, become prime objectives. Rembrandt's drawings in the 1640's take on an architectural quality. Tectonic structure becomes the means of realizing new goals and ideals. But once he had mastered this, in the 1650's, Rembrandt adopted a much more abstract style which is serenely calm and relaxed. Time slows down in these

later drawings as movement becomes less rapid and curves become quieter. A new richness of tone also appears comparable to effects achieved with the palette. But this richness, unlike that of Rubens, is almost silent emphasizing only the essentials of form, light, and emotion. It is a kind of expressionism that allows reality to act as a mirror to Rembrandt's mental attitudes and perceptions, and this overrides all other considerations in his late draughtsmanship.

The difference between figure and genre scenes disappears as faces become so generalized as to be unrecognizable. Line takes on a pure quality free of washes, and as spatial relationships expand in the late drawings of Rembrandt, so too does his ability to make universal statements which transcend the barriers of his own time.

In his late years, after the death of his first wife Saskia, Rembrandt underwent a period of financial hardship culminating in bankruptcy. His work lost favor with the general public as his style became too revolutionary for his contemporaries. Yet in this very expression of his personality Rembrandt produced examples of creative insight that were unlike anything previously attempted with his pen. Within the structure of his artistic goals Rembrandt the draughtsman emerged as the greatest of modern masters whose drawings are the key to his entire artistic contribution. They convey a mystical universal impression of their creator and as such they speak triumphantly of a genius whose gifts richly endowed the artistic heritage of the seventeenth century.

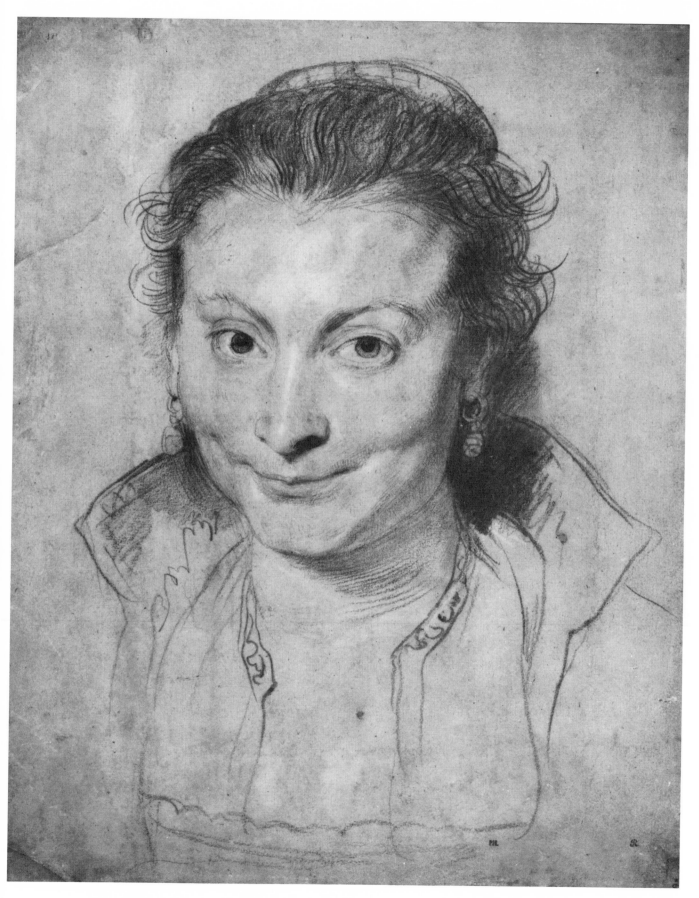

87 SIR PETER PAUL RUBENS b 1577, d 1640
Flemish (Antwerp; Italy; Paris; London; Madrid)
Portrait of Isabella Brandt, the Artist's first Wife, c 1623 (?)
Black, red and white chalks.

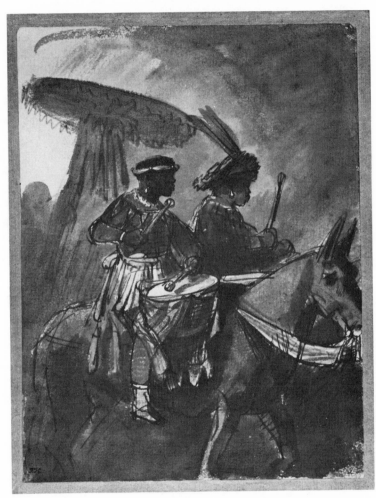

88

88 REMBRANDT HARMENSZ VAN RIJN b 1606, d 1669
Dutch (Leyden; Amsterdam)
A Negro Commander and Kettledrummer, c 1637–8
Pen and brown ink, with washes of brown and yellow, and red
chalk, heightened with white.

89 SIR ANTHONY VAN DYCK b 1599, d 1641
Flemish (Antwerp; Italy; London)
Endymion Porter and his son Phillip, c. 1633
Black chalk, heightened with white, on light brown paper.

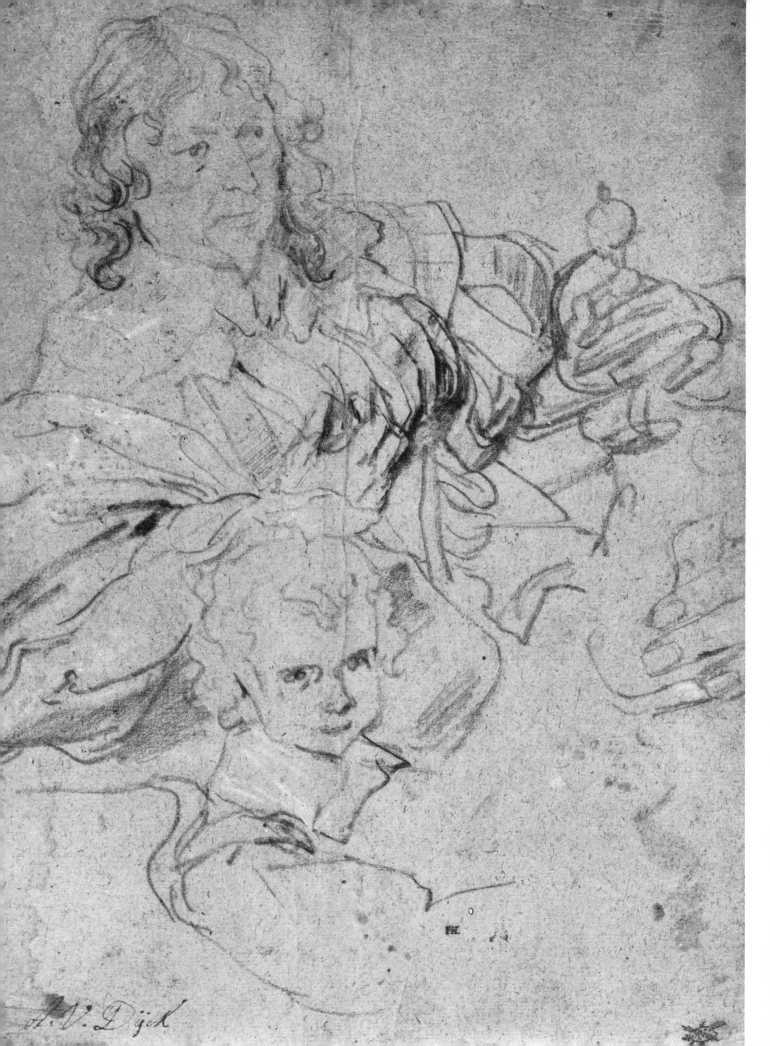

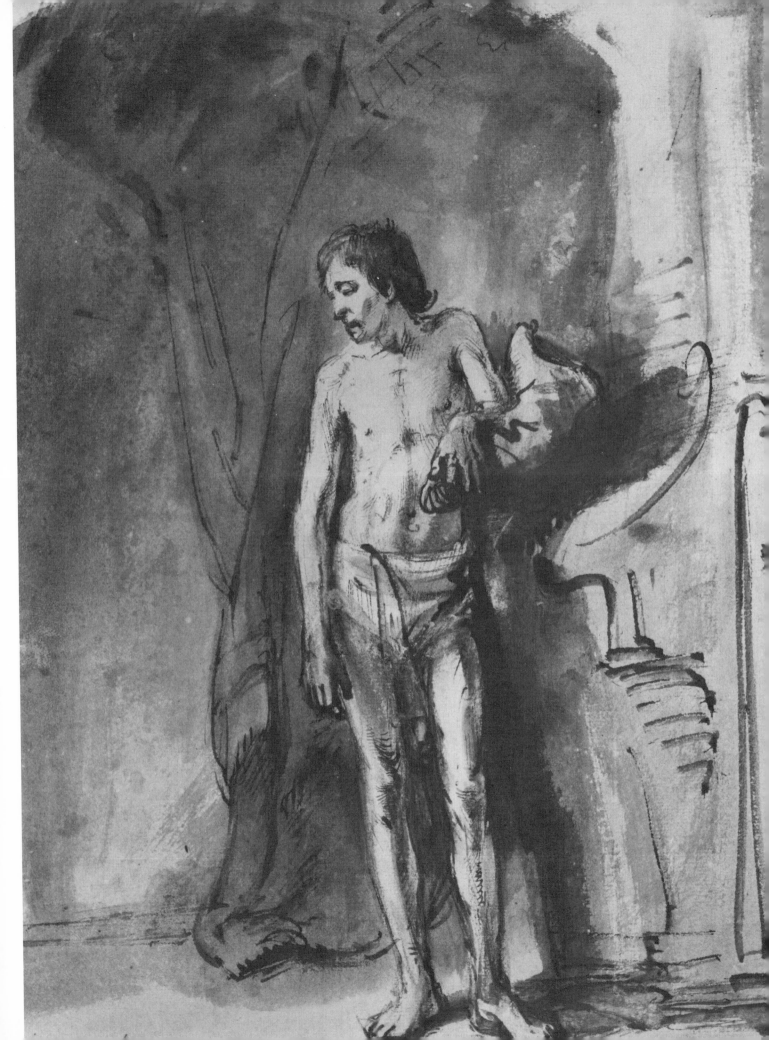

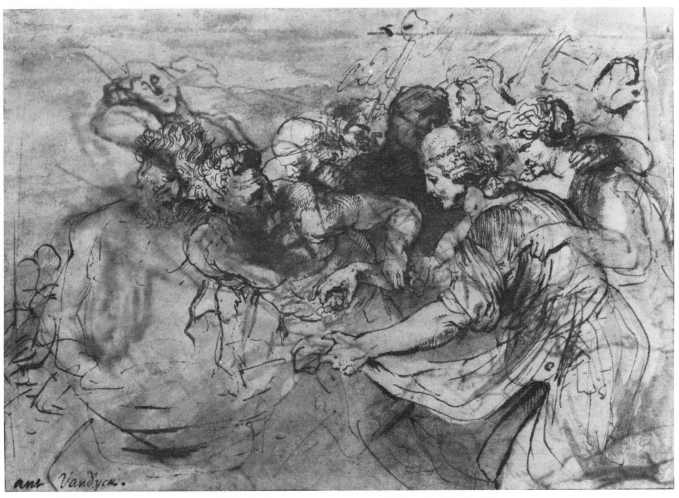

91

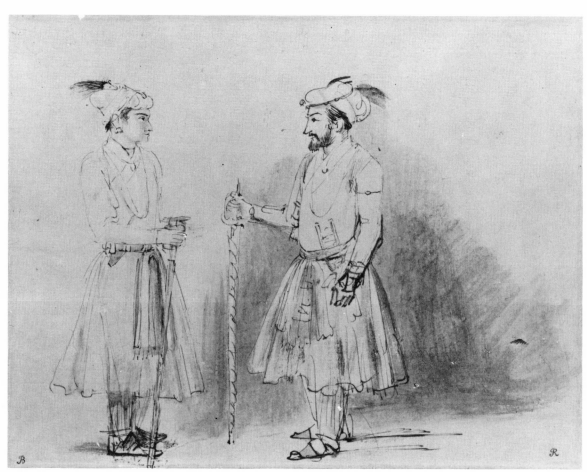

92

92 REMBRANDT HARMENSZ VAN RIJN b 1606, d 1669
Dutch (Leyden; Amsterdam)
*A Mughal Prince (Emperor Jehangir or Shah Jahan?) conversing
with a younger Man, c 1654–1656*
Pen and brown ink, with grey-brown wash.

93 REMBRANDT HARMENSZ VAN RIJN b 1606, d 1669
Dutch (Leyden; Amsterdam)
*Four Sheikhs (Muslim Religious Teachers) Beneath a Tree, c
1654–1655*
Pen and brown ink, with brown wash.

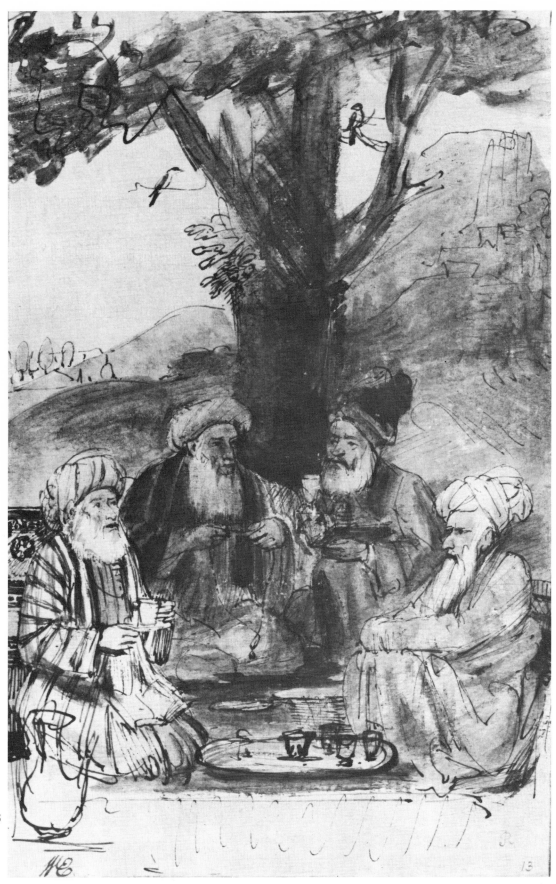

93

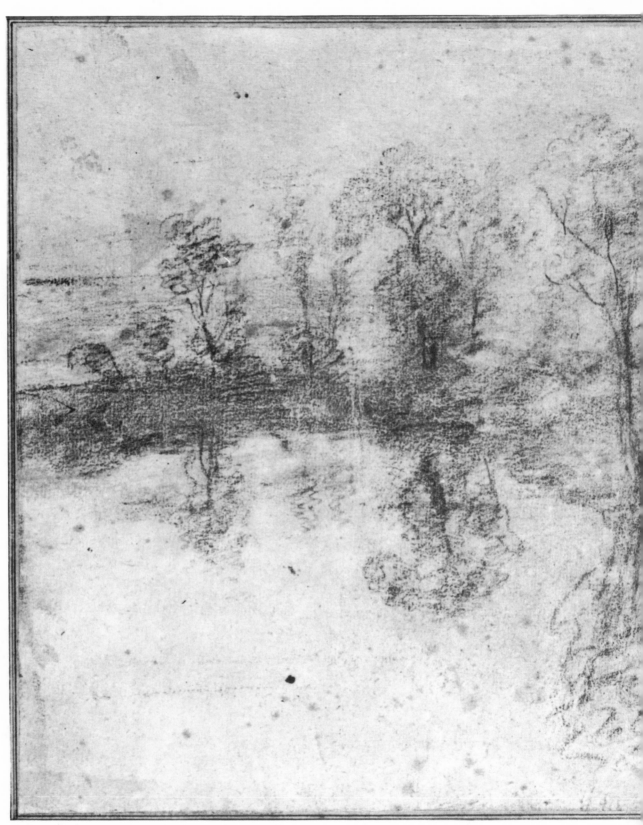

94 SIR PETER PAUL RUBENS b 1577, d 1640
Flemish (Antwerp; Italy; Paris; London; Madrid)
Trees reflected in Water at Sunset
Black and red chalks, touched with white.

die boomen werde siet in het water bruijnder
onde wel perfecter in het water als de boomen selue

hee 'shadow of a tree is greatter in y water
'and more parfect then y trees themselues, and
darker'

R

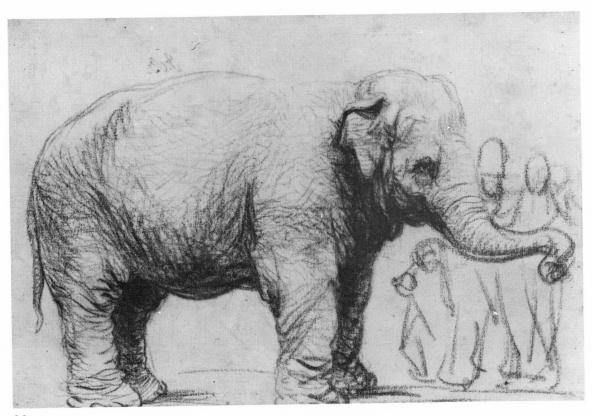

95

95 REMBRANDT HARMENSZ VAN RIJN b 1606, d 1669
 Dutch (Leyden; Amsterdam)
 An Elephant, c 1638 (?)
 Black chalk.

96 SIR PETER PAUL RUBENS b 1577, d 1640
 Flemish (Antwerp; Italy; Paris; London; Madrid)
 The Martyrdom of St Paul, c 1637
 Oil colors over black chalk.

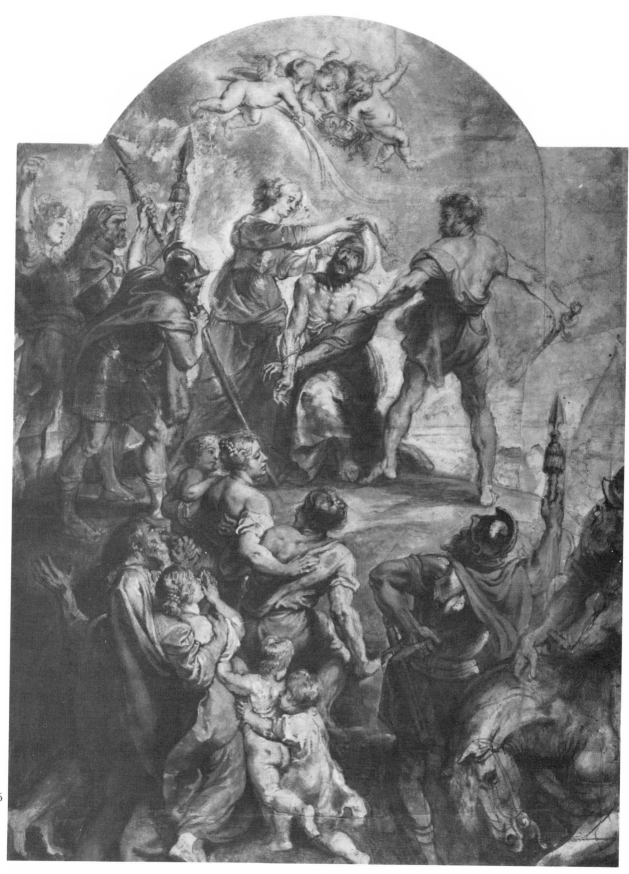

96

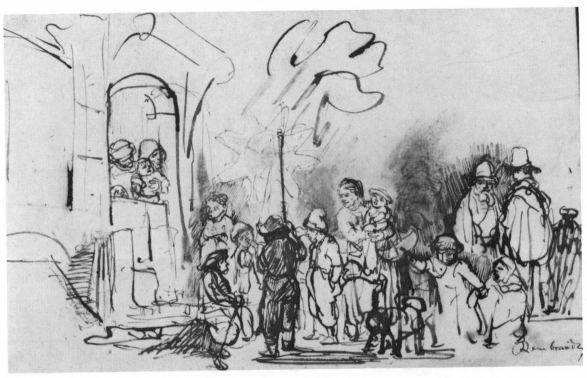

97

97 REMBRANDT HARMENSZ VAN RIJN b 1606, d 1669
 Dutch (Leyden; Amsterdam)
 The Star of the Kings, c 1635
 Pen and sepia with sepia wash.

98 SIR PETER PAUL RUBENS b 1577, d 1640
 Flemish (Antwerp; Italy; Paris; London; Madrid)
 Study for a Figure of Christ on the Cross, c 1614–1615
 Black chalk, heightened with white and touched with pale brown
 wash.

99 SIR ANTHONY VAN DYCK b 1599, d 1641
 Flemish (Antwerp; Italy; London)
 A Meadow bordered by Trees
 Watercolor and bodycolor, on blue-grey paper (OVERLEAF)

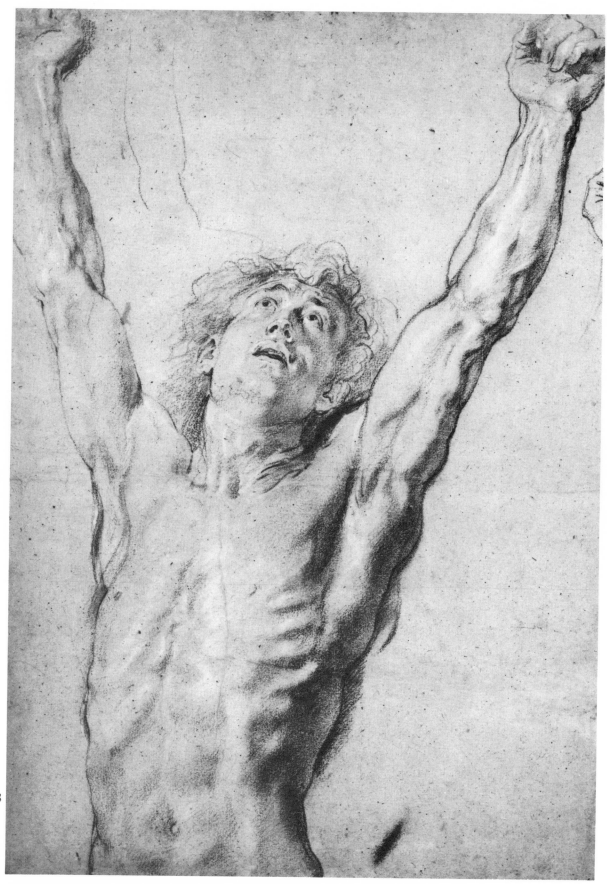

98

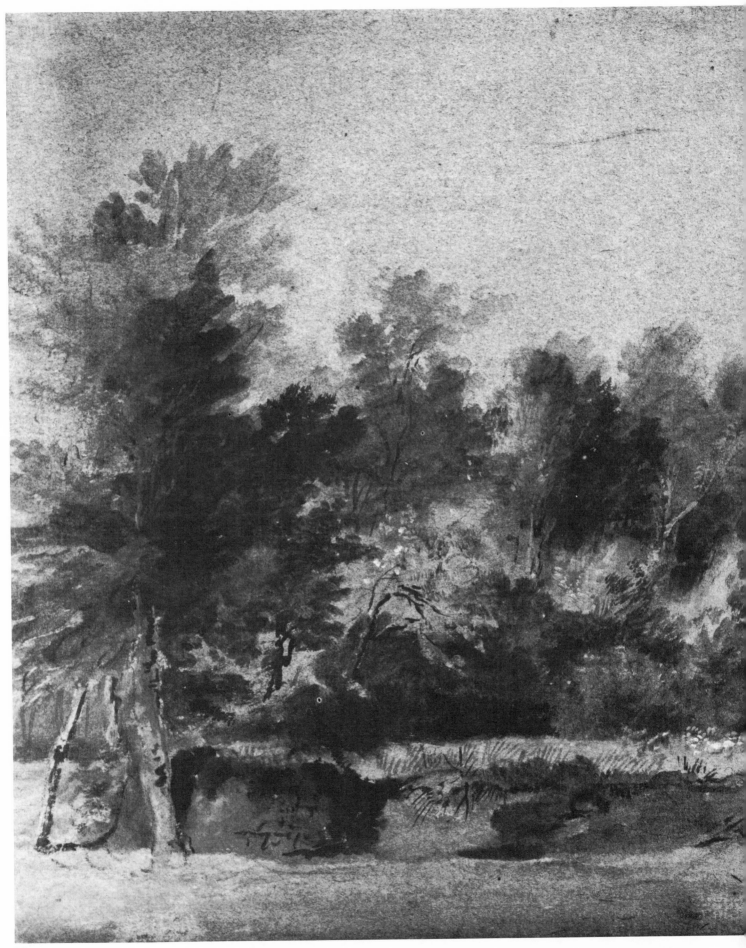

99

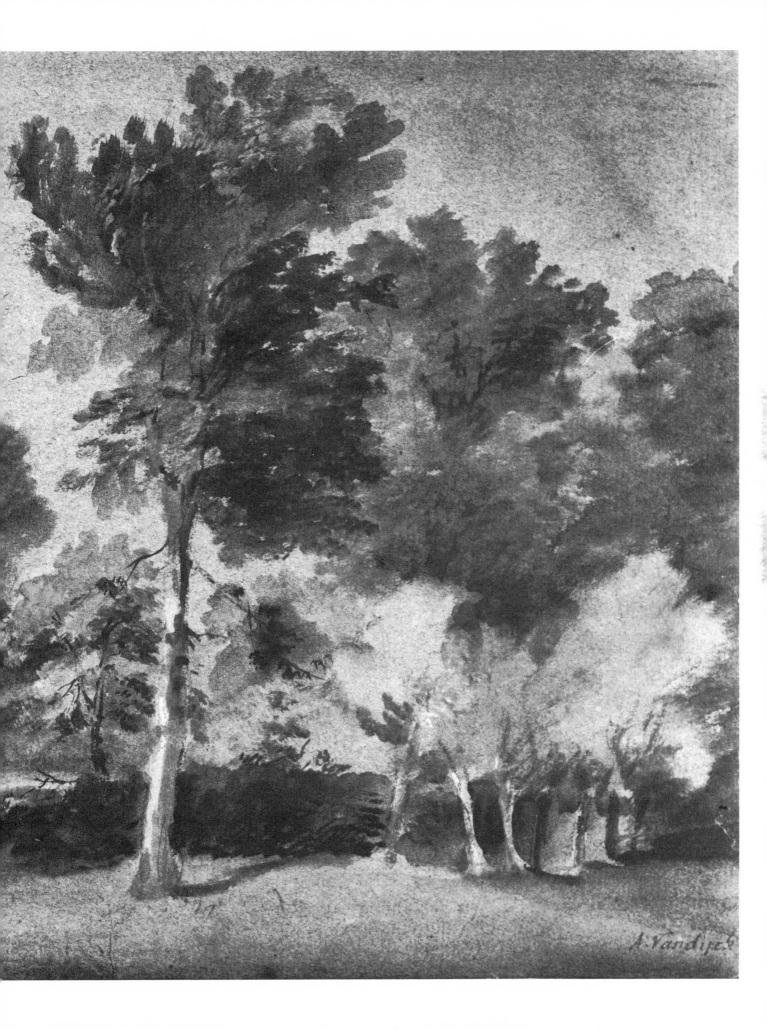

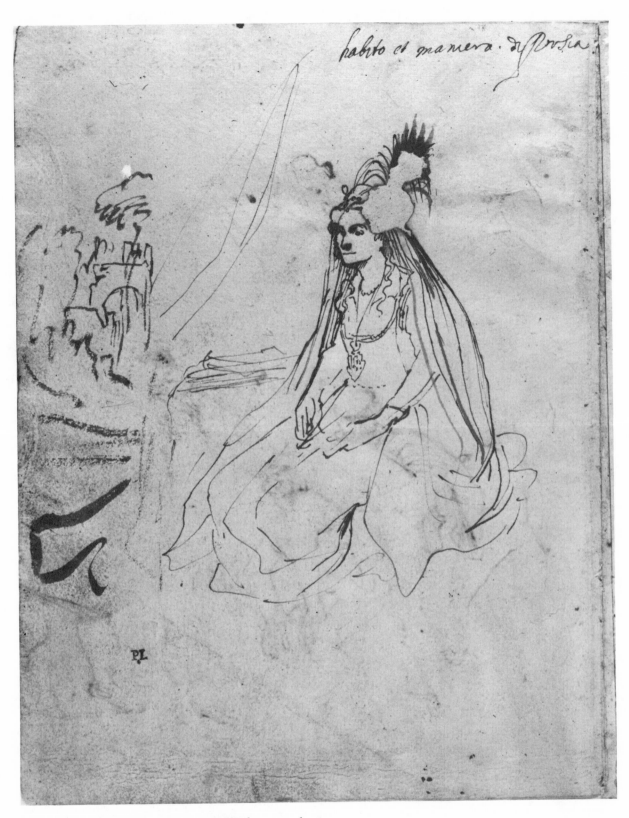

habito et maniera di Persia

100 SIR ANTHONY VAN DYCK b 1599, d 1641
Flemish (Antwerp; Italy; London)
Studies for the Portraits of Sir Robert (right) and Lady Shirley
(left), 1622
Pen and brown ink.

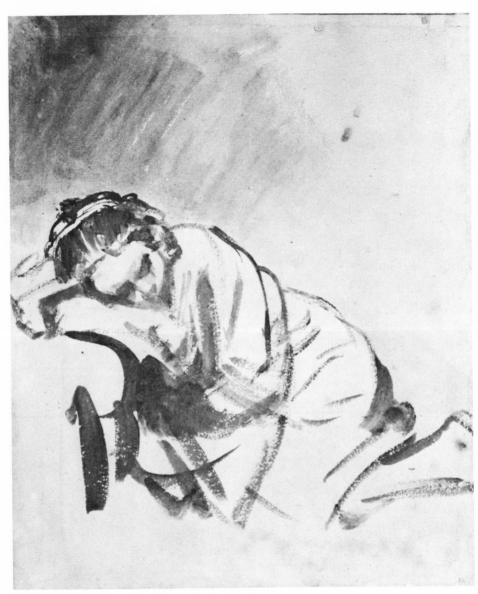

101

101 REMBRANDT HARMENSZ VAN RIJN b 1606, d 1669
Dutch (Leyden; Amsterdam)
Sketch of a Girl sleeping, c 1660–1669
Brush drawing in washes of brown.

102 SIR PETER PAUL RUBENS b 1577, d 1640
Flemish (Antwerp; Italy; Paris; London; Madrid)
A Lioness, before 1618
Black chalk, heightened with white, and yellow bodycolor.

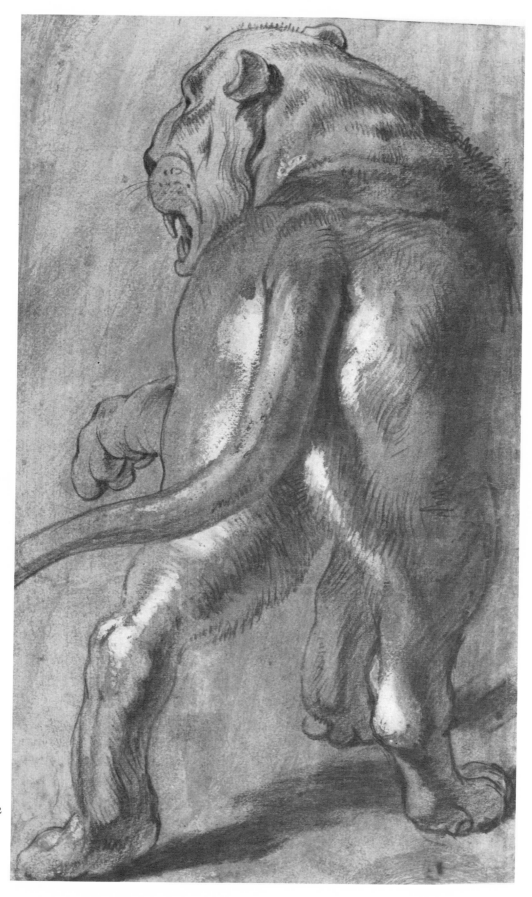

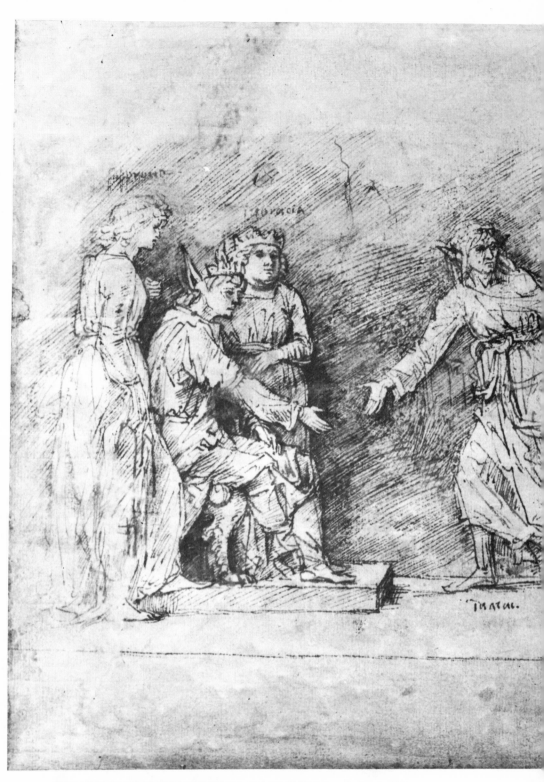

103 REMBRANDT HARMENSZ VAN RIJN b 1606, d 1669
Dutch (Leyden; Amsterdam)
The Calumny of Apelles, after the drawing by Mantegna
Pen and brown ink, with brown wash.

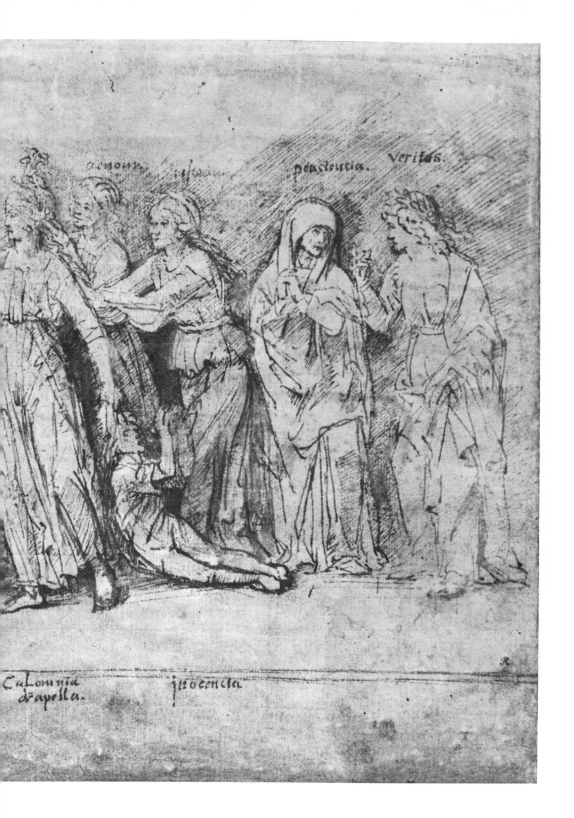

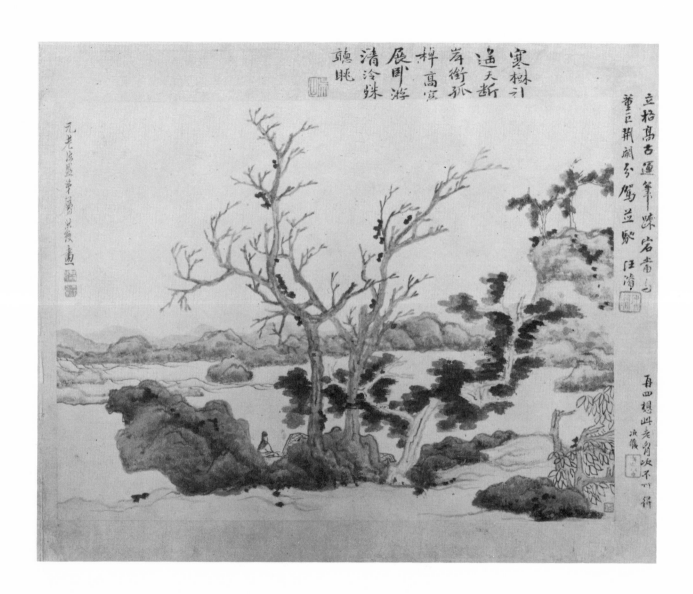

104 CH'EN HUNG SHOU b 1599, d 1652
Chinese (Nanking)
Trees beside a River, and distant Hills, c 1647
Brush drawing in washes of ink and color on paper.

7

Chinese and Japanese Brush Drawings

THE CIVILIZATIONS OF EGYPT AND MESOPOTAMIA declined and were transformed out of recognition. The glory that was Greece passed into memory and was only resurrected in other parts of Europe with the help of fragments and surviving texts. However, in the heartland of China there has been an unbroken development of cultural tradition, principally in the arts, through which the Chinese have attained intellectual and emotional fulfilment.

In contrast with other civilizations, it is not possible in China to draw a sharp distinction between the arts of painting and drawing. Both have a common origin and are uniformly signified by the word *hua*. Indeed, both employ the same technique and use the brush as a common instrument. It is true that certain uses of the brush in China more closely approximate Western styles of drawing, nevertheless, the two arts are so closely linked that only the most technical of analyses can make useful and meaningful distinctions between them.

It is not difficult to understand and appreciate ancient forms of Chinese drawing. They possess a fundamentally realistic approach wherein the brush is used to construct uniformly thick outlines, devoid of all shading. It is a timeless interpretation of pure drawing that invests all forms with curved lines following formless structure only when dealing with masses of water or air.

Generally, the early Chinese draughtsmen did not feel the need for Western techniques of perspective. Instead, the vertical surfaces of their pictures are exploited for their own sake and become essential to the work's composition. In essence, Chinese drawings refuse to accommodate themselves to strict canons of spatial relationship precisely because they do not admit the necessity of a background plane which Europeans since the Renaissance have always considered essential. The Chinese artist thought in terms of a metrical perspective which saw surfaces as

imaginary voids wherein his innermost thoughts could be recreated. And because this was the case, the Chinese grew fond of drawing on vertical and horizontal scrolls which did not require a view from a single perspective in order to provide aesthetic and emotional pleasure.

At the end of the fifth century a Chinese portraitist, Hsieh Ho, wrote a critique of those artists whom he most admired. As a preface to this work Hsieh Ho drew up a short treatise in which he enumerated six important principles of Chinese art which were well known before his time, and which have survived as a fundamental basis of Chinese aesthetic theory concerning painting and drawing.

Hsieh Ho declared that for a man to be a truly great master his work had to be endowed with,

1. A spiritual consonance of the 'life breath' which manifested itself in the creation of movement.

2. The correct use of brush work known as the 'bone-method'.

3. An accurate representation or depiction of objects so as to capture their true form.

4. A correct use and application of color.

5. An appreciation of the arrangement and layout of design so as to present optimal compositional effect.

6. A respect for the traditions of the past evinced by repeatedly copying the works of the great masters.

Of these six timeless principles the first was considered the most difficult to understand but by far the most important. This mysterious 'life-breath' was called *Ch'i* and was considered the source of energy within the artist himself from which emanated all creative output. Without it the artist could not hope to produce great works; it was in essence his passport into the realm of the masters.

After intense concentration the level of creative energy in an artist would rise and he could prepare for work. It is rare to find a Chinese draughtsman making preparatory sketches in charcoal or any other medium. In almost every case the work is apprehended as a whole and if when finished it is not acceptable then the entire process is begun again.

The delineation of minute detail in Chinese drawings finds purest expression in Buddhist and Taoist works where absolute accuracy was dictated by religious precepts which forbade any naturalistic or impressionistic deviation on theological grounds. It is in these drawings that one always finds linear techniques preferred to those of calligraphy which was reserved for purely secular works.

That sect of Buddhism known as *Ch'an* in China and *Zen* in Japan had the most profound effect on the draughtsman's art in both countries. As a doctrine it first appeared in China in the sixth century having been brought from India by the patriarch Bohidharma. Unlike other forms of Buddhism this new sect objected to the inherent importance of religious symbols and scriptures. It was held that neither of these traditional devotional aids were necessary in proceeding along the path of

true enlightenment. Instead it was taught that one could find the Buddha within one's own soul through introspective contemplation. This sense of awareness of 'Buddha essence' was to be found in all things created by nature, and as a source of energy it approximated the *Ch'i* or life-breath held in such reverence in the principles of Hsieh Ho.

Such inspiration is almost impossible to communicate in words, but does find articulate expression in the spontaneous action of the artist's brush which transformed each drawing into a reflection of the inner spirit of its creator.

Any technique was acceptable so long as it fulfilled this need for illuminating self-expression. The calligraphic approach, which had been in use since the first century, was found to be particularly helpful in the creation of spontaneous works and soon found favor with the artistic practitioners of *Ch'an* (*Zen*). The use of calligraphic brushstrokes made it possible to endow drawings with a much more subtle modulation of form than had heretofore been achieved. A new three-dimensionality was now possible using lines of varied thickness, and many artists adopted this method in combination with linear techniques to create richer expressions of their vision of man's place in the universe.

The very fact that the use of calligraphy (the art of beautiful writing) was adopted very early in the development of Chinese drawing points to the common origin and mutual interdependence of each art form. Both calligraphy and drawing were eventually to develop along different paths, but there was a common intellectual and technical bond between the two that remained constant throughout the historical development of each. There are obvious factors which explain this situation. First, both drawing and writing relied on the use of soft hair brushes, India ink, and paper or silk. Second, the characters of Chinese script are as much drawn from nature as the work of Chinese artists. Third, both have a common desire to express the rhythm of their creator's thoughts and feelings. In essence, both calligraphy and drawing are symbolic manifestations of creative energy, and each compliments the contribution of the other, particularly on religious and decorative scrolls where they share common ground.

Of all the forms of Chinese drawing that which is most foreign to Western conceptions of draughtsmanship is the so-called 'boneless method' wherein blotches of ink are piled one upon the other in a highly expressionistic manner. Yet even in some of these works there are recognizable elements in use, and the number of works which contain absolutely no linear conventions are very rare indeed.

In short, the importance attached to linear rhythm in all Chinese drawing cannot be emphasized too strongly. It is inevitable that one finds contours to be the key to both form and construction. In all the dynasties of great Chinese draughtsmanship—the T'ang (618–906); the Sung (960–1279); the Ming (1368–1644); and the Ching (1644–1911), one cannot escape the central importance of linearity regardless of stylistic variants. Perhaps this is the case because the medium of Chinese drawing does not change with chronological progression. The Chinese use of line is con-

CHINESE AND JAPANESE BRUSH DRAWINGS

156 tinuously flowing and modulated, though their work is generally unequal to the refined subtlety of the Persians. Further, in Chinese drawing there is little of the broken, quick, staccato line found in the art of fifteenth century Europe, or the comparatively weak and flaccid contour of Hindu draughtsmanship. This is not to say that Chinese drawings are bereft of a sophisticated appreciation of plasticity or volume. On the contrary, their use of contour expressively addresses itself to these particular problems and imparts a most useful and satisfactory solution.

Because Chinese drawings reflect an abiding faith in the cosmic energy of a universal spirit, rather than the personality of the individual, it is understandable that what appears on the paper or silk is an idealized type-form rather than a direct reflection of nature or the events of everyday life.

Many of the greatest Chinese draughtsmen did spend considerable time in close communion with natural surroundings. It was through such activity that the mind of the artist penetrated the various moods, and mentally absorbed the essential images of the environment. But when the brush was actually applied to paper or silk what emerged was far from simple reportage. Instead, one sees an artistic representation of the innermost feelings of the artist expressed universally rather than from a point of external observation. In other words, the psycho-mystical side of Chinese drawing is always present, even in the simplest of scenes, and the result is an interpretive level of consciousness that is unique to China alone.

The Chinese referred to their landscapes as 'mountain and water pictures'. These were the subjects most frequently chosen, and the usual method of treatment relied heavily on romantic inspiration. The Chinese were primarily an agricultural people, but that did not prevent their artists from indulging in a passion for swift running torrents, plunging waterfalls, mist-covered mountains, and retreats of wild solitude. It was in such environs that the inner spirit of creativity was given greatest freedom of action.

The great Chinese scholar-draughtsmen who fled in times of trouble from political and military chaos had their own technical conventions designed to impart maximum visual and psychological impact to their drawings. Instead of placing the spectator on ground level, as was common in European art, the Chinese move above the earth creating horizons with mountain ranges and misty fog and cloud banks. Nothing in the foreground is so highly detailed as to be a distraction. Distant peaks are allowed every possibility to capture the imagination of the observer with their grandeur. In essence, one's eye is liberated from particulars so that the universal statement of the work can be made without hindrance. Empty spaces were intentionally used as an element to aid the contemplative purpose of the landscape. The spectator must fill these voids for himself. Symmetry was clearly not necessary in such a system, and men were never central in the world as it was seen by the Chinese artist. This latter characteristic in many ways identifies the quality and purpose of their art.

★　　★　　★

As cultural progenitors, the Chinese have always been of prime importance in setting styles for the rest of Asia, and nowhere was their influence more profound than on the arts of Japan. Like the Chinese, Japanese draughtsmen relied almost exclusively on paper and silk, India ink and watercolor, mineral pigments, and of course the brush. Their paper came from plants such as the mulberry tree, bamboo, grasses, and rice. Their inkstick or *sumi* was made by combining pine soot and fish oil or glue. And their brushes were usually tufts of badger hair fixed conically at the end of bamboo sticks.

The Japanese also developed a variety of drawing tecniques. First, they produced sketches of animals, landscapes, and individuals that were no more than graphic notes for use in later compositions. Also, one finds examples of *Shita-e* (preparatory sketches) using only basic lines over which blank paper or silk was placed so that tracing and color could be filled in. Further, there was the method called *kakiokoshi* which literally means 'drawing again'. Here the original lines of a work are re-emphasized once color has been applied so that the general outline will be more noticeable and not compromised or obscured by colors and tints. Finally, there is the technique of *Sumi-e* which most closely approximates European ideas of drawing. These are black and white drawings using only India ink (*sumi*) to create lines of various thickness as well as a type of chiaroscuro.

Sumi-e was introduced into Japan from China in the thirteenth century and remained essentially unchanged until the late nineteenth century when, during the Meiji period, new media such as charcoal, pencil, and graphite were adopted as supplements to India ink. It was natural that *Sumi-e* should retain its popularity for so long in the highly traditional society of Japan where Buddhist teachings exerted a profound influence for over 700 years.

In the austere confines of the tea room a complex Zen ritual evolved in which *Sumi-e* played an essential role. The tea ceremony was considered one of the most civilizing activities a man could enjoy. Indispensable to the ceremony were the *kakemono* or vertical scrolls decorated with ink (*sumi*) pictures which were hung in a particular niche in the tea room. These scrolls were changed periodically to suit the occasion, the season, and the special days of celebration, and it was not unusual for a wealthy family to possess over a hundred *kakemono*.

Upon first examination a work of *Sumi-e* appears confusing—just a few blotches of ink on a plain background. But soon shapes and forms begin to appear. The intention of the artist to create a small part of nature impressionistically was fundamental to *Sumi-e*. Only black ink was used, for the Japanese draughtsman recognized that it was impossible to attempt to reproduce the hues and tints that actually exist in nature. Black is the only non-artificial tone that can be employed to represent the truths of all colors.

Artists in many cultures have been aware of ink as a satisfactory medium for drawing because as a substance it carries the risk of blotting, streaking, and thinning as the brush or pen moves along. But for the masters of *Sumi-e* these problems were

overcome by treating such phenomena as positive and integral parts of their technique. Thus, the 'broken ink' and 'splashed ink' styles of *Sumi-e* were considered means of refining and enlarging the scope of the draughtsman's art. The result was an accommodation of man to nature. The accidents of the brush heightened the sense of reality to be found in these ink drawings in the eye of the discerning observer.

Japanese draughtsmen, like their Chinese brethren, not only developed certain technical skills in drawing, but also evolved stylistically through a number of schools whose progress was conditioned in part by the political and economic factors that governed everyday life in Japan.

From the sixth through the tenth centuries there was continuous Chinese influence on Japanese art that was assimilated directly or through Korea. These ties were cut after the downfall of the T'ang dynasty in China in 894. For three centuries thereafter the Japanese enjoyed an artistic isolation that fostered the birth of a truly indigenous art form called *Yamato-e*. This style centered around Kyoto and Nara, the acknowledged capitals of Japanese civilization, and stressed themes and motifs entirely original to the Japanese experience. *Yamato-e* relied on the use of hair-thin lines to create outline drawings of animate and inanimate objects. These were then filled in with intensely bright colors in sharp contrast to the severe tones always employed in older works. Yet although the interpretive style of *Yamato-e* survived for centuries, the cultural hegemony of Kyoto declined during the twelfth century as civil wars between the great feudal families and clans swept the land with merciless ferocity. By 1185 the clans of Minamoto and Hōjō gained supremacy, and after Kyoto was generally laid to waste they established a rival center of power at Kakamura, south of Tokyo, and ruled there until 1392.

It was during the Kakamura shogunate that Zen Buddhism was embraced by the Japanese. Zen, the contemplative pursuit of enlightenment, created in Japan a new demand for Chinese art, particularly that which was produced during the Sung Dynasty. As the cult of Zen spread throughout the country, Japanese draughtsmen and painters looked for a style that would best reflect their belief, and during the fourteenth and fifteenth centuries they developed an approach called *Suiboku-ga* or black painting. In *Suiboku* line was absolutely essential. In contrast with the slow simple contours of *Yamato-e*, the masters of 'black painting' attacked each work with a series of rapid brush strokes which placed all emphasis on linear analysis. *Suiboku* accurately reflected the Zen approach to life where no composition was predetermined, but took shape out of the spontaneity of individual creative interpretation. Naturally such a philosophy was also very attractive to the practitioners of *Sumi-e* which shared certain methods in common with the masters of black painting.

The separate development of the Chinese-inspired 'black art' and the entirely native born *Yamato-e* continued from the fourteenth century until modern times. As patronage became available, not only from the court, but also from the rising warrior and feudal classes, the hereditary principle played a significant role in the

kinds of drawings and paintings that were produced. The great family schools of Tosa and Kano, who maintained the opposing traditions of Japanese and Chinese-inspired art from generation to generation well into the nineteenth century, were the chief beneficiaries of affluent patronage. Each in its own way made a unique contribution to the development of Japanese drawing by adding a strong decorative element to what was produced, while at the same time refusing to abandon traditions that had been maintained for centuries.

Before the seventeenth century, most Japanese representational art was executed by and for an elite with either a religious or political motive. All patronage emanated from the upper classes, and no bourgeoisie emerged as an alternative source of revenue. But in the Tokugawa period (1615–1867) the growth of a viable merchant community produced profound changes in society that directly influenced the art of the time. A tension developed between the artistic guardians of tradition and the prophets of a new age. As the old elite sources of support found competition in the middle classes the artists of Japan responded with work executed on a more modest scale to suit the tastes and needs of new customers. Drawings and paintings became a source of entertainment in addition to their traditional roles of inspiration and edification. This new approach to art was called *Ukiyo-e*, the art of the floating world, and was developed primarily at Edo (Tokyo) and Osaka. The emergence of *Ukiyo-e* marked the beginning of the great age of genre drawing, painting, and engraving in Japan. As an art form it contained many stylistic elements common to traditional interpretation. But the unique contribution of *Ukiyo-e* was its ability to draw thematic material from the picaresque side of Japanese life that was familiar to everyone.

While such an approach captured the fancy of the middle classes in Edo and Osaka, other schools and styles were making their presence felt throughout the country. In the eighteenth century new Chinese-inspired movements developed in Japan under the names of *Bujin-ga* and *Shijō*. These were schools of scholarly art whose masters, having studied the work of the Ming and Ching dynasties, produced landscapes in ink whose light and freely handled brushwork expressed a poetic feeling of ease and contentment. The scholars themselves were often included as subject matter in these drawings, but even at such a comparatively late date the human figure never assumed much importance in relation to natural scenes.

Both the *Bujin-ga* and *Shijō* masters approached landscapes, flora, and fauna in a highly idealistic manner. Their brushes were used as a means of achieving intellectual fulfilment rather than simply for the creation of beautiful objects, and few Japanese artists before or after these scholar-draughtsmen possessed such interpretive skill or technical virtuosity. These were the last Japanese draughtsmen to emerge completely free of Western influence. Once the country entered the international world after 1868, when the Meiji dynasty was restored, an enormous diversity began to appear in all the traditional areas of creative output. The Japanese learned to see things from the European perspective of objective realism. Later even

CHINESE AND JAPANESE BRUSH DRAWINGS

the doctrines of Impressionism found a receptive audience in Japan. Gradually an amalgamation of traditional and modern techniques took place, but it was unthinkable that Japan's ancient inheritance would ever completely disappear. The instinctive need of the Japanese artist to perceive objects and figures intuitively as part of the world's totality, rather than in opposition to the environment, was the key to all their greatest examples of graphic art. This was a quality that managed to survive even the most determined onslaughts by a variety of alien cultures.

Japanese drawings have often been considered less profound than those produced by the Chinese. Yet in the depiction of swift and vibrant movement their draughtsmen are unsurpassed. The Japanese possess an artistic tradition going back over 1300 years, and of all the countries of the world there are few whose culture has been more conducive for the production of great drawing.

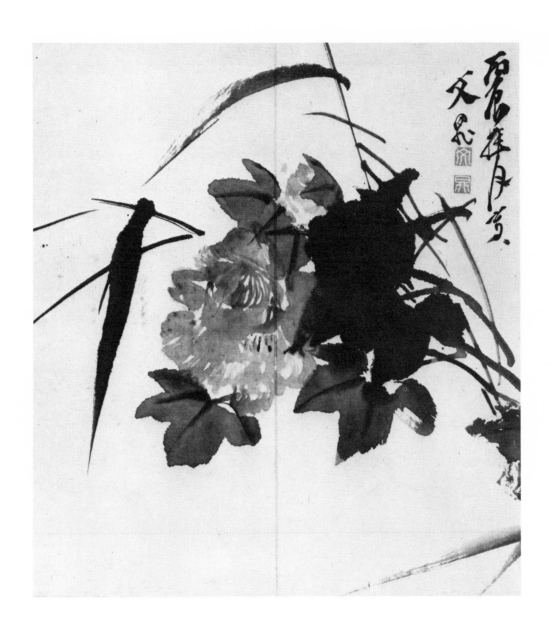

105 TANI BUNCHŌ b 1763, d 1810
Japanese (Bunjinga)
Flowers and Bamboo, 1818
Brush drawing in ink, with watercolor.

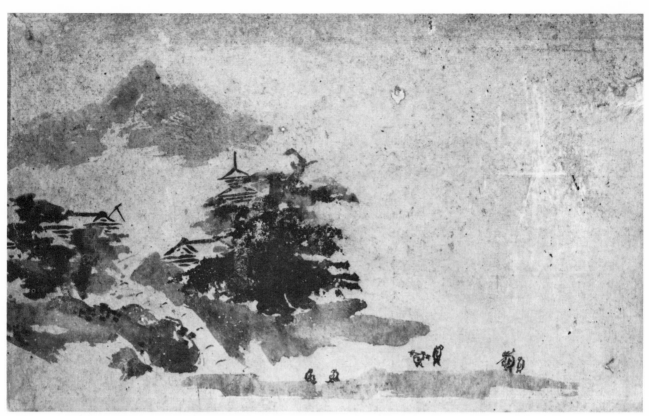

106

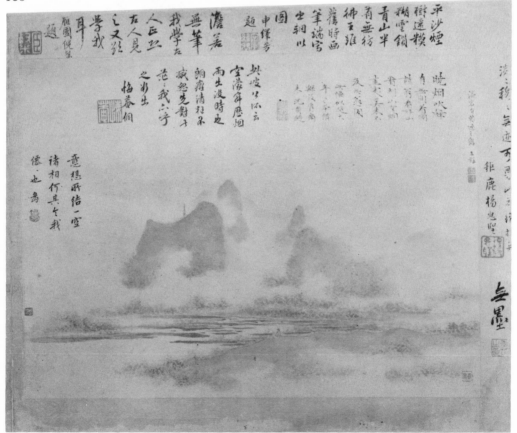

107

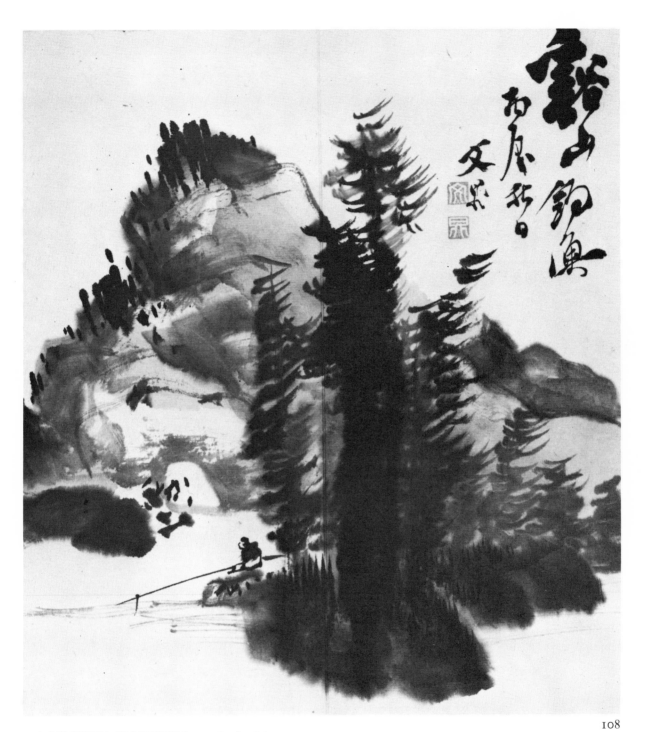

108

106 NUKINA KAIOKU b 1778, d 1863
Japanese (Bunjinga)
Scholars in the Mountains, 1853
Brush drawing in ink, with watercolor.

107 HU YÜ-K'UN *fl* mid-seventeenth century
Chinese (Nanking)
*Landscape in the so-called 'Boneless Style': A River with
a Mountain covered with Morning Mist, c* 1647
Watercolor on paper.

108 TANI BUNCHŌ b 1763, d 1810
Japanese (Bunjinga)
Fishing in the Melting Mountain, 1818
Brush drawing in ink.

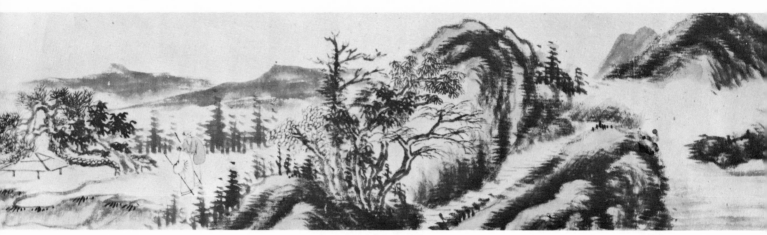

109

109 SESSON b 1504, d 1589
Japanese (Sesshū School)
A Hill Village, c 1550–1560
Brush drawing in grey wash.

110 ANON. CHINESE *c* ninth century
Tunhuang
Punishment of Sinners in the Ten Courts of the Underworld,
prior to their Reincarnation
Brush drawing in black ink, with watercolor, on paper.

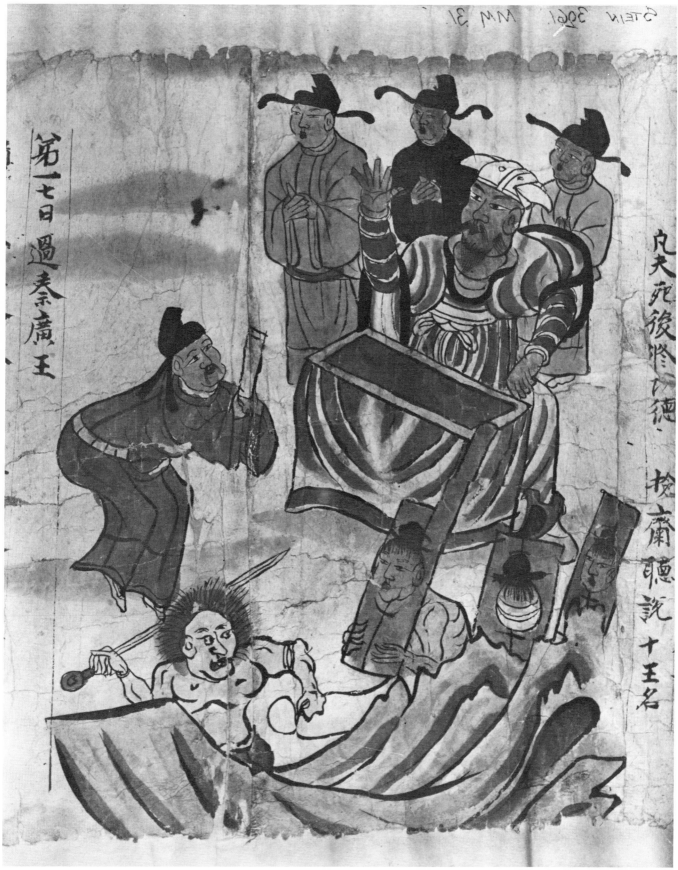

第一七日過奏廣王

凡夫死後修功德
檢廳聽説十王名

111 KAO FENG-HAN b 1653, d after 1747
Chinese (Yangchow)
Fan Leaf: Mountainous Landscape with Pines, 1725
Watercolor and ink wash on paper.

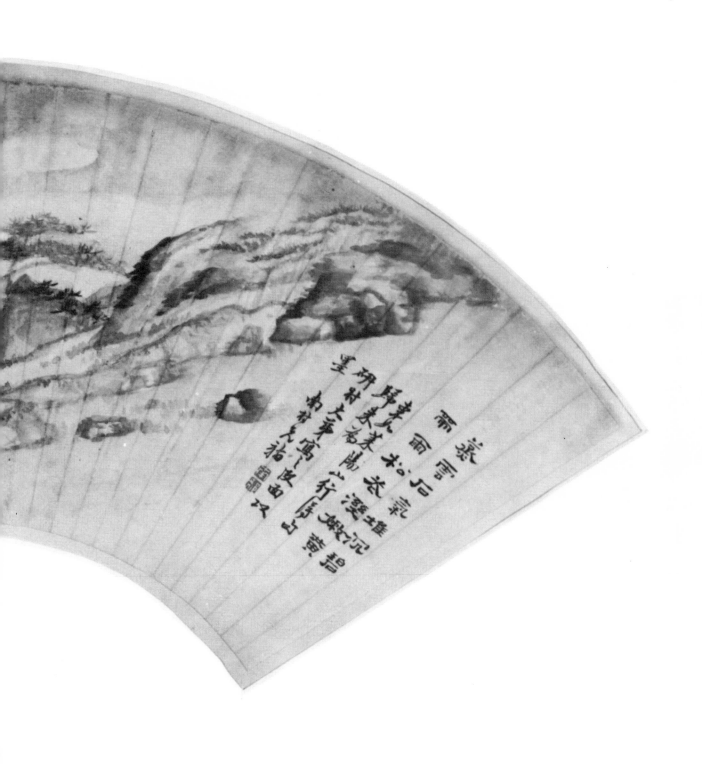

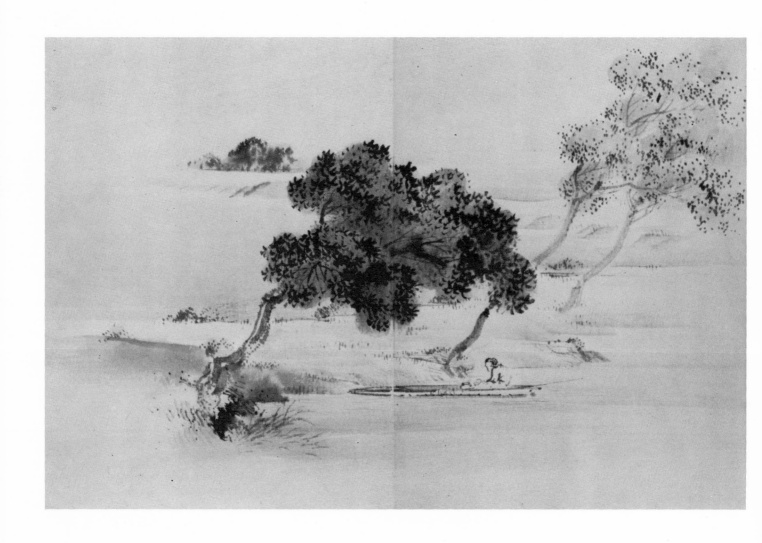

112 YAMAZAKI KISUI b 1786, d 1837
Japanese (Shijō School)
Scholar in a Boat
Brush drawing in ink, with watercolor.

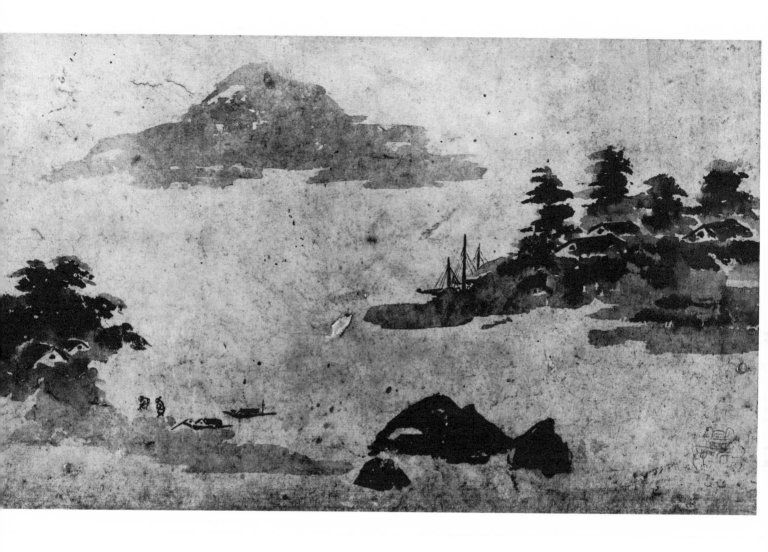

113 SESSON b 1504, d 1589
Japanese (Sesshū School)
A Fishing Village, c 1550–1560
Brush drawing in grey wash.

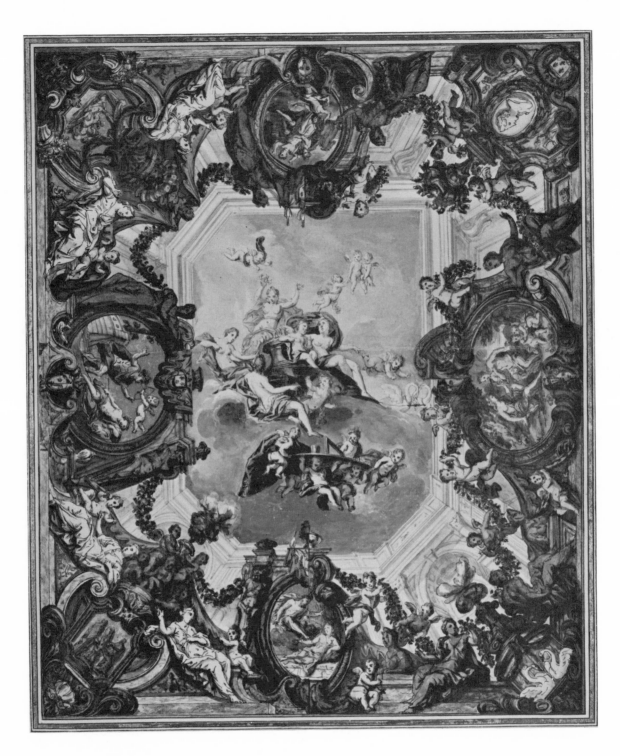

114 ANTOINE COYPEL b 1661, d 1722
French (Paris)
Design for a Ceiling-piece: The Triumph of Venus
Pen and ink, with watercolor and bodycolor.

8

The Rococo Tradition in France and Italy

VOLTAIRE ONCE WROTE, 'all styles are good, except the boring ones', and by this criterion the Rococo must be judged excellent. It was essentially a French style that was manifest in all the creative arts, though eventually it found universal expression throughout Europe particularly in Italy and the Rhine valley.

The origin of the word Rococo can be traced most properly to the *rocailles* and *coquilles* (rocks and shells) which form an important part of its decorative repertoire. As with many labels for artistic styles, the word Rococo originally bore a pejorative connotation, and only became legitimized by art historians of the late nineteenth century. Contemporaries of the time thought of it as a 'modern' style or a *genre pittoresque*. But whatever term is applied, we can see in Rococo art an all-abiding concern with a decorative use of rhythmic 'C' and 'S' curves, scrollwork, fanciful tracery, and a sensitivity to material and texture; all designed to achieve a consistent artistic effect of harmonious movement.

Many have thought of the Rococo as an artistic reaction against the styles of the Baroque. While it is true that much of the art of the period appears in opposition to the academic ponderousness of Poussinism, there is still in the Rococo an obvious emulation of certain Baroque motifs, mainly those of Rubens, whose lively use of color was greatly admired.

Although the Rococo became a dominant style throughout Europe its chronology was most clearly defined in France where the movement exerted greatest influence. With the death of Louis XIV in 1715 and the establishment of a Regency for the child-king Louis XV, a transitional period began. This blossomed into the glories of the high Rococo at a time roughly approximate with the majority of the new king. Conveniently for art historians, the Rococo finds itself in rapid dissolution

by the time Louis XV dies in 1774.

If it was true that the seventeenth century was a time of absolute royal control of French artistic production, it could be argued that the eighteenth century witnessed a shift in patronage to the aristocracy when the court of Versailles was dissolved and the child-king was brought to the Tuileries Palace in Paris. In the capital the *noblesse d'épée* and *noblesse de robe* mingled with the new financial and intellectual elites who managed to gain at least partial entrance into the inner sanctums of society and transformed its views on the art of good living.

The connoisseur of fine art became a public figure. Private collections grew in number and importance. A thriving art trade rose to serve the new aquisitiveness of wealthy patrons, and the Salon institutionalized their tastes. As the demand for works of art increased, and as public morals relaxed in reaction to the political and economic severity of the Sun King's reign, so too were conditions ripe for the flowering of the Rococo.

Painters and draughtsmen began to take a less serious view of life. Themes of love were infinitely preferable to those of military glory. Pictures and drawings were no longer designed to stun the spectator but rather to amuse and entertain him. There was a new intimacy and privacy in the art of the Rococo. Rhythm, always an important ingredient in Baroque art, became more rapid, graceful, and sinuous. The French Rococo was essentially a decorative style stressing the pleasurable rather than the heroic side of life. Such naturalism (for an appreciation of nature was also an essential element) carried with it a modicum of eroticism with an emphasis on personal indulgence. In many ways such art was a novel contribution in the progression of Western civilization.

As a style the Rococo of necessity contains a well developed ornamental element, but it is by no means confined solely to decorative invention only. Through the whole-hearted adoption of certain Baroque illusionary techniques Rococo artists made illusion itself the very idealized subject of pictures and drawings. In essence, the Rococo was neither the end of an era nor a mere transitional phase, it was the true beginning of an epoch with its own strongly developed character.

A full appreciation of the Rococo requires an awareness of the continuing tension between the artificial and the natural. Everything is changeable and in motion—nothing is immutable. The artifice of art is celebrated for its own sake, so is novelty—and it was the taste for artificiality and the thirst for novelty which eventually destroyed the Rococo itself.

Rococo artists always have a strong feeling for prettiness and gaiety. Themes such as the love-play of Venus and Pan or the picaresque and comic episodes of the *Comedia dell Arte* were especially in favor. The Rococo broke new ground by emphasizing the relaxed human qualities of life rather than the grand and resplendent motifs of Baroque drama.

Of all the representational media, drawing most clearly expressed the goals and desires of the Rococo. Life in France and Italy was not completely frivolous and

abandoned. The philosophy of the time and the intellectual drive of the encyclopedists led men to place a high premium on the joys and rewards of reason. Thus, it is not at all incomprehensible that during this period the concept of the 'idea' should be linked to that of simple 'beauty'. Drawings were appreciated as individual works of art in themselves, suitable for hanging in the boudoir or salon, and not just as preparatory studies for a canvas or fresco. The theoretician was replaced by the connoisseur, and the autonomous drawing became a highly prized possession.

The Rococo drawing is perhaps most noted for its sense of the contemporary and its spontaneous grasp of immediacy. No medium could better portray and reflect the sense of elegance and pleasure so highly valued by the new patrons of the arts. In *pierre rouge*, a sanguine red chalk, the draughtsman found a particularly adaptable tool which gave the plasticity he prized to his figure studies. It was especially effective when combined with white and black chalk in a *dessin estompe*, or smudged drawing, which seemed, in its smudges, to trap the breath of life.

It has been said that eighteenth century France was well served artistically by its draughtsmen whose gossamer-like touch showed them to be fully alert and sensitive to the emotional and intellectual currents of the age. Rococo drawings were constantly exploring the possibilities of art in a manner essentially the same as the enquiries and speculations pursued by the *philosophes*. Both groups devised artificial constructions within some acceptable form of reality, and both sought an informal freedom of expression that had heretofore not been appreciated.

However much one intellectualizes the legitimacy of Rococo draughtsmanship, it is impossible to ignore that its essential purpose was to give the observer enjoyment and entertainment. In Rococo art, few suffer; life is idealized and human existence is a paradise which is gay, youthful, and eternally happy. The darker sides of life are generally shunned and art becomes a play wherein all the participants are heroes and heroines.

Of all the practitioners of Rococo draughtsmanship none was more representative of the time that Jean-Antoine Watteau (1684–1721), though his untimely death at the age of thirty-seven took place almost before the Rococo style reached its maturity. Much of Watteau's technique was derived from Rubens whose works Watteau studied in the galleries of the Luxembourg Palace. But unlike Rubens, Watteau found it impossible to confront the realities of life. As a consumptive, he was plagued by constant ill-health. However, his work never became despondent or morose but emphasized instead the transitoriness of all existence. Watteau placed a high premium on the seriousness and importance of pursuing and capturing pleasure while it could still be enjoyed. For Watteau sentiment and sensibility were all-important, and in this context he might be regarded as one of the greatest of the artists of the post-Renaissance era.

As a draughtsman Watteau demonstrated great technical virtuosity combined with a highly developed lyrical imagination. His style, although tense and vigorous, speaks of an enchanted world where dreams and fantasies combine with

THE ROCOCO TRADITION IN FRANCE AND ITALY

charming glimpses of intimate everyday reality.

Watteau's keenness of observation made him the greatest of the Rococo naturalists, despite the fact that in his world Pan and Venus, nymphs and shepherds, dryads and oreads reigned supreme in an idealized theatrical society. Watteau evinced little interest in historical subjects. He did not receive great commissions from the Crown or the Church, and apparently had little ambition to create large public pictures. Instead he popularized a pictorial obsession with love—love both transient and timeless, and in the *fête galante* he actually created a new category of art, which dispensed with overt stories and plots in favor of an analysis of psychological values.

It is interesting to note that in order to pursue these goals in his drawings Watteau invariably employed a rich crimson chalk which created an effect noticeably different from the yellow chalks of the previous century. This medium not only added a sensuousness of color to his work but also an increased plasticity. Other media were also employed in Watteau's drawings, and in his most ambitious and finished works he adopted the technique of *quatre crayons* in which two types of sanguine were combined with black and white chalk to create something almost as brilliant in its effect as oil-paint on canvas.

Watteau's drawings attract the viewer not only for their spontaneous freshness but also for their remarkable ability to portray reality clearly, yet without harshness or dryness. His drawings, much more than his paintings, convey his appreciation of both personalities and objects in the world of tangible reality. More importantly, one can see in Watteau's draughtsmanship a suspicion that limitless pleasure is less desirable than a true appreciation of the transitoriness of enjoyment.

Surprisingly, if we consider the stereotypes generally applied to the Rococo, Watteau's work never ignores the ultimate conclusion that the basis of art lies in a personal conception of reality. That is why much of his work concentrates on a single psychological moment such as a tender embrace, a tragic rejection, a chord of music, or the height of passion. In Watteau's world love and pleasure fight a losing battle against time which can only be resolved in a return to the less exalted plane of realistic perception. Thus, escape is only momentary and the conception of living consciously is never lost.

Within ten years of Watteau's death the style of Rococo decoration spread throughout Europe. In Germany it was put largely at the service of the Church. In Italy, and particularly in Venice, draughtsmen devised formats which were immensely popular with the individual patron who saw in the drawing an independent example of artistic achievement.

When assessing the drawings of Rococo Venice one must give pride of place to Giovanni Battista Tiepolo (1696–1770) who, while strongly attracted to themes of love and pleasure, still asserted the importance of the grand and heroic gesture. If Watteau was attracted to theatrical themes, Tiepolo was positively entranced by them. Both his paintings and drawings erect stages upon which elegant pageants

are endlessly but ambiguously acted out. In his figures Tiepolo presents individuals of unflappable *hauteur* who seem beyond the influence of everyday life and its problems. Yet this *hauteur* is contrasted with the grotesque of Punchinello, the lechery of the satyr, and the sinister quality of the warlock or soothsayer. Tiepolo's habit (followed by his gifted son Gian Domenico) of making drawings in series, each a variation on a set theme, enabled him to exploit the medium in an almost musical way, and gave a new dimension to the drawing as a collector's object.

While Tiepolo and his followers were creating a fanciful but not wholly reassuring kingdom of art in Venice, Watteau's achievements were followed up in France by Francois Boucher (1703–1770), who owed much of his success to the patronage of Louis XV's intelligent and ambitious mistress, Madame de Pompadour. One of Boucher's chief gifts was as a draughtsman. He was the first artist, in 1745, to exhibit drawings at the Salon. Immensely versatile, he executed over 10,000 sheets. These span the gamut, from pretty nudes in a state of post-coital peace to impressions of nature and crisp illustrations for the plays of Molière.

It is not difficult to identify the differences between Boucher's and Tiepolo's work; the former is anxious to lull the viewer with sensuality; the latter tries to carry him into an endless swirl of exalted motion and fantasy. Boucher was never committed to the heroic vision or to divine or transcendental experience. His works are never a refuge for aristocratic religiosity nor are they ironic. Instead, Boucher preferred an attractive, playful, disarming appreciation of the pleasures of the flesh.

However great the differences, there are also striking similarities between Boucher and Tiepolo. Both evince a willingness to portray mythical situations which catered to society's desire for glamorous escapism. Yet neither artist was ever lulled into mistaking the fiction of his work for philosophical assertion. Profundity was boring, and was therefore shunned. Yet in the work of both Boucher and Tiepolo there is a calm assurance—they ventured without nervousness, because they were confident of their power over the world of appearances. They could portray it or reshape it, just as they wished.

In everything done by Boucher, Tiepolo and Watteau, we recognize an underlying discipline which saves it from frivolity. If we compare the turbulent emotion of Rubens with the errotic fantasies of Boucher and Watteau, we see how the art of the Rococo reflects the respect for reason that dominated the thinking of French society during the reign of Louis XV. This reasonableness is an ever-present quality in Rococo art, but nevertheless, was unable to rescue the style from the internal inconsistencies which eventually led to its popular rejection.

In the second half of the eighteenth century the Rococo style in France was rapidly moving toward dissolution. Critics advocating either a Romantic or Neo-Classic revival increased in number, and the demand for a more substantial and socially appropriate art form was frequently expressed. This was an understandable development in a rapidly changing world, and to a degree the Rococo furnished

THE ROCOCO TRADITION IN FRANCE AND ITALY

the ammunition for its critics by creating a level of thematic and stylistic abstraction that was beyond both the tastes and comprehension of the society of the time.

It is precisely this quality of abstraction that makes late Rococo design and draughtsmanship so attractive to the modern eye which is now accustomed to such forms of expression. A paramount example is found in the graphics of Jean-Honoré Fragonard (1732–1806), whose brilliant technique, emphasizing a crisp spontaneity and immediacy, marked him as the preeminent artist of his generation. There is much of Watteau and Boucher in Fragonard's drawings. Yet whereas his two predecessors always injected a modicum of solidity into their work, Fragonard's draughtsmanship is entirely suffused by an airy gossamer-like brightness. His drawings exude a warm and comfortable glow emanating from an especially effective use of space and light. Fragonard's figures are bereft of individual personality, and with increasing frequency his drawings delight in the sheer movement of endless curves, spirals, and arabesques.

Fragonard's atmospheric treatment of light vibrates tantalizingly without the distraction of individual characterization. His work lacks the inherent discipline of Boucher and in certain ways is the immediate precursor of the Romantic challenge to reason and sensibility. People are of less importance to Fragonard than nature. But even in his landscapes a dramatic impression of the flux of environment is more persuasively proclaimed than are the individual components that make up the work's totality.

Fragonard's subjects are always of secondary importance when compared with his desire to focus on erotic stimulation. Whereas Watteau and Boucher always looked for suitable situations, however contrived, to present their idealized fantasies, Fragonard could inject the ecstacy of orgasmic experience into the most unlikely of situations. In his artistic system, individual characterizations are not really necessary precisely because all that one need consider is the attraction of the feminine form, always soft, lithe, and willing. Particulars rather than universals are his stock-in-trade, but unlike his predecessors one is never really sure with Fragonard where fantasy stops and reality begins. It is this blending of the real with the unreal that marks Fragonard as a great romantic idealist, despite the triviality of much of his subject-matter.

It has been said that art has no duty to society other than to be itself. When devoid of social didacticism art is often most inspired and imaginative. But without the protection of this social imprimatur art forms are also objectively vulnerable to criticism. It is not surprising that late eighteenth century moralists marshalled a virulent attack on the methods of the Rococo, once artists like Fragonard carried the style beyond traditional limitations. Those who criticized demanded both clear narrative and moral content—aims not shared by the painters and draughtsmen of the Rococo. Although Fragonard himself refused to alter his approach, society's needs radically changed during the course of his career, and soon those who refused to adapt found themselves out of favor and forgotten.

THE ROCOCO TRADITION IN FRANCE AND ITALY

With their emphasis on pleasure and enjoyment the drawings of the Rococo addressed themselves to one of the most important aspects of the relationship that exists between art and life. However, so artificial did the Rococo eventually become in its pursuit of idealized happiness that counter-movements naturally arose to offer new paradigms to society. The Neo-Classic school preached greater moral discipline, and the Romantic movement advocated an escape into the realms of the imaginary and the introspective. Both modes of interpretation attracted enthusiastic adherents, and as man was carried into the 'modern' era of the nineteenth century, so did the art of drawing expand into new realms of artistic motivation and expression.

THE ROCOCO TRADITION IN FRANCE AND ITALY

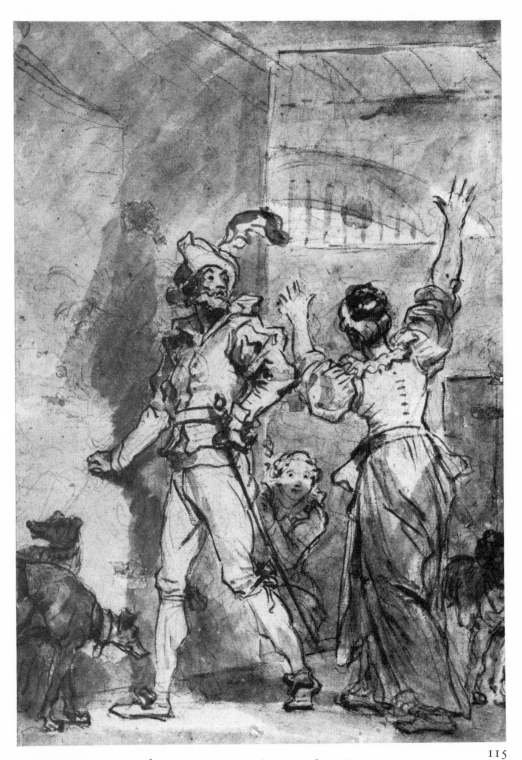

115 JEAN-HONORÉ FRAGONARD b 1732, d 1806
 French (Grasse; Paris; Italy)
 Scene from Don Quixote
 Black chalk, with brown wash.

116 HUBERT ROBERT b 1733, d 1808
 French (Paris; Rome)
 Rome, the Villa Ludovisi, 1764
 Pen and brown ink, with brown wash, and watercolor.

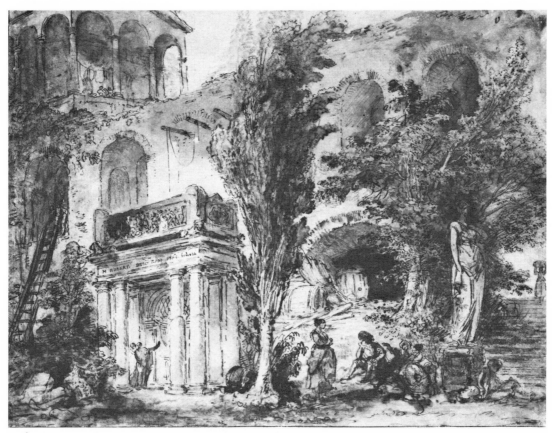

116

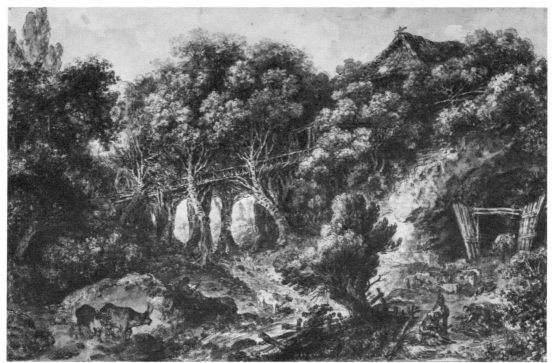

117 JEAN-HONORÉ FRAGONARD b 1732, d 1806
French (Grasse; Paris; Rome)
A Hermitage overlooking a Stream
Pen and ink, with watercolor.

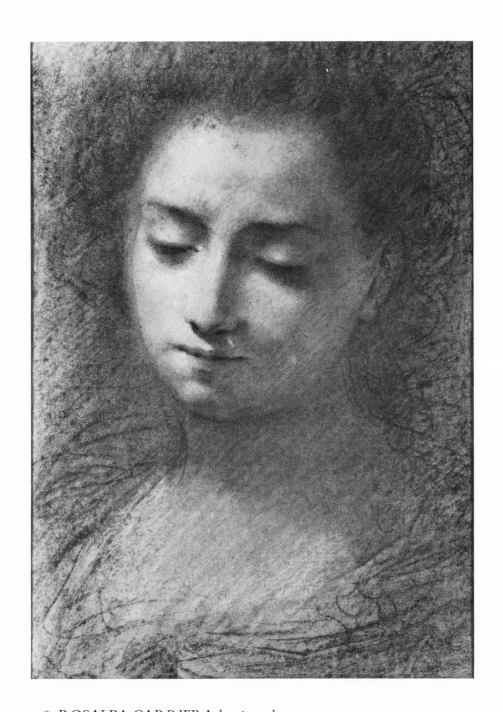

118 ROSALBA CARRIERA b 1675, d 1757
Italian (Venice)
Head of a Young Woman
Black and colored chalks, touched with bodycolor, on blue-grey paper.

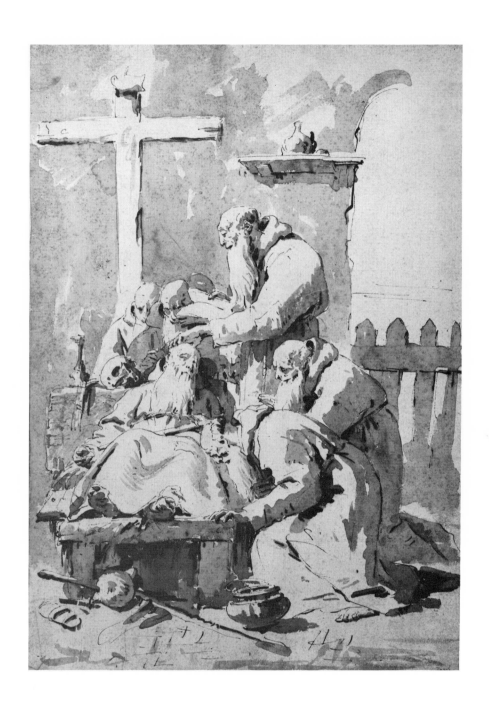

119 GIOVANNI BATTISTA TIEPOLO b 1696, d 1770
Italian (Venice and elsewhere in Italy; Wurzburg; Madrid)
The Death of a Franciscan
Pen and brown ink, with brown wash over black chalk.

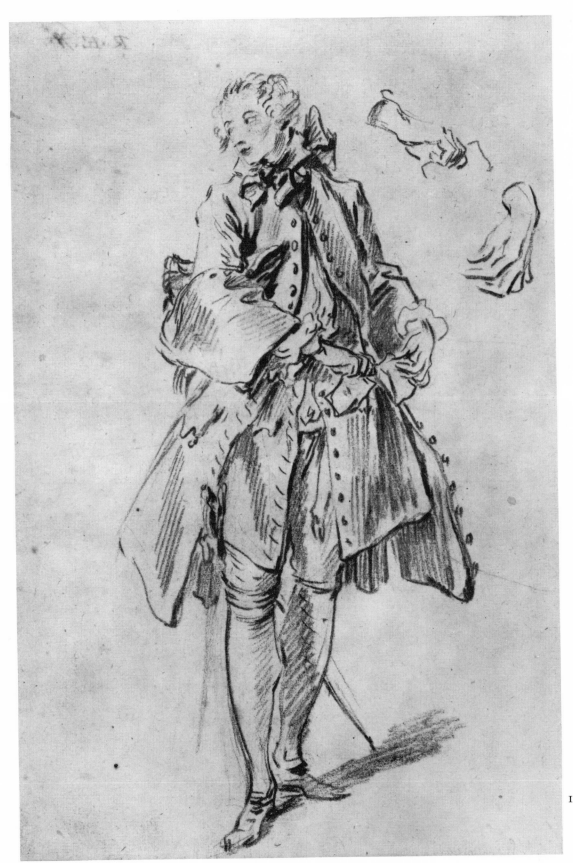

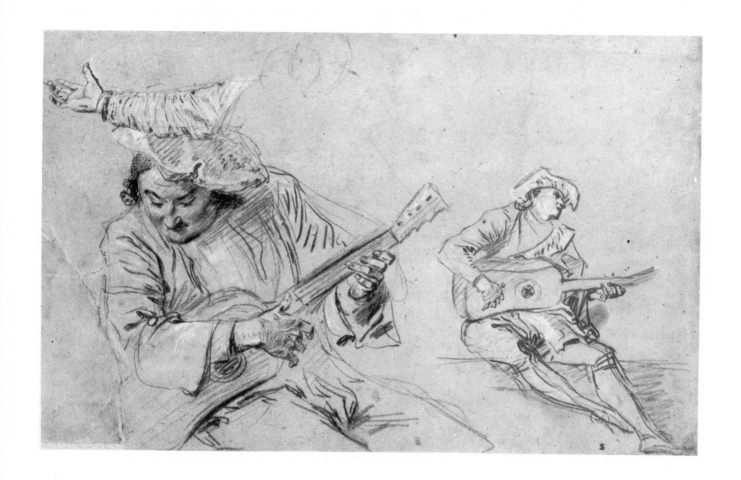

120 FRANCOIS BOUCHER b 1703, d 1770
French (Paris; Italy)
*Study for the Figure of Eraste in Act IV, Sc. III of Molière's
'Le Dépit Amoureux'*, before 1734
Red chalk.

121 JEAN ANTOINE WATTEAU b 1684, d 1721
French (Valenciennes; Paris)
Studies of a Man playing a Guitar
Red, black and white chalks, on brown-toned paper.

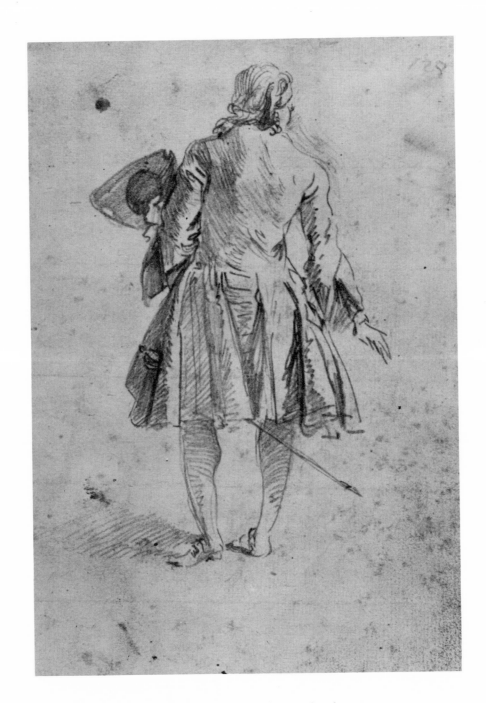

122 GIOVANNI PAOLO PANNINI b 1691/2, d 1765
Italian (Piacenza; Rome)
A Gentleman seen from behind
Red chalk and black chalk.

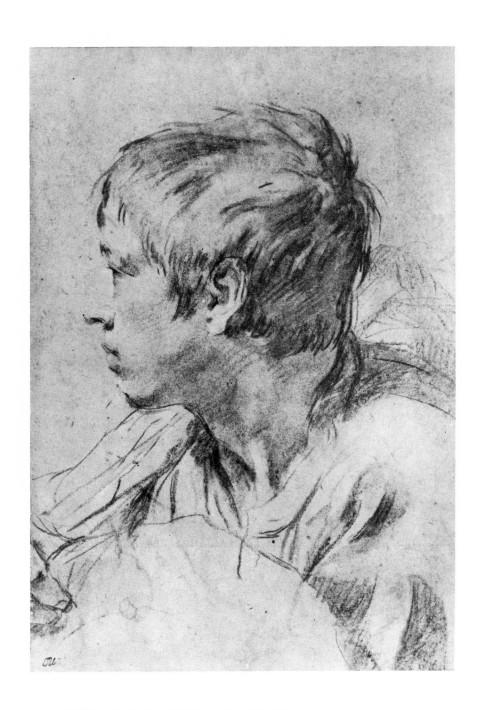

123 GIOVANNI BATTISTA PIAZZETTA b 1682, d 1754
Italian (Venice)
Head of a Youth
Black chalk, touched with white, on grey paper.

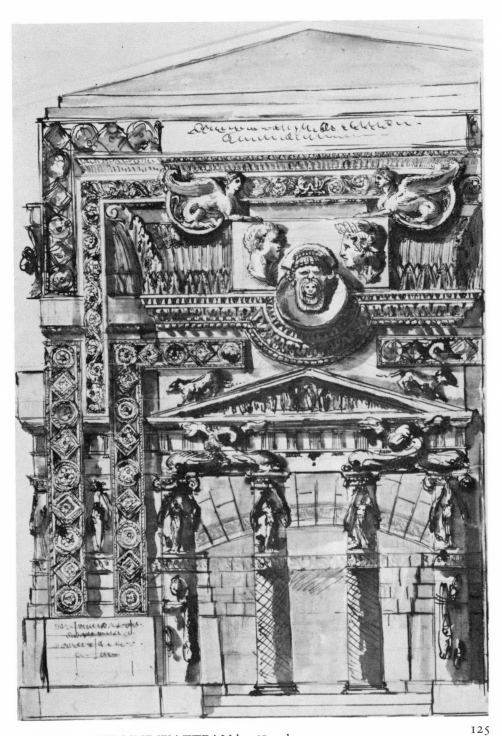

124 JEAN-ANTOINE WATTEAU b 1684, d 1721
French (Valenciennes; Paris)
A Woman at her Toilet
Red, black and white chalks.

125 GIOVANNI BATTISTA PIRANESI b 1720, d 1778
Italian (Venice; Rome)
*Imaginary Elevation composed of various Architectural and
Sculptural Elements, c. 1760 (?)*

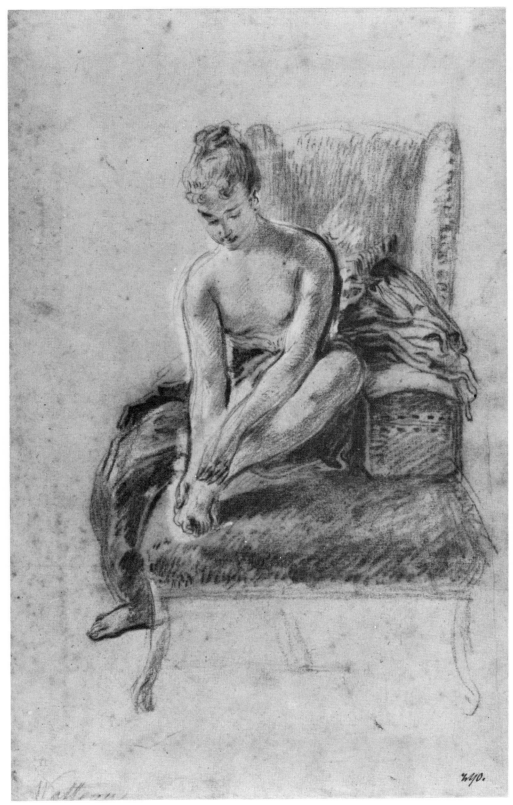

124

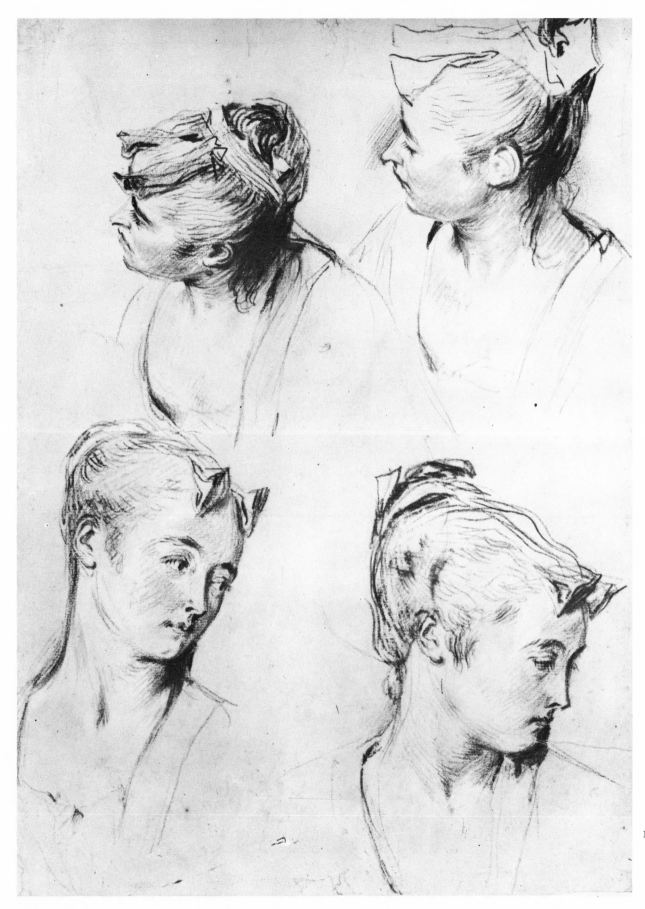

126

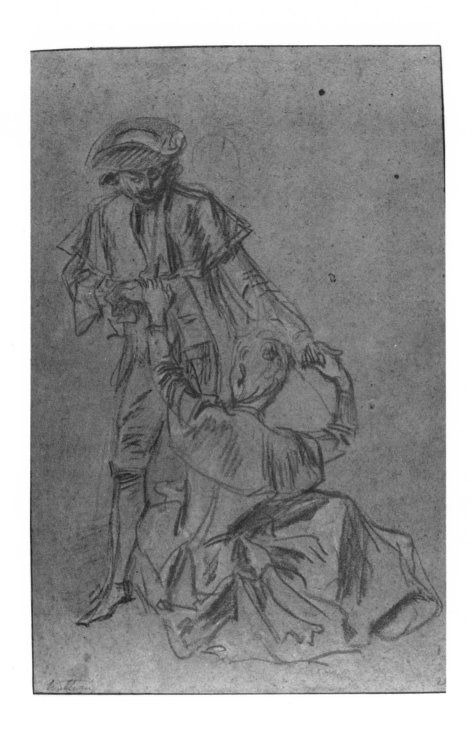

126 JEAN-ANTOINE WATTEAU b 1684, d 1721
 French (Valenciennes; Paris)
 Four Studies of the Head of a Young Woman in Different Poses
 Black, red and white chalks.

127 JEAN-ANTOINE WATTEAU b 1684, d 1721
 French (Valenciennes; Paris)
 Study for two of the principal Figures in 'Le Départ de Cythère'
 Red and black chalks on light brown paper.

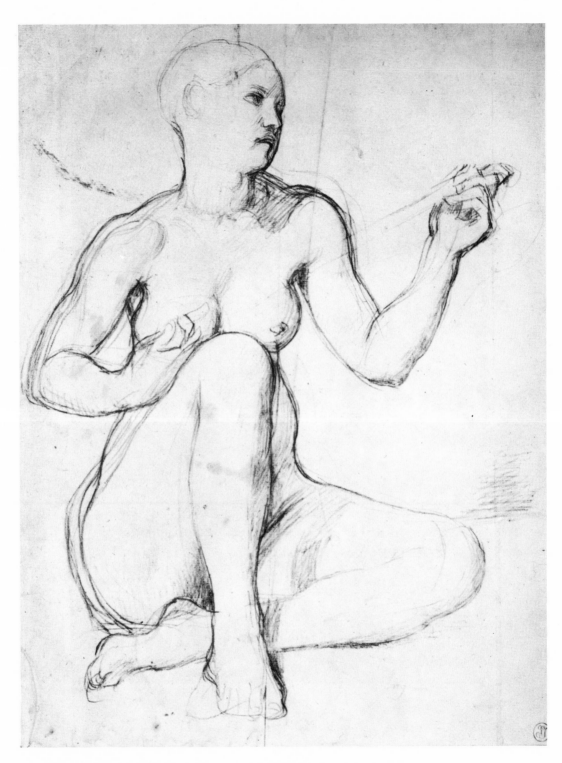

128 JEAN-AUGUSTE-DOMINIQUE INGRES b 1780, d 1867
French (Paris; Italy)
Nude Study, *c* 1839
Black chalk.

9

From the Romantics
to the Pre-Raphaelites

THE ROCOCO WAS STYLISTICALLY INFLUENTIAL in most parts of Europe during the first three-quarters of the eighteenth century, yet by 1750 its demise was already being forecast. Intellectuals, in particular, began to criticize it, while a new philosophy, expressed both in literature and the arts, arose and prospered in Western Europe. The era of the Romantics had begun to dawn.

Romanticism as a literary and artistic movement celebrated the personal triumph of the hero and the majesty and collective strength of the nation. Freedom, power, emotion, and nostalgia—the Romantics worshipped all these. Revolution was in the air as the old bonds that constrained man's creative powers were snapped. The *Ancien Regimes* of Europe were toppled and everywhere there was idealistic enthusiasm for liberty and justice.

Confrontation with the realities of a decadent society were anathema to the Romantic mind. But the ever-present necessity of such an exercise resulted in an introspection which examined the dark, mysterious, and often macabre tendencies in man's hidden nature. The Romantic courted disaster through such analysis, but this quality of adventurousness was not confined simply to an attraction for the exotic. If what was found was not always pleasant, it was at least illuminating and consistent with the honesty of self-appraisal expected of a natural man. Such activity was viewed as a flight *to* reality rather than an avoidance of substantive problems. Consequently, the Romantics found themselves raising serious questions as to just what was real and what was contrived illusion.

The Romantics' artistic deification of nature was essentially a sensuous act which found fullest expression in England and France where the philosophy of nature and the libertarian ideal long held important places in the minds of men.

Romantic sensuousness emphasized intuitive feelings over rationalism. Experience of all that nature contained was now regarded as of pre-eminent importance. Logic and reason were, by comparison, shallow and confining.

Romanticism, however dynamic, was not the only contender for pride of place as a successor to the Rococo. A strong Neo-Classic movement also arose during the last half of the eighteenth century, and while many have viewed it as an opposing and altogether hostile doctrine to the Romantic creed, there are common bonds between the two movements which reinforced the strength of each as time progressed. Both movements attempted to satisfy the public's desire for a return to the grand achievements of antiquity, and as such both found a common origin in the work of Giovanni Battista Piranesi whose engravings as early as the late 1740's evinced the ideals of both movements.

Piranesi believed firmly that his Romantic and Neo-Classic solutions were the answer to the confusion of the Rococo. He invented a style which was dominated by the themes of antiquity. It achieved its impact through a nostalgic celebration of the grandeur and might of classical architecture. Piranesi was fascinated by the emotion architecture conveys especially when it is in ruin. But at the same time he appreciated that this celebration had to have its own internal consistencies and that mere topography, however orthodox, could not completely satisfy contemporary artistic needs.

In essence, the Neo-Classic and Romantic movements were allied in their joint rejection of the world as created by the masters of the Rococo. Though each had its own answers and formulae for a new universal system, there was common agreement between the two that radical changes were necessary if man was to be liberated from the artistic decadence of his artificial environment.

Many artists of the late eighteenth and early nineteenth centuries painted and drew in both Romantic and Neo-Classical styles, but in the end it was Romanticism that emerged triumphant as the escapist desire of men overcame their need simply to clean up the Rococo. It was not merely a case of new themes for the Romantic content of a work of art was not determined simply by subject matter. Similar themes had appeared countless times throughout the entire history of art. Rather it was the emphasis of a new relationship between the artist and his subject which separated the Romantic movement from other periods. During this epoch the artist undertook to get inside his subjects and probe to the heart of their essential being. He was not just interested in the physical structure of objects or landscapes. Instead, he was fascinated by the psychological and emotive qualities conveyed by such objects to his senses. Indeed, so close was the Romantic artist's sympathy with the literary themes of his time—to Byron, Scott, and the pseudo-legendary Ossian —that the pictures and drawings of the era acquired a poetic content heretofore never seriously appreciated by the critical eye.

The Romantic style was essentially Baroque in thrust. Movement of all types was accepted as a by-product of natural phenomena. No contrast of light and color

was considered too extreme if the drama of movement could be captured with optimal clarity. Because of this sense of drama in Romantic art, one is constantly confronted with fantastical constructions wherein the unusual or the ingenious are valued for their own sake as well as for the effect they create. There is an uncontrollable energy in such work. Man is rarely at peace with his environment and there is little that could be called perfection in the totality of the artist's vision. On the contrary, the deformed, the ugly, and the freakish are either the constant companions of the observer, or else one is thrust into a sublime landscape where the quest for eternal perfection remains an unanswered question. In short, the Romantic movement operated vigorously at both ends of the emotional scale and rarely does the work of art exist in a state of unselfconscious equilibrium.

In France, the Romantic movement was initially associated with the iconoclastic political fervor of the French Revolution. The art of both David and Gros was noticeably propagandistic, and at the same time idealized the hero and in so doing provided an essential link with the mannerist art of the late Renaissance that was to last substantively until the era of the Impressionists.

The art of the early Romantics was still tied to its time, regardless of theme, in that it was primarily a State controlled art. Those qualities of individuality and liberty with which the movement is generally associated are found much more clearly in the drawings and paintings of succeeding generations, most particularly in the work of Géricault and Delacroix.

The importance of Romantic drawing and painting lies initially in its own aggressive self-respect. Middle class society in France had become so demoralized in the aftermath of the Napoleonic debacle that works of grandiloquent historical content were no longer required of artists as a passport to respectability. Jean-Louis Géricault (1791–1824), who died prematurely at the age of thirty-three, was the first of his generation to assert the equality of his kind of painting and drawing with the varieties that were already accorded recognition by the official arbiters of taste in the Academy.

In his drawings, which are particularly revelatory of his emotional attitudes, Géricault begins with precise naturalistic studies but after a few initial strokes he tends to monumentalize and enlarge the scale of visual perceptions. Géricault was fascinated by the movement of horses. They were magic Valkyrean steeds and appeared frequently in all types of his work. The desolate plight of madmen was also a theme he returned to repeatedly. He was attracted to all that was hideous and sinister and found ample subject matter for his art in the poor house and on the guillotine. Géricault's was the darker side of Romanticism and his work stands as an example of expansive imagination raised to almost visionary heights. In his pursuit of such 'truths' Géricault achieved one of the prime ambitions of the Romantics—a transition from naturalistic classicism to a more flexible description of nature. In this he, like his illustrious compatriot, Eugène Delacroix, paved the way for the Impressionists of the 1860's and 1870's, and if there were no other reason to

remember Géricault this fact alone would entitle him to a place in the annals of the history of modern art.

Like Géricault, there is much in the freely expressed draughtsmanship of Eugène Delacroix (1798–1863) that challenged academicism and rejected the constraints of formulaic interpretation. It was natural that Delacroix should be an intense admirer of the poetry of Byron and the music of Berlioz. All the Romantic creative arts celebrated the struggle of heroic idealism against impossible odds, and in the graphic work of Delacroix the Romantic movement witnessed statements of great power and majesty. His drawings almost always have a frenzied speed about them. Yet despite their frenetic character they also possess an intense concentration on spatial relationships. This is most clearly seen in his use of curves. These, mingled in rhythmic intertwining patterns, tend to culminate in a central thrust of movement which leads the eye to some dramatic climax.

It was not until he adopted the technique of Rubens that Delacroix fully achieved his potential. In the work of that great master, emphasizing as it did the use of significant line, Delacroix found a suitable ideal for emulation. Rubens rejected descriptive linear constructions in favor of loose and freely suggested forms. Delacroix absorbed this method entirely and in his late drawings, which exhibit rough and abrupt strokes that convey a sense of violence unknown in the academic art of the period, one never encounters objects but rather the suggestion or effect of objects. Delacroix sought to portray the particular form or nature of an object without narrow literalism, and once this goal was achieved he felt no higher ideal could ever be artistically realized.

No graphic medium was foreign to Delacroix's hand. Anything that could convey his intense desire to create a whirlwind of movement was employed. It has been argued that Delacroix transformed and generally revolutionized the art of drawing by establishing methods and goals that were to inspire most succeeding generations of draughtsmen. The grandioseness of such a claim is of course debatable, but few can doubt that Delacroix's work was the artistic quintescence of the French Romantic movement, and in his drawings one observes the anticipation of the reunion of man with his environment which was the inarticulated goal of the age. One also notes the degree to which his drawings foreshadow those of the Impressionists.

It has been pointed out that the French Romantic movement was initially nurtured on the enthusiasm resulting from the destruction of the *Ancien Regime*. This revolutionary fervor received a subsequent boost in the coup of 1848 which brought Napoleon III to power and produced as offspring those Romantic artists who became known as Realists. They advanced further in the quest for 'actuality' in art and only the most contemporary of themes were considered suitable by them for interpretation. It was a favorable time for the birth of the popular caricature. Honoré Daumier (1808–1879) was one of the chief satirists of the day in the French press, and his drawings possess not only an acute plasticity but also a powerful

ability to synthesize all that was socially significant. His grasp of the realities of French society was unrivalled.

Daumier had a profound appreciation of the positive effect of sculptured mass and corporeal presence. It has been argued that he is the most baroque of all nineteenth century draughtsmen. One never finds hard edges in Daumier's drawings. Instead soft contours blend; blurred strokes are universally employed; space, form, and mass combine into a fused whole, which in turn is set into motion through the intense interaction of its components. Daumier was not a genuine naturalist like Géricault. He almost invariably drew from memory, and with his pencil, pen, and wash he created a vast array of splendid commentaries all of which bore the common stamp of a search for artistic truth in realistic assessment.

Jean Baptiste Corot (1796–1875) was also a leading exponent of the Realist school. There is a certain primitive quality in Corot's drawings. Yet their graphic simplicity and sensitivity expresses a sense of form more acute than that of any other artist of the period. Corot was fascinated by the question of time and the problem of capturing precise moments. The ethereal appealed strongly to him and in many ways he stands as a link between the style of Watteau's Rococo and the gossamer-like impressions of Monet and Sisley.

Romantic Realism sought to create a new world. It was unmistakably a political art form as David's had been in earlier years. But to the Realists it was the people as a whole who were heroic. Individual freedom did not necessarily mean demagogic idolatry, and in Realist drawings both subject and technique took revolutionary steps in the reformation of artistic attitudes.

French Romantic drawing is naturally identified with spontaneous expressiveness and rapid movement of line. But there is another side to the movement that should not be ignored. Many art historians would not use the term Romantic when discussing the formal linearity found in the draughtsmanship of Jean-August Ingres (1780–1867) for to do so appears to stretch a point. Yet in certain ways Ingres' work can be considered Romantic. For him line was everything. It was endowed with a spiritual quality. This attitude placed Ingres close to the traditions of the German Nazarenes and the English Pre-Raphaelites. And while it is true that an attachment to line in its purest form is technically anti-Romantic, because line is something which does not exist in nature, still Ingres comes within the Romantic fold due to his personal quest for absolute artistic truth in his graphic expressions. Ingres' fascination with the exotic was also a Romantic characteristic as was his frequent indulgence in sentimental nostalgia and sensuality. This side of Ingres' drawing was always in conflict with his attraction to the formal classicism of David, Ingres' declared model, and we are always aware of the contradiction this produced in Ingres' own work.

It seems that both the Romantics and the Neo-Classicists strove for truth in different ways. The severity of the latter style, as frequently expressed in Ingres' drawings, relied on the tension of unreleased emotion rather than the spontaneous

explosions so often found in Géricault and Delacroix. This inner tension conveyed by Ingres' crisply uncompromising pencil injected a touch of intellectuality into Romantic drawings that was almost absent in other artists of the movement whose work was so clearly dominated by overt appeals to the senses.

While the Romantics flourished and extended their influence throughout French art in the first half of the nineteenth century, the movement was also making its impact felt in other parts of Europe. In Spain Francisco Goya, once the country's chief exponent of court Rococo art, dramatically adopted Romanticism after losing his hearing due to illness in 1792/3. Without the ability to hear Goya lost much of the joy of life so evident in his Rococo work. But his powers of observation quickened as if to compensate for the loss, and in his late *caprichos* and *invenciones* he conjured up imaginary images so grotesque and tragic that they make him the quintessential Spanish Romantic.

Goya retreated into physical as well as spiritual isolation and the artistic by-product of his introversion was a new and highly cynical analysis of the hidden truths contained in man's soul. Goya looked deep into the recesses of human consciousness and was both frightened and sickened by what he found. Yet he was compelled to devote his artistic energy to exposing these malign traits, as if through the act of exposure he achieved some sort of mental purgation or catharsis. Goya's drawings are not overtly satirical as are those of Daumier and Rowlandson. Instead they represent an active search for the essentials of human existence whatever the consequences. In the cynicism of Goya's drawing there is an expression of the belief that the veneer of man's civilization is so thin that whenever the fundamental values of the existing order are seriously questioned violence and chaos are the inevitable results.

Nothing was too hideous or tragic for Goya to draw. No figure was too deformed or grotesque. No act was too cruel to escape his pen. Even the unthinkable, such as the God Saturn devouring his children was considered fit for artistic expression.

In the silent prison of his country house, Goya created thousands of such images and with each passing day he retreated further and further into darkness. His visions were expressed in his drawings which obviously were executed at top speed, without superfluous detail or decoration. Goya's linework, whether in pen or brush, is always highly expressive even at its most disturbing. There are no melodious rhythms of continuing contour in his mature graphic work. The observer is never lulled into a sense of relaxed observation for nothing is taken for granted. All is excited inspiration and tension, and this is emphasized in Goya's refusal to employ more than two media on the same sheet of paper. Polychrome drawings by the master are almost unknown, and only the essentials of light and darkness, accentuated by occasional washes, are left to play on the viewer's mind.

In essence, Goya's disturbed Romantic vision of the relationship of man to his environment represents another dark side of the movement. But this aspect of

the Romantic style was of the greatest importance and was to influence directly a number of artists particularly those attached to the English school.

When one speaks of the foundation of the English Romantic movement it must be remembered that active political revolution did not play a direct role as it did in France and Spain. English Romanticism was certainly born out of protest and dissidence, but the sources of its discontent were more abstract, and emanated from emotional reactions to the disappearance of peasant life and folk culture; from the continuous threat to the land by urban industrialization; from the decline of living standards in the nation's cities.

The movement initially divided into two groups: those who found in landscape and nature an ultimate source of inspiration, poetic content, and truth; and those who moved instead toward an investigation and celebration of the irrational, the supernatural, and the introvertedly psychological.

This latter group of artists formed around the person of William Blake (1757–1827) whose visionary influence still rates an important place in modern thought. Blake stands at the center of the world of mystical art in England but there were others such as the Swiss-born Henry Fuseli, John Flaxman, and George Romney (best known for his slick theatrical portraits in oil) whose drawings are similar to Blake's in subject matter, but who remained independent in their stylistic approach. However, it was Blake who posed the central question of how creative imagination could be reconciled with an exact study of nature, and when he claimed the world of imagination as the world of eternity Blake clearly defined the fundamental aspect of his work.

William Blake was a profoundly religious man. He made a devout study of not only the Bible but also the works of Dante, Milton, Boehme, and Swedenborg. His imagination flew toward the gates of the occult and his joys were manifested in worlds and kingdoms unknown to other men. Blake was never aware that his work was a flight from reality. As far as he was concerned his work represented the only reality that existed. The corrupting influence of the material world was a fantasy in his view, for it was not of God and should not be of man. Only spiritual reality was eternal in Blake's world and this reality could only be found in the shining visionary experience of ecstatic joy which is a major theme of his graphic work.

In this sense Blake is completely separated from the other Romantic artists of his generation. He was not at all concerned with the disputes of rival styles, the overthrow of eighteenth century motifs, or the establishment of new aesthetic doctrines. Instead, Blake's art was a personal statement of his commitment to the universality of God's imperium which he saw as the only possible road for the salvation of the collective and individual souls of mankind. For the final generation of the Romantics, the Pre-Raphaelites, who looked back nostalgically to the mysteries of medieval faith, there was only Blake's art as an intermediate signpost to the source of their inspiration. Retrospectively, they gave him an important place in the Romantic tradition.

In Blake's draughtsmanship there is a graphic purity which is unaffected by the variety of myths and stories he chose as subject matter. In his illustrations for the *Book of Job*, Dante, Grey's poems, or *Paradise Lost*, Blake presents endless examples of figurative movement which are so animated that they offset the occasional hint of coldness in his style. There is a constant interplay of elongated curves in Blake's compositions. His forms undulate rhythmically and his consistent use of symmetry and repeated bold strokes generates an excitement that reaches its climax when it combines with the vitality of his colors which range across the whole of the spectrum.

As with many Romantic artists Blake relies heavily on movement to convey idea. Fire, wind, and smoke swirl in endless permutations. Natural phenomena and natural creatures are seen as no one has seen them before. In the contrast between heavily muscled nudes reminiscent of Michelangelo and the long etherially evanescent creatures taken from Gothic sculpture, Blake finds a kind of dualism that is also evident in his literary work, where he contrasts the forces of the body with the forces of the spirit.

Blake's draughtsmanship is not flawless. He was such a convinced individualist that he had a tendency to exaggerate. Yet, despite technical shortcomings, there was more than enough magnetism in Blake's personality to draw around him a circle of disciples who show strong traces of his influence in their own graphic expressions. In the work of Blake's circle—John Varley, George Richmond, Frederick Tatham, Edward Calvert, John Linnell, and Samuel Palmer, there was an aesthetic and emotional brotherhood that anticipated the Pre-Raphaelites. But unlike the Pre-Raphaelites only one of Blake's circle was to produce significant and profound works of graphic art. Samuel Palmer so worshipped Blake that he almost became the master's alter ego. For him, as for Blake, there was a magical quality in all things. Likewise, there was much in the literary themes of Milton and Spencer that captivated Palmer's imagination. His world was a visionary one but his subjects were the familiar landscapes of Dulwich and the Shoreham Valley. Palmer's drawings move on the other side of natural reality, and the technique of Blake that he most clearly absorbed was the ability to depict natural scenes in a manner wholly unlike anything that conformed to the visual experience of ordinary men. Yet at the same time, Palmer transports the spectator into a serene atmosphere in which the harmony of creation can be perceived more clearly. To widen the boundaries of perception was a fundamental goal of the graphic art of the visionary English Romantics, and this quality alone helps to explain why their work is so acceptable to the modern eye which is constantly in search of new and unusual visual experiences.

The other side of the English Romantic movement was just as anxious to produce works of strong visual impact. But the visionary element so endemic to Blake and his circle was replaced by this group with a fragile, transparent naturalism that found in landscape a prime source of inspiration. Watercolor drawings as a medium were carried to their greatest perfection by the English Romantics for they

found them to be unpretentious yet harmoniously direct in impact. Watercolor as a technique was preferred because it was easy and quick to master, yet at the same time contained the potential to endow any scene with the subtlest nuances of color, shade, and light.

The English landscape as portrayed in watercolor does speak directly of the mystical bond that existed between Romantic artists and nature. And perhaps it is this essential bond that provided such ties as existed between all segments of the English Romantic movement. The union of emotion and intellect did not prevent the realistic depiction of nature. Indeed it could be argued that landscape for the English Romantic was less a state of mind than it had been for the masters of the French Rococo. The difference really lay in the Romantic tendency to see and perceive things in an entirely new way based on a heightening of awareness foreign both to French eighteenth century sensibilities, and to the French habit of constructing landscapes in the studio, removed from the actual source of inspiration.

The acceptance of the landscape as a legitimate area of artistic production was not easily accomplished. Sir Joshua Reynolds, first President of the Royal Academy, whose canons of painting were promulgated in his *Discourses* (1769–1791), made it clear that landscape because it lacked the essential quality of human presence must be ranked well below history painting, genre scenes, and even portraiture. Reynolds considered the landscape of marginally greater importance than still-life or studies of flora, but without man he felt it could never achieve great distinction. During Reynolds' command of the English artistic world, both in and out of the Royal Academy, few artists had the courage to devote much attention to landscape. Perhaps the most outstanding exception can be found in the drawings of Thomas Gainsborough, but these were rarely translated into major public works in oil.

The Romantic artists who succeeded Reynolds rejected his views on landscape. Their enthusiasm reflected the increasing scientific interest in nature which in the seventeenth and eighteenth centuries manifested itself first in philosophy, then in literature, and lastly, in the Romantic era, in the blending of science and art in painting and drawing. Nature was entitled to artistic representation in and for itself. So strong was this new attraction to a study of sky, water, wind, land, and color that Romantic enthusiasm often produced distinct variations of approach which united realism and naturalism under the common umbrella of subject theme.

In England, the landscape draughtsman relied increasingly, as has been noted, on the creation of optical sensations through the use of transparent shades. These hues were devoid of contour and suggested form; mass and shape were treated in such a way that the work became almost abstract. There is, nevertheless, even in the absence of line, a precise control of tone that conveys reality to the spectator. Thus, with the greatest watercolorists, such as J. M. W. Turner (1775–1851), John Constable (1776–1837), Thomas Girtin (1775–1851), and John Sell Cotman (1782–1842), one finds a manipulation of light, shade, mass, and proportion, so as to suggest

in a wide variety of ways all the tangible and intangible components of nature's kingdom.

Girtin, Cotman, and Constable were all dead when the last of the Romantic English movements emerged in the nineteenth century. Only Turner was briefly alive to see the work of the Pre-Raphaelite brotherhood which was formed in 1848. It was a movement which deserved the name 'Romantic' because of its desire to escape from its own time to an imaginary situation where artistic creativity might achieve greater fulfilment. The Pre-Raphaelite mind found solace in a time and country which were not its own. Italy of the early Renaissance became the adopted homeland of the movement in its nostalgic artistic revolt against academic painting, industrialization, and the materialism of the Nation State. It was an art of poetry and innocent sensuality, highly didactic and moralizing in tone, yet at the same time attached, as Blake had been, to the mystical and the hermetic.

Strictly speaking the Pre-Raphaelite movement only lasted from 1848 when it was founded by William Holman Hunt (1827–1910) and John Everett Millais (1829–1896), until the dissolution of Rossetti's Oxford Pre-Raphaelite circle in 1863. However, the term has become generally associated with all that art produced in England during the second half of the nineteenth century which evinced strong attraction to medieval symbolism and literary content.

The Pre-Raphaelites were initially subjected to much public criticism of their work. They owed much to the defense of their work undertaken by Ruskin, the leading critic of the time. Gradually the movement entrenched itself in popular taste and it might be argued that it was this very last phase of Romanticism that achieved greatest universal popularity among the public.

Looking back one can see a firm belief in all the Romantic schools in the legitimacy of ideal types. Artists and draughtsmen could celebrate their humanism by elevating their craft above all others. This tended to act as an excuse for whatever excesses or errors they might commit, and challenged the world to accept their doctrines of liberation and personal freedom. It was the Romantic artist who perpetuated the creed of the Enlightenment into the nineteenth century. This was the bond that tied Goya to Delacroix to Constable to Corot to Turner and Daumier. Visionary raptures of the occult and supernatural, together with an attraction to the exotic and foreign were all generally related to eighteenth century conceptions of the universality of reason. And however much Romantic artists sought to escape, creatively and technically, into the hidden dimensions of pure sense perception, something always held them back, even by the narrowest of strands, as a rational assertion of their humanity and a constant reminder of the time in which they lived.

Romantic drawing has never really disappeared. There are still distinguished practitioners of the movement alive today, though few would label themselves as Romantics. Yet so long as man has the impulse to blend reality with visions of other worlds, there will be a place for the Romantic among those who practice the graphic arts, particularly the art of drawing.

FROM THE ROMANTICS TO THE PRE-RAPHAELITES

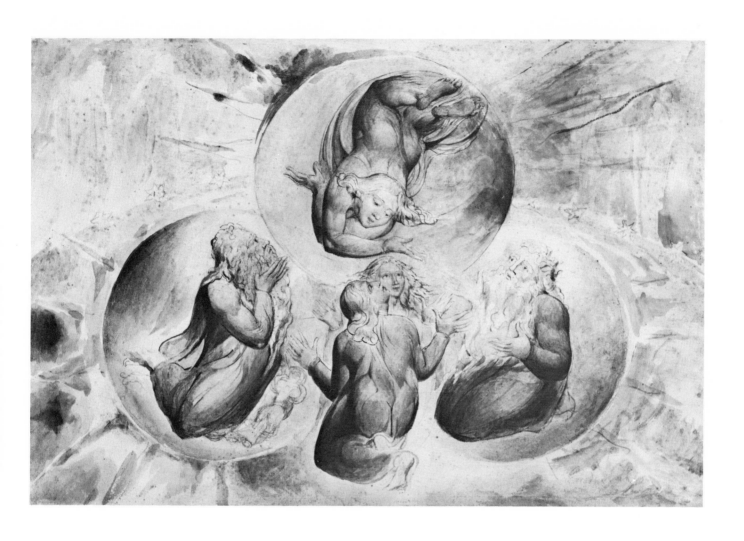

129 WILLIAM BLAKE b 1757, d 1827
English (London)
St Peter, St Thomas, Beatrice and Dante, with St John descending
Pen and ink, with watercolor.

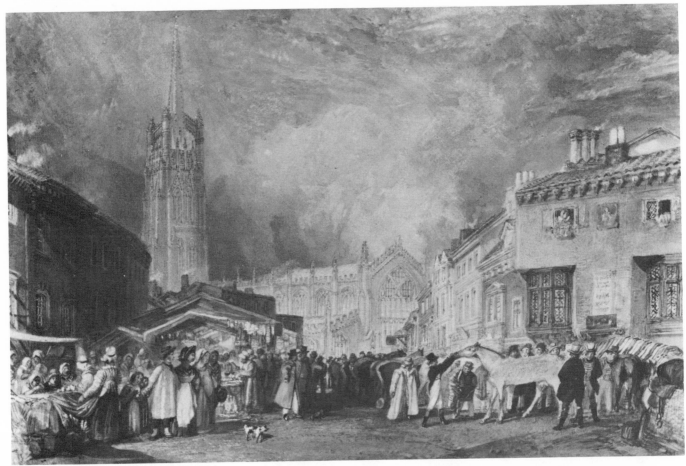

130

131

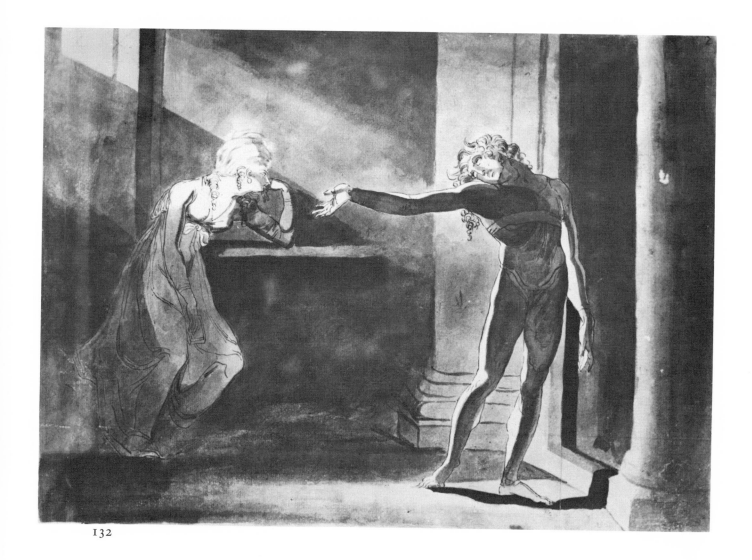

132

130 JOSEPH MALLORD WILLIAM TURNER b 1775, d 1851
English (London; England; Scotland; Wales; and the Continent)
Louth, Lincolnshire, the Horse Fair, before 1829
Watercolor.

131 JOSEPH MALLORD WILLIAM TURNER b 1775, d 1851
English (London; England; Scotland; Wales; and the Continent)
Paestum in a Storm, after c 1830
Watercolor over black lead.

132 HENRY (JOHANN HEINRICH) FUSELI (FÜSSLI) b 1741, d 1825
Swiss (Zurich; Rome; London)
Hamlet and Ophelia, 1770–1778
Pen and ink, with washes of grey and rose.

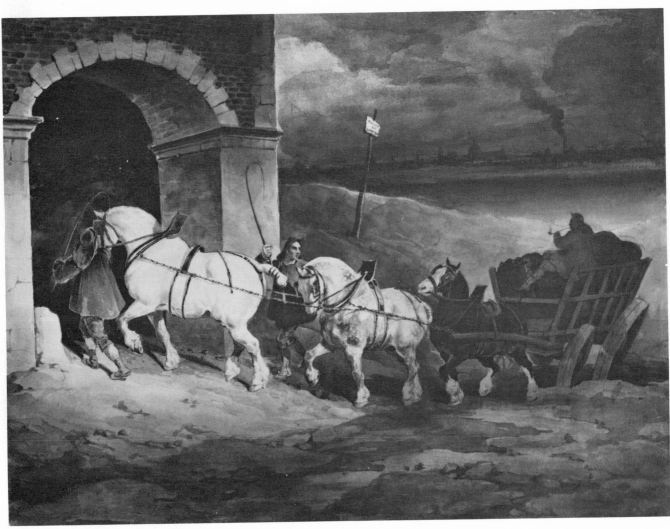

133

133 JEAN-LOUIS-ANDRÉ-THÉODORE GÉRICAULT b 1791, d 1824
French (Paris; Italy; England)
The Coal Wagon, c 1820–1821
Watercolor over black chalk.

134 SIR THOMAS LAWRENCE b 1769, d 1830
English (London; Rome)
Portrait of the Countess Rozalie Rzewuska
Black chalk and stump, touched with red chalk.

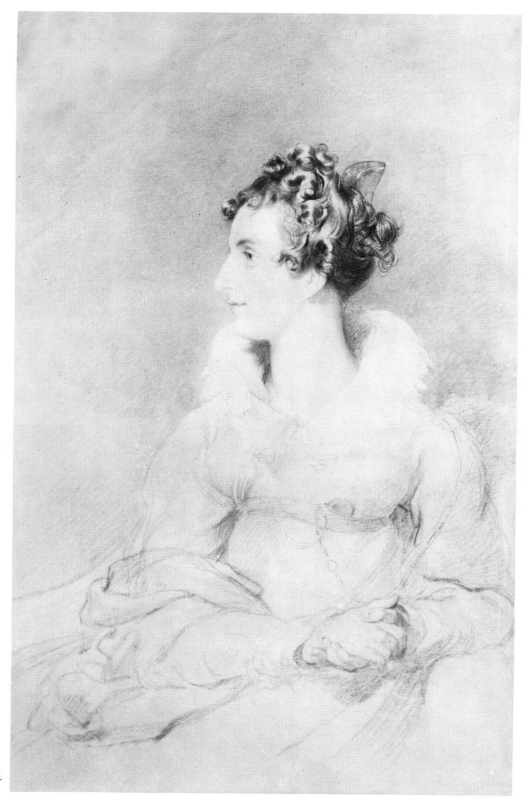

134

135 JOSEPH MALLORD WILLIAM TURNER b 1775, d 1851
English (London; England; Scotland; Wales; and the Continent)
A Sea Shore
Watercolor.

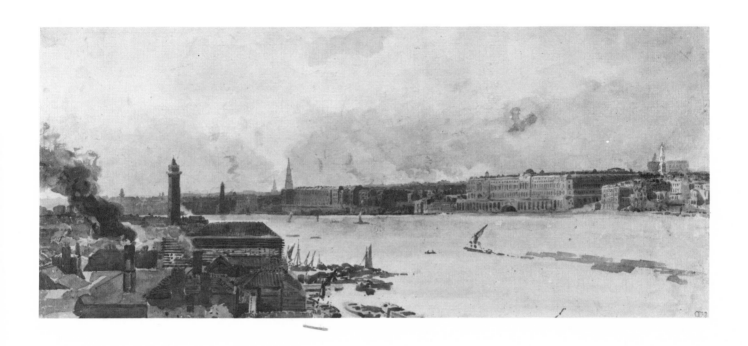

136　THOMAS GIRTIN b 1775, d 1802
English (London; Paris)
The Thames, from Westminster to Somerset House c 1797–8
Watercolor.

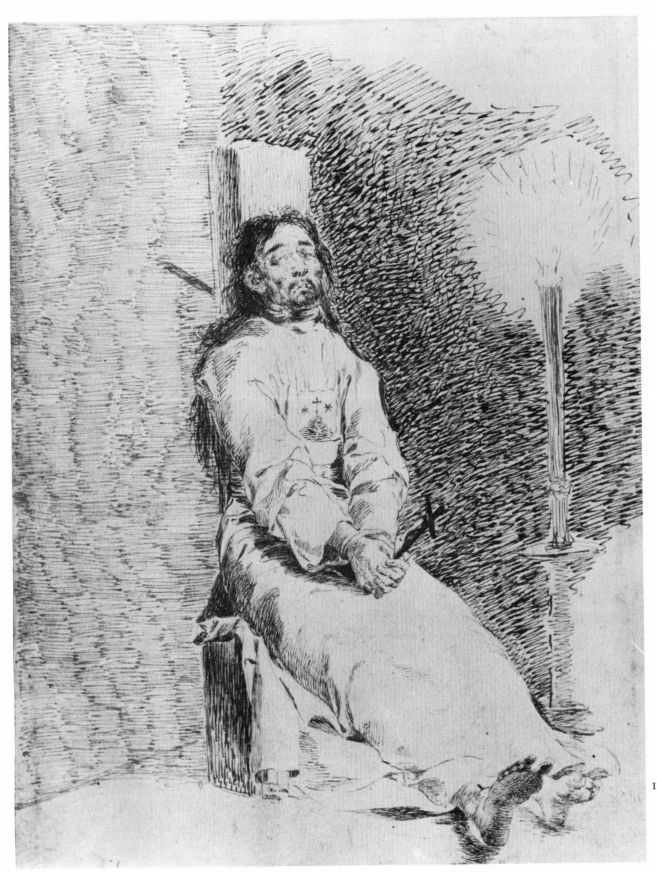

137

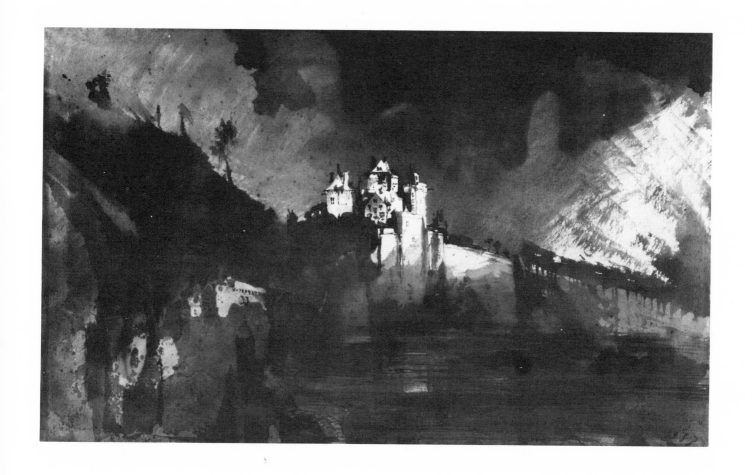

137 FRANCISCO JOSÉ DE GOYA Y LUCIENTES b 1746, d 1828
Spanish (Madrid; Italy; Bordeaux)
The Garrotted Man, c 1778–80
Pen and brown ink.

138 VICTOR-MARIE HUGO b 1802, d 1885
French (Besancon; Paris; Spain; Germany; England; Guernsey)
A Castle above a Lake
Brush drawing in brown wash.

139 JOHN CONSTABLE b 1776, d 1837
English (Suffolk; London)
Hampstead Heath in a Storm
Watercolor (OVERLEAF).

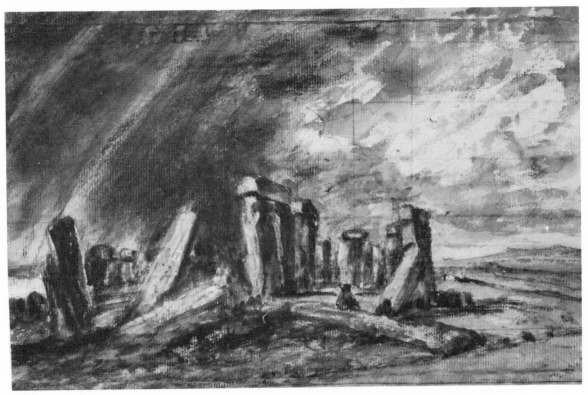

140

140 JOHN CONSTABLE b 1776, d 1837
 English (Suffolk; London)
 Stonehenge, before 1835
 Watercolor over black chalk.

141 JEAN-AUGUSTE DOMINIQUE-INGRES b 1780, d 1867
 French (Paris; Italy)
 Sir John Hay, 6th Bart, and his Sister, Mary Hay, 1816
 Black lead.

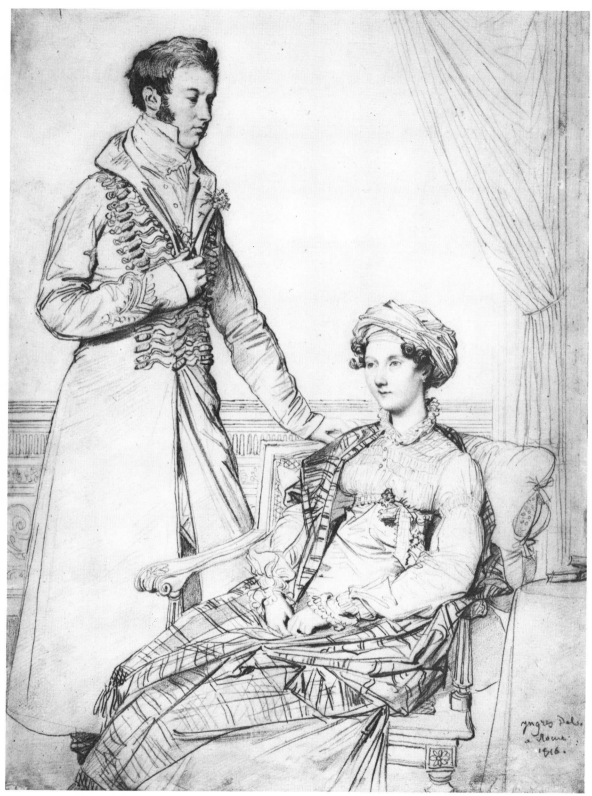

141

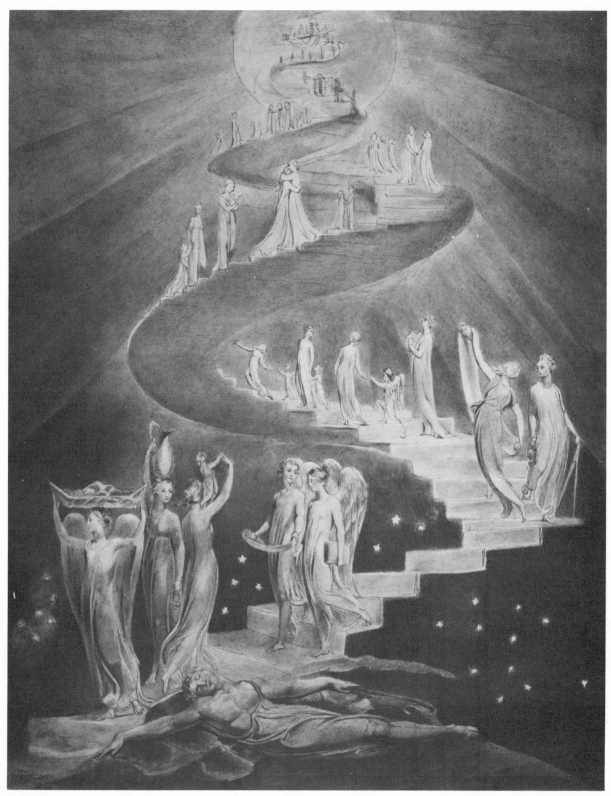

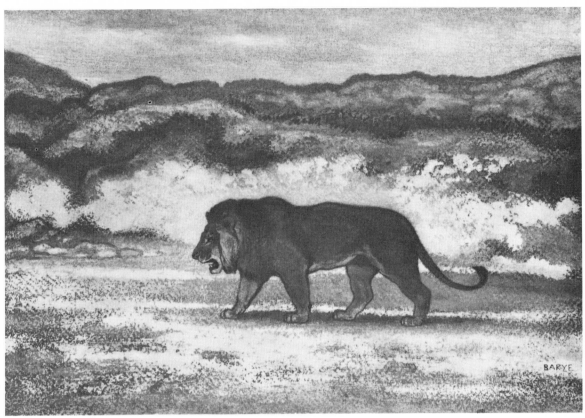

143

142 WILLIAM BLAKE b 1757, d 1827
 English (London)
 Jacob's Ladder
 Pen and ink, with watercolor.

143 ANTOINE-LOUIS BARYE b 1796, d 1875
 French (Paris)
 Lion on the Prowl
 Watercolor and bodycolor, heightened with gum arabic,
 the surface of the paper scraped away in the center.

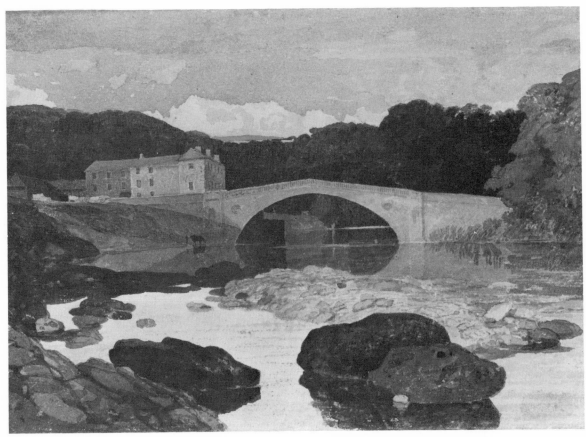

144

144 JOHN SELL COTMAN b 1782, d 1842
English (Norwich; London; Normandy)
Greta Bridge, c 1805
Watercolor.

145 FERDINAND-VICTOR-EUGÉNE DELACROIX b 1798, d 1863
French (Paris; England; North Africa)
Studies of a Seated Arab, c 1832
Black and red chalk, with watercolor, heightened with white,
on brown–grey paper.

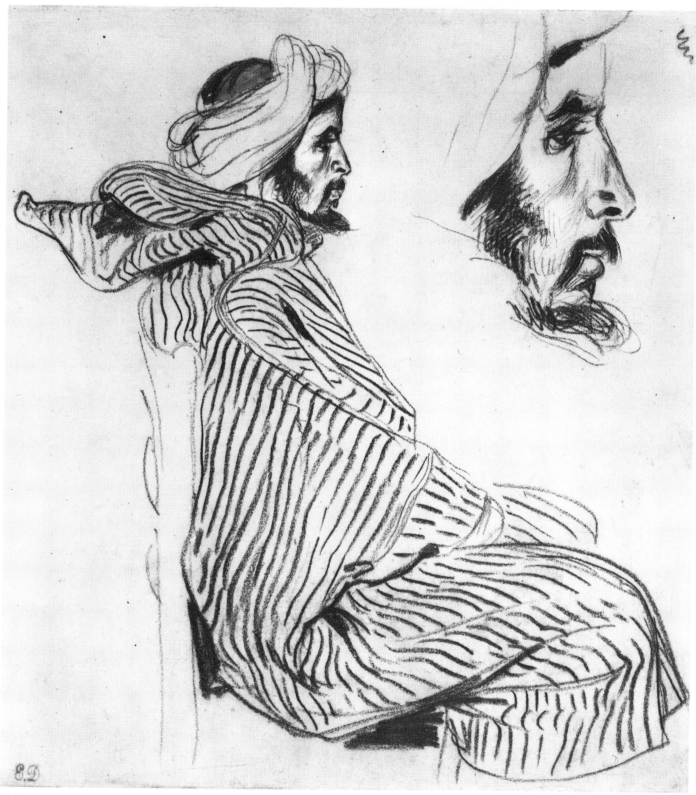

145

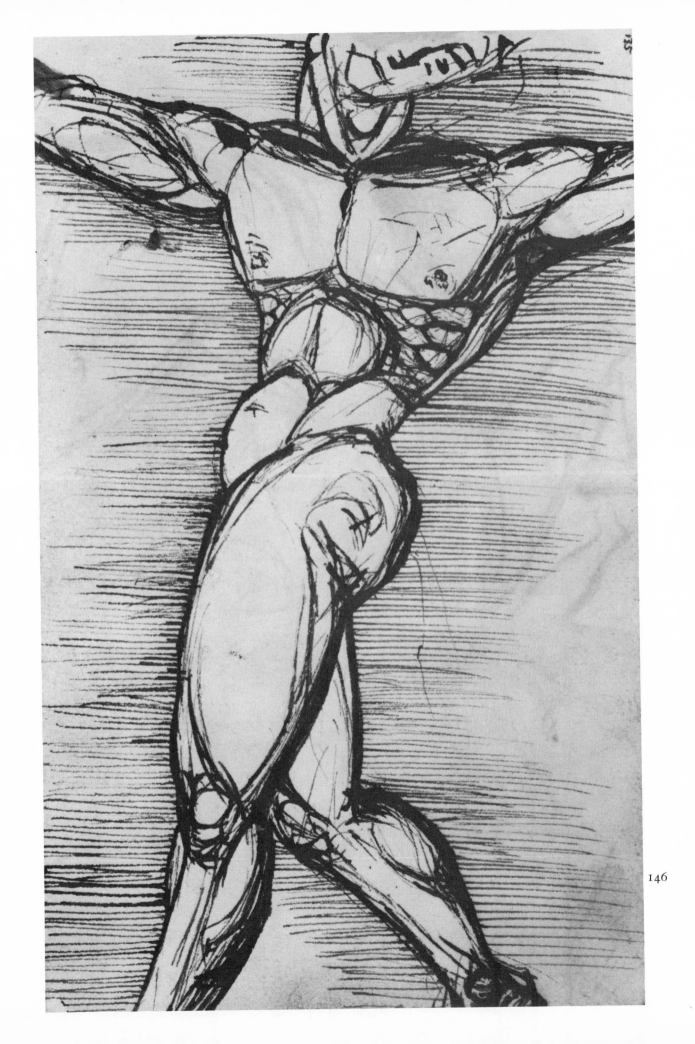

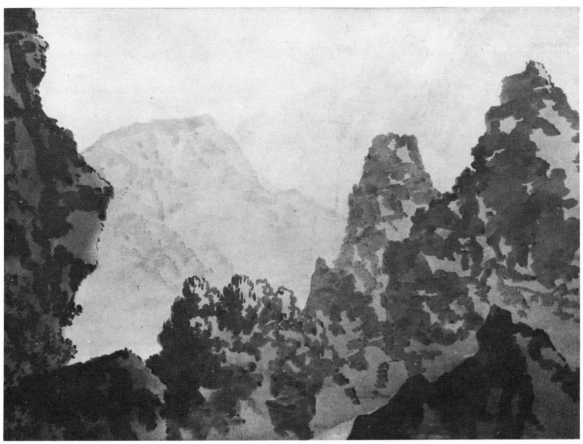

147

146 SAMUEL PALMER b 1805, d 1881
English (London; Shoreham; Italy)
One of a Series of Drawings illustrating the Book of Ruth
Pen and brown ink

147 ALEXANDER COZENS b 1717, d 1786
English (Russia; Rome; London)
A Rocky Landscape, c 1786
Brush drawing in washes of brown and grey on brown-toned paper.

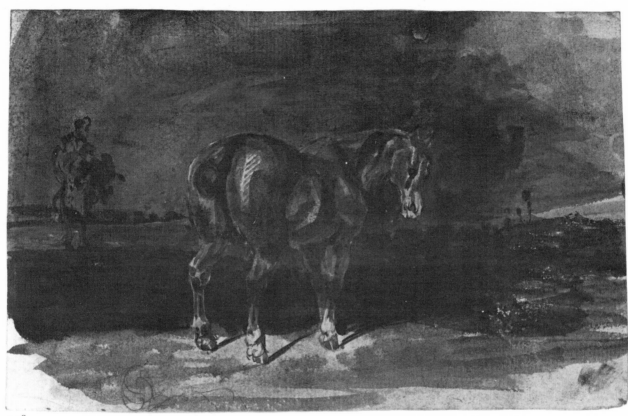

148

148 FERDINAND-VICTOR-EUGÉNE DELACROIX b 1798, d 1863
French (Charenton; Paris; England; Algiers)
A Horse in a Stormy Landscape, c 1825
Watercolor.

149 HONORÉ DAUMIER b 1808, d 1879
French (Paris)
A Mountebank playing a Drum, c 1868
Pen and brown ink, with watercolor and bodycolor over black chalk.

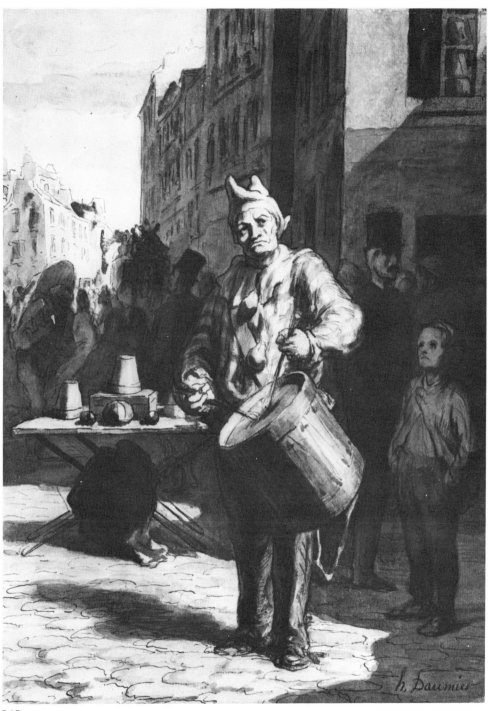

149

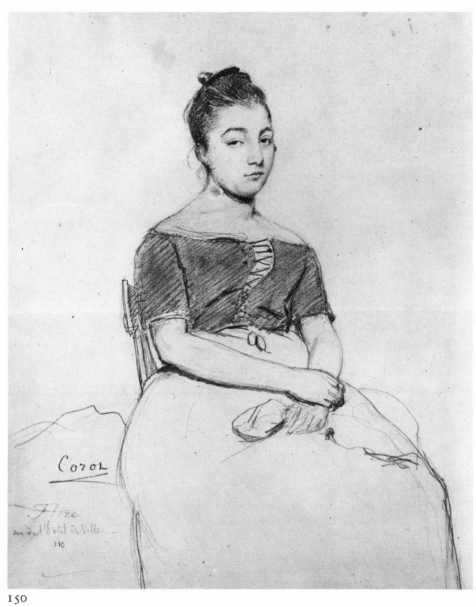

150

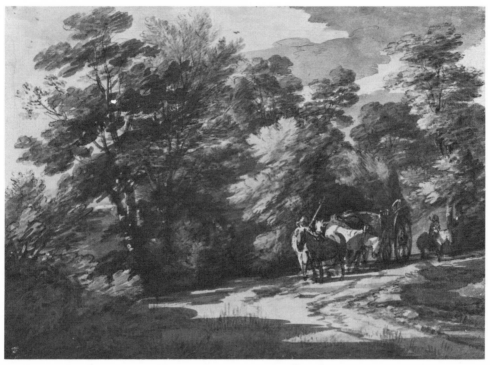

151

150 JEAN-BAPTISTE-CAMILLE COROT b 1796, d 1875
English (Paris; Italy; England)
Portrait Study of a seated Woman: 'Flore Rue de l'Hôtel de Ville 110', c 1845–1850.

151 THOMAS GAINSBOROUGH b 1727, d 1788
English (Ipswich; London; Bath)
Cart on a Woodland Road, c 1760–65
Watercolor.

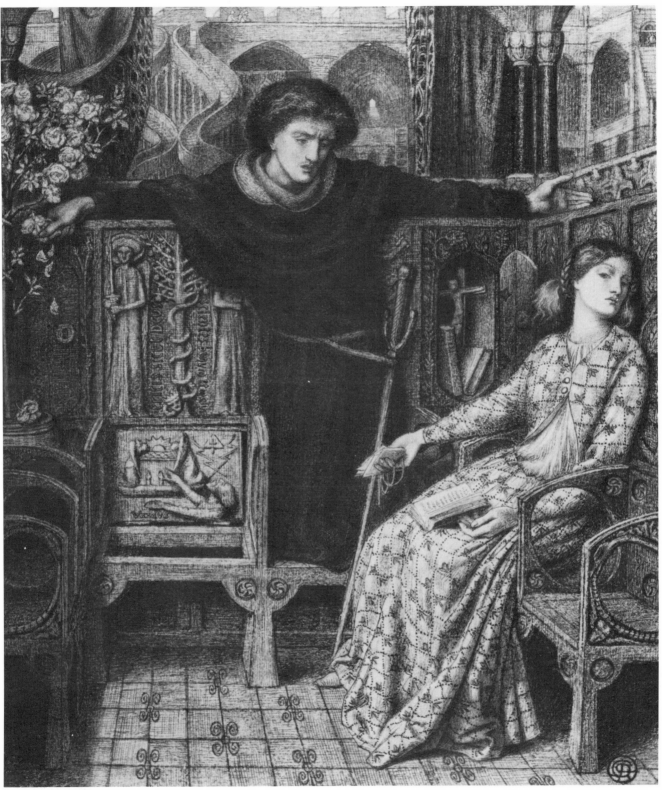

152

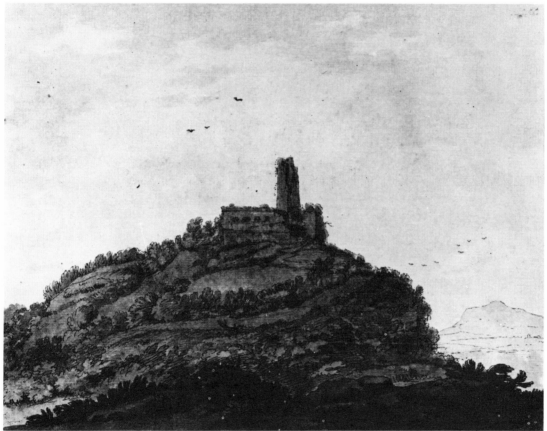

153

152 DANTE GABRIEL ROSSETTI b 1828, d 1882
English (London)
Hamlet and Ophelia, 1858
Pen and ink, over black lead.

153 ALEXANDER COZENS b 1717, d 1786
English (Russia; Rome; London)
Landscape with a Fortress
a) Preliminary 'Blot)
b) Finished Composition
Brush drawings in washes of black and brown.

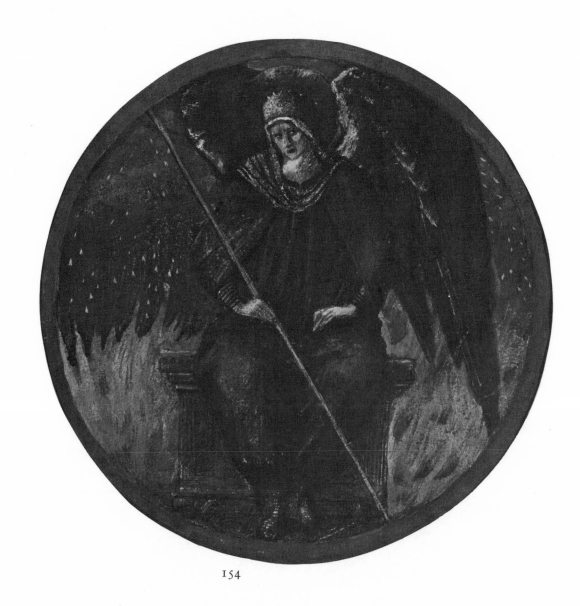

154

154 SIR EDWARD COLLEY BURNE-JONES BART. b 1833, d 1898
English (Oxford; London; Italy)
The Black Archangel
Bodycolor, heightened with gold.

155 FRANCISCO JOSÉ DE GOYA Y LUCIENTES b 1746, d 1828
Spanish (Madrid; Italy; Bordeaux)
*Victims of the Inquisition going to an Auto da Fe: 'For being
of Jewish Ancestry', c 1796–1798 (?)*
Brush drawing in brown wash.

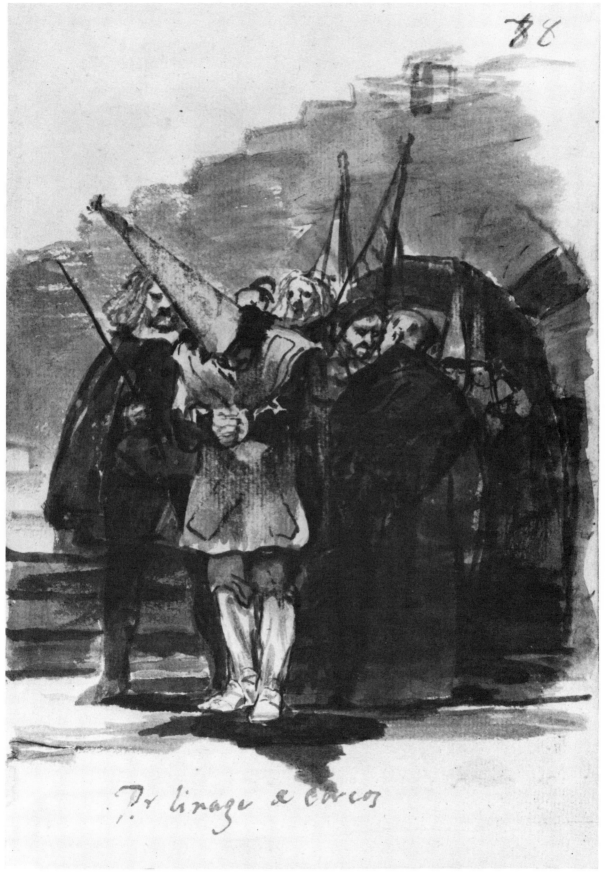

P.ᵒ linage de Circos

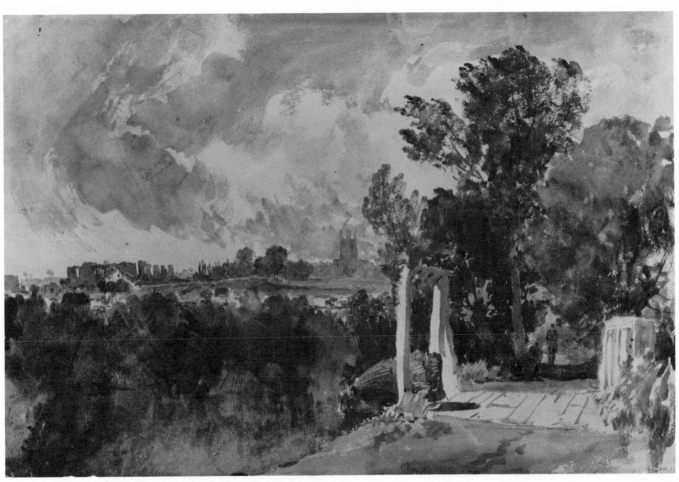

156

156 JOSEPH MALLORD WILLIAM TURNER b 1775, d 1851
English (London; England; Scotland; Wales; and the Continent)
Benson or Bensington, near Wallingford (?) 1806–1807
Watercolor.

157 GEORGE ROMNEY b 1734, d 1802
English (Dalton, Lancs; London; Italy)
Head of a Demon
Black lead

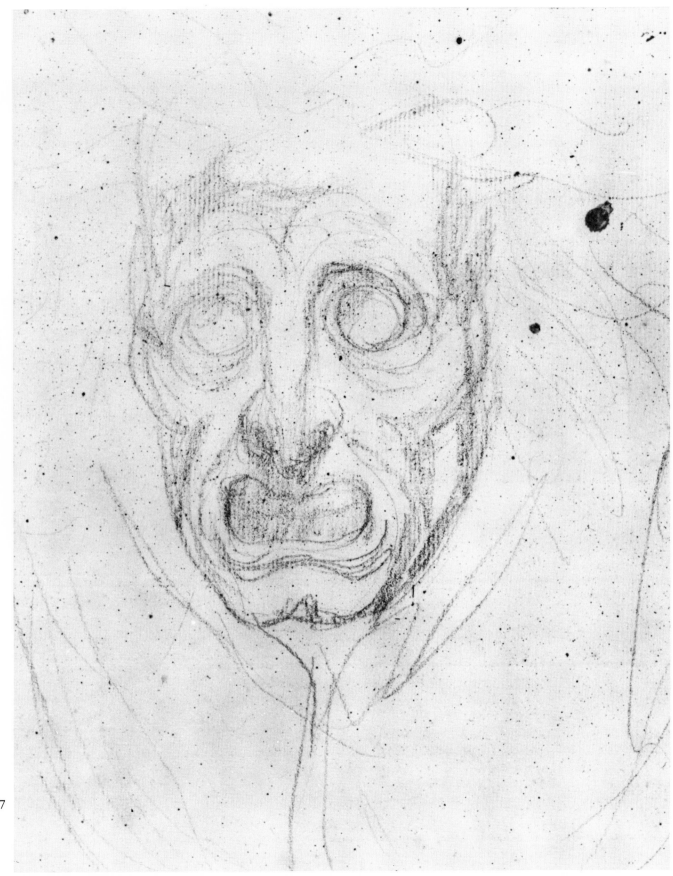

157

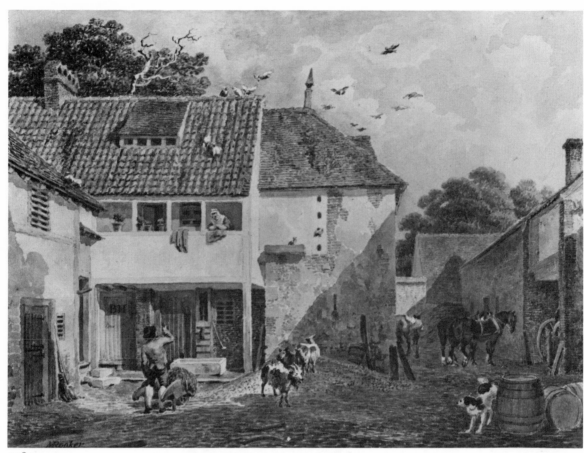

158

158 MICHAEL ANGELO ROOKER b 1743, d 1801
English (London)
Farmyard at Thetford, Norfolk
Watercolor.

159 HONORÉ DAUMIER b 1808, d 1879
French (Paris)
Head of an Old Man looking upwards
Brush drawing in reddish-brown oil color.

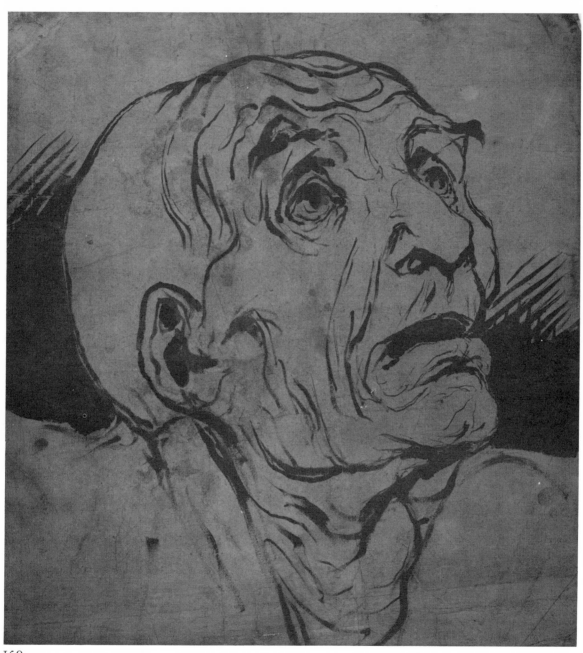

159

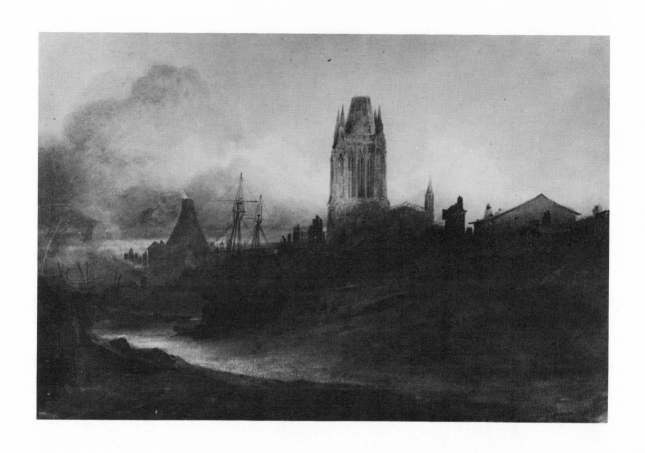

160 JOHN SELL COTMAN b 1782, d 1842
English (Norwich; London; Normandy)
Bristol, St Mary Redcliffe, 1801
Watercolor strengthened with gum.

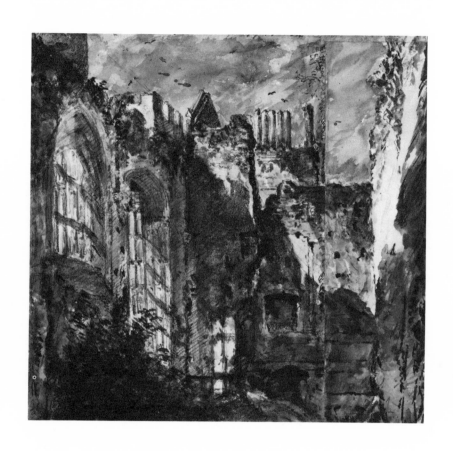

161 JOHN CONSTABLE b 1776, d 1837
English (Suffolk; London)
The Ruins of Cowdray Castle, near Midhurst, Sussex, c 1834
Watercolor over black lead.

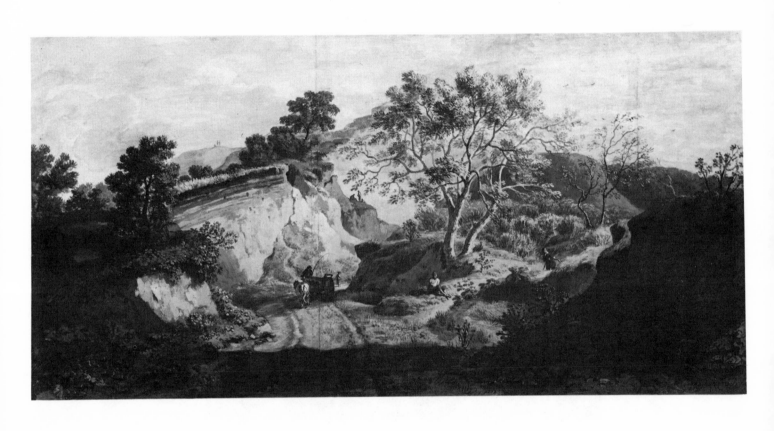

162 WILLIAM TAVERNER b 1703, d 1772
English (London)
Sand Pits, Woolwich
Bodycolor.

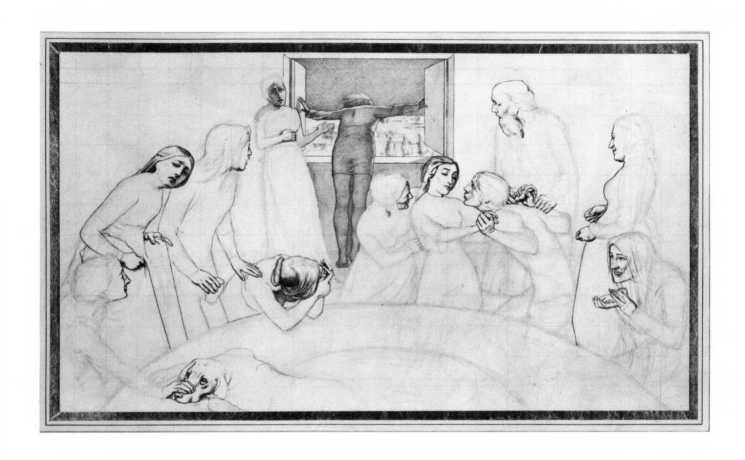

163 SIR JOHN EVERETT MILLAIS b 1829, d 1896
English (London)
The Eve of the Deluge, c 1850
Pen and ink, with grey wash, over black lead: squared for
enlargement.

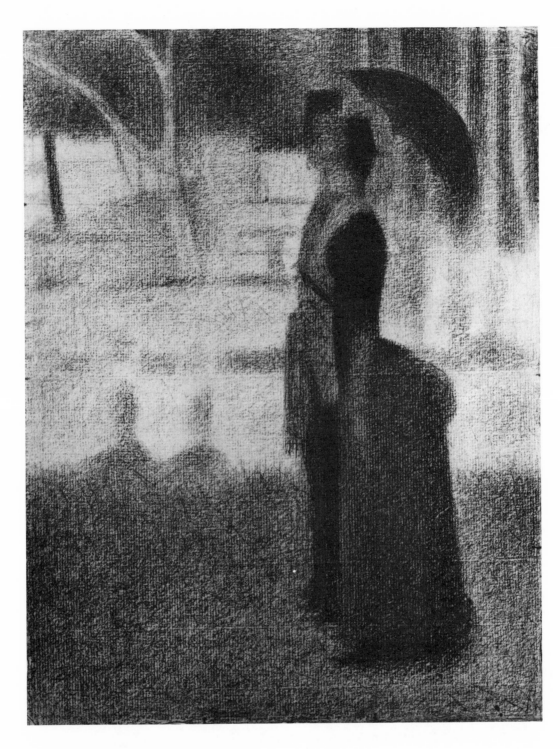

164 GEORGES-PIERRE SEURAT b 1859, d 1891
French (Paris)
Figure Study for 'La Grande Jatte', c 1885
Conte crayon.

IO

The Impressionists and their Circle

PARIS IN THE 1860's was the cultural center of Europe. It was the city of Flaubert, Zola, and the de Goncourt brothers, and was a metropolis undergoing miraculous transformation by the architectural genius of Baron Haussmann. But perhaps most importantly, Paris was the capital of the empire of Napoleon III.

Like his monarchical predecessors the Emperor viewed the artistic community of Paris as a valuable tool for maintaining and propagating the traditional beliefs and orders of society. Through the rigid and sometimes reactionary Count Nieuwerkerke, *Intendant* of the Beaux Arts who lived in a seventeen room suite on the first floor of the Louvre, all artistic life was regulated at the behest of the court.

The French Academy and the Salon were the recognized fonts of State patronage of the arts. But their criteria of acceptability were very narrow and circumspect. The general climate of 'official' art in the 1860's was heavy with sentiment and bombastic rhetoric. The glorious enthusiasm of the Romantics was worn out, and public taste had grown accustomed to much that was banal and superficial. There were a few artists of achievement, chief among them Gustave Courbet, whose school of realism attracted public attention and whose commitment to modernity warranted some acknowledgement. But other artists, perhaps equal to Courbet, but lacking his egoism and drive, were unable to obtain a public showing of their work, thanks to opposition from the leading academics of the class, who, not only feared competition but were wary of the socially upsetting tendencies of 'modern' art, and were frightened of the search for a new order which such movements might foster.

However, by 1863 numerous Parisians were tired of the blatant favoritism

of the Salon. In the press liberal idealogues actively protested, and demanded space in that year's Spring exhibition for artists who had previously been denied recognition.

Surprisingly, public criticism did have some effect. The Emperor himself paid an incognito visit to the Salon des Beaux Arts just before the annual exhibition was about to open and demanded to see those pictures that had been rejected by the Academy. After examining a few items Napoleon III declared, some say out of animosity to Nieuwerkerke, that those works of art that had been rejected were just as good as those scheduled for exhibition. He ordered the organizers of the Salon to take all the rejected pictures to adjoining rooms in the Palais de l'Industrie and issue invitations to the artists involved to exhibit in a *Salon des Refusés*. Thus, for the first time artists such as Manet, Pissaro, Jongkind, and Whistler were brought to public attention. It was an important step for the artists involved, but was to prove of even greater significance as an influence on a number of younger artists, who visited the exhibition and carried away in their minds ideas that were to have the most profound effects on modern art. Among those who attended the *Salon des Refusés* were Monet, Renoir, Cézanne, and Sisley, all of whom were to make enormous contributions to the school of art that came to be called Impressionism.

The new Salon was a short lived affair. On opening day the Emperor and Empress attended but they were so offended by the theme of modern sensuality contained in Manet's *Le Dejeuner sur l'herbe*, that they agreed with the demands of both the critics and the academicians of the Beaux Arts that such an exhibition should not be repeated the following year. Consequently, those artists whose creativity was in advance of society's tastes, but with a rare exception whose politics were never controversial, had to wait a number of years for their own *Salon des Independants* which granted them an official sanction to present their works to the public on a footing of equality with the Academy.

Such a state of affairs did not mean that artistic progress and production stagnated. Even without the formal blessing of State patronage young artists forged ahead along independent routes, experimenting with techniques designed to produce a visual impact hitherto unknown. French artists of the late nineteenth century became as enraptured with the psychology of vision as their predecessors had been with the physiology of human perception. In their meeting places, such as the famous Café Guerbois they exchanged views, discussed their aspirations and ideals, and generally supported each other's ambitions to become successful and prominent.

The Franco-Prussian War of 1871 and the Paris Commune that followed sealed the fate of Napoleon III's empire. French authoritarian civilization gave way to a new liberal democratic ideal which regarded protection of the creative arts as one of its prime goals. No longer was the Academy used as a tool by the government to suppress unpopular forms of social expression. The Beaux Arts did remain an uncontested bastion of the Establishment, but in an environment devoid of State control progressive artists created new institutional outlets for public appreciation

of their works and in so doing set the stage for an irreversible trend in modern art.

In April of 1874 Monet, Renoir, Pissaro, Cézanne, Degas, and twenty-five others staged their first joint exhibition in the studio of Nadar the photographer on the Boulevard des Capucines. Because of personal differences Manet declined to be represented. The public showed sufficient interest in the exhibition to offer encouragement for the artists to stage subsequent annual affairs, and over the next twelve years eight such exhibitions were held. The critics were generally mixed in their reviews. One journalist, Louis Leroy, contemptuously described the works he had seen as 'Impressionist' in contrast to the Realist art which was then in vogue. But this ostensibly pejorative description found a positive reception among the artists involved. In subsequent shows they referred to themselves as 'The Impressionists', since they found in the word a most apt description of what they were explicitly trying to accomplish.

Impressionism is a catch-word today for all the art produced in France up to the turn of the century. Yet it can only be truthfully applied to those years of the Impressionist exhibitions 1874–1886, and beyond that time to a handful of artists like Monet and Sisley who never abandoned the original tenets of the movement. Cézanne only contributed to the Impressionist exhibitions twice; Degas always refused to allow his works to be called Impressionist; Renoir, Pissaro, and Gauguin moved onto other things; Seurat, Van Gogh, and Toulouse-Lautrec were of the following generation; Redon was consistently a man apart even when he exhibited with the Impressionists as a gesture of defiance against the Salon.

Despite this, the term Impressionism is of some general use as a broad descriptive frame of reference in late nineteenth century French art. To begin to understand the movement, and its relation to the art of drawing, one has to begin with the bourgeois Edouard Manet (1832–1883) whose work managed to shock an emperor but whose politics were always of the mildest non-revolutionary nature. Manet the artist had become disenchanted with the realism of Courbet, relying as it did on mass and relief to create 'illusion'. He turned instead to a personal style that marked a vigorous renewal in France, and while Manet never adopted the exact technique of Impressionism it can be argued that it was his genius that created the aesthetic of the movement.

Manet developed a technique of tone painting that is also found in his draughtsmanship. Things were seen by the artist as the photograph or black and white television camera sees them—i.e. as a series of light patterns based on layers of tinted greys. Monet and others adopted this technique and systematized it. They demonstrated, for example, that light reflecting on something as neutral as water produced a series of tinted colors based on grey which was an entirely new form of spectral analysis.

No one extended Manet's stylistic and technical discoveries more effectively than Claude Monet, whose work was of the greatest importance to Impressionist painting. But conversely, it cannot be said that Monet added anything of substance

to the draughtsman's art. This was not due to lack of skill but rather to conscious intent. Monet, like all the Impressionists, placed high value on the essence of a captured individual moment, encapsulated as it were by accident on the artist's canvas. Work had to be executed exclusively from life. It was impossible to produce successfully in the artificial environment of the studio. Monet felt that everything in a picture must be geared to the ultimate expression of spontaneity, rapidity, and an all-encompassing fascination with light and its reflection. Strong influences from Turner and his school are obvious in Monet's work but are always tempered by fundamental independence of style. Monet makes no attempt to hide brush strokes. Paint is built up directly on the canvas to be seen as paint, and, with such a technical approach, it is clear that drawing, either as a preparatory or independent media, has little place.

Monet and Sisley and even Renoir, during his Impressionist period, produced hardly any drawings at all. Sketches were not considered necessary, indeed in such a spontaneous system of painting they had no valid place. Drawing was considered to be entirely subordinate to color, and color was laid onto canvas with a tissue-like delicacy. It created an envelope of ever-changing shades of light in which the individual strokes were disguised. There was no real linear demarcation between forms in these works since line was not observable to the Impressionists as an essential or objective part of nature. Indeed, the Impressionists viewed air, water, and sky as forming a whole without constituent parts or profiles. Their awareness of the constant changes of light upon familiar scenes was viewed primarily in terms of light. This can be seen, for example, in Monet's numerous studies of water lilies.

The Impressionists ignored form and plane or else blended them together into light and shadow. Such things could not be portrayed accurately with the pencil or even by the pen with added wash or with pastel crayon, though occasionally these media were employed experimentally.

Because of the stylistic emphasis on light many Impressionist pictures looked unfinished to contemporary eyes. The nineteenth century Frenchman was accustomed to seeing subjects completed in detail. But with their bright color, so different from the dark shades of the Romantics, Impressionist painters began to 'complete' their works using only light. They rejected the idea of a 'significant' subject and substituted instead an independent autonomous view of reality that required the spectator to rethink in his own mind just what were the essential components of the everyday natural environment which he saw about him.

Because so much of the pure Impressionist school's output was a clear rejection of drawing as a preparatory medium, and because so few autonomous drawings were produced by these artists, one has to look at contemporaries of Monet and Sisley who were not strictly speaking Impressionists, in order to discover the true masterworks of draughtsmanship of the period. Foremost among this group was Edgar Degas (1834–1917) whose graphic influence was so profound that no great artist from Bonnard to Picasso could truthfully say he had not profited

from studying his drawings.

As a young man Degas fell under the influence of Ingres who conveyed to his student a belief in the paramount importance of line. Degas declared 'I was born to draw' and throughout his career upheld a tradition that was being challenged by those who rejected all contours in favor of the vibrating luminosity of light. Degas was immensely interested in the movement of figures. His female models, who became the almost exclusive subjects of his work, were repeatedly depicted in a series of gestures ranging from the exercises of the dance to simple domestic acts such as bathing, drying with towels and combing and brushing hair. It was the exact angle of a given gesture or action that captivated Degas' imagination. His total lack of interest in women as sexual objects—at least when he was drawing them—imparts a somewhat cold and emotionless quality to his work. Yet at the same time Degas' very attraction to the importance of the human figure stressed the difference between his work and that of the pure Impressionists, whose prime concerns regarding subject matter lay in other areas.

It has been suggested that Degas was the 'Impressionist of line'. His avowed attachment to draughtsmanship, his ability to catch every twitch, sigh, and arabesque of movement was the stylistic signature of his work. In his early and mature periods, he used finely sharpened lead pencil to provide a synthesis of minutely detailed observations. And in his late years, after 1885, when his sight was failing, Degas turned first to soft crayons and finally to charcoal, pencil and pastels, using numerous quickly sketched strokes and hatchings devoid of the crisp agitation so often found in his pencil work.

Degas was a quiet reactionary who found it difficult to adjust to the dissolution of the monarchy in France. He dressed in the fashions of an earlier era and his personal frustrations were such that he eventually became an almost total recluse. Degas lived in isolation surrounded by his numerous paintings and drawings. He found it impossible to share his artistic experience with anyone except a very few trusted friends. While there was no decline in either his imagination, skill, or graphic technique, his last years were, from the personal point of view, a tragic conclusion to a career that was one of the most fruitful of his generation.

The sadness of Degas' life is well known and stands in sharp contrast to the joyous and exuberant career of Pierre-Auguste Renoir (1841–1919) who launched a highly individual interpretation of Impressionism. Like Monet and Sisley, Renoir executed hardly any drawings during his purely Impressionist years. Yet after 1869 he began to produce significant works of draughtsmanship, together with paintings, that represented light in all the colors of the rainbow rather than with the toned greys of Monet and his followers. From the 'rainbow palette' Renoir moved onto the 'broken color' palette used so effectively by Watteau, Gainsborough, and Goya. This was a technique whereby tints were mixed first on the palette and then applied in small strokes to the canvas. Each color retained its autonomy from those which had already been applied. Eventually all the artists of Renoir's generation,

even Monet, imitated this technique in works covering a variety of subject matter.

Renoir has often been described as the most French of all the Impressionists. Neither Japanese nor Spanish influences, both popular among his colleagues, crept into his work. Renoir's sole abiding interest was in French art. The styles of both Delacroix and Ingres are detectable in his drawings, though it was the former who exerted the strongest and most lasting influence on his work.

There was a period in Renoir's career, from 1879 to 1886, when he completely broke with Impressionist interpretations and returned to traditional paths, applying himself to increasingly simplified forms and giving much less importance to color. He nearly imprisoned himself in what Baudelaire called the linear 'straight-jacket', but this return to the past was short lived and under the renewed influence of Romantics like Delacroix, Renoir managed to balance perfectly the harmony of line and color in his work. Plasticity rather than movement was the keynote to Renoir's style. Whether they are in chalk or sanguine, his late drawings stand as autonomous works in themselves. Solid line replaces the light sketchy technique of his earlier years and effects a union of object and environment. A serene confidence, based on a clear conception of structural and architectural order permeates these works, and it can be argued that it is in Renoir's late non-Impressionist period that his true gifts as painter and draughtsman are finally realized.

Between 1884 and 1891 a general revolt against the precepts of both Impressionism and Realism took place. While Monet and Sisley continued steadfastly on the lines they had already chosen established artists such as Renoir, Cézanne, and Gauguin, together with a new generation led by Seurat, Lautrec, and Van Gogh, declared their creative independence and adopted new styles which profoundly affected the representational arts.

After 1884 light ceased to be the subject of all-abiding concern for these artists. Some of them feared that art was losing all its formal structure as a result of Impressionism, and it was in the name of structure that they developed what can only be called a pseudo-scientific method that substituted theory for spontaneous creation.

In the work of Cézanne and Seurat we see the divergence of the two major traditions of the nineteenth century French school. Cézanne continued on the road indicated by Delacroix, while Seurat followed in the path of Ingres. Yet Seurat was the more instinctively radical of the two artists, and his work evinced a highly individual development of style and interpretation.

For Seurat space was a combination of movement and immobility conditioned by the laws of mathematics. No artist since Piero della Francesca was as adept as Seurat in the use of geometry. Every square inch of canvas or paper was planned with precision before a drop of paint or ink was applied. There is a strong sense of intellectual order in Seurat's drawings which clearly bespeaks the creative genius of the classical renascence he helped create in the last years of the century. By rejecting spontaneity and by using Renoir's rainbow palette 'scientifically' Seurat

developed an artistic structure wherein lines, curves, and solid forms assumed a unique relationship to one another. The method was called 'Divisionism' and aimed at achieving optimal luminosity and harmony by employing all colors without substantive blending. In essence, the color of light, so important to the Impressionists, was treated by Seurat as a unitary whole which could be isolated from all other positive colors. By balancing this technique against the use of dots, whose predetermined size depended upon the dimensions of the surface, Seurat created harmonious patterns in which slow climbing lines, cool colors, and tonal chiaroscuro conveyed a sense of calm, while short rapid lines and bright colors transmitted a feeling of gaiety and joy. In short, Seurat chose his medium with a sensitivity to the emotional themes of his work, and so attractive was the outcome of this technique that many artists of the time were soon using it, with greater or less consistency, in their own work.

At the same time there were other artists whose individualism was so great that they stand apart from their generation. Odilon Redon (1840–1916) has been called the French William Blake. His passion was to record the transcendental images of the subconscious—this places him as an early pioneer of Surrealism. Conversely in the drawings and paintings of Vincent Van Gogh (1853–1890) there is an agitated restlessness that is readily identifiable as something unique. Van Gogh's lines continuously curl and uncurl in flowing spirals reminiscent of the German High Gothic. Regardless of what media he used Van Gogh always attacked his subject in a hailstorm of dots, dashes, and random hatching. There is in his work what is known as a Northern sense of light—Turner's work possesses a similar quality. Yet Van Gogh often seems to make light into a hostile exterior force more to be feared than worshipped. In his graphic and painted work one sees a reestablishment of a tragic statement in modern art—in this Van Gogh's over-burdened genius reminds us of Francesco Goya. Both Nietzsche and Ruskin found it impossible to cope with the materialism of their age. Madness was for them, and also for Van Gogh, the only escape from a world which grew increasingly intolerable as it grew more materialistic.

The classical renascence which eventually all but ended the Impressionist experiment was a necessary reaction by artists against the unsubstantiability Impressionist technique encouraged. Impressionism's weakness is its lack of appeal to the intellect. The modern passion for works of this school is understandable, for Impressionist art makes no demands other than on sheer emotive feeling. The spectator has no need to feed in extra information; he does not have to meet the kind of demands made on him by the classical themes of a painter such as Poussin. Yet the major Impressionists were themselves intelligent men, who thought seriously about their methodology. Renoir and some of his colleagues could have basked in the success which public recognition of their work eventually brought. But such a benign contentment was simply not possible to them. They saw only too clearly that an artistic crisis had been reached in the 1880's. Impressionism was the

logical and ultimate conclusion to the impulse toward naturalism that had been growing since the time of Watteau. In the naturalistic sense, no one could surpass Monet's representation of landscape. In essence, he had achieved perfection but in so doing took his art to a dead end.

For draughtsmen in particular Impressionism produced an impasse which most artists interested in graphic media came to recognize and which they struggled to overcome. There were new roads and new styles to be explored, and new techniques with which to experiment. By the end of the nineteenth century the art of drawing was firmly established as a legitimate and separate art form in its own right. The days of aesthetic apologetics were over. The great draughtsmen had already provided society with a heritage from which all lovers of beauty could benefit, and in the cosmopolitan arena of the international art world creative men prepared themselves for changes that would prove both radical and far-reaching.

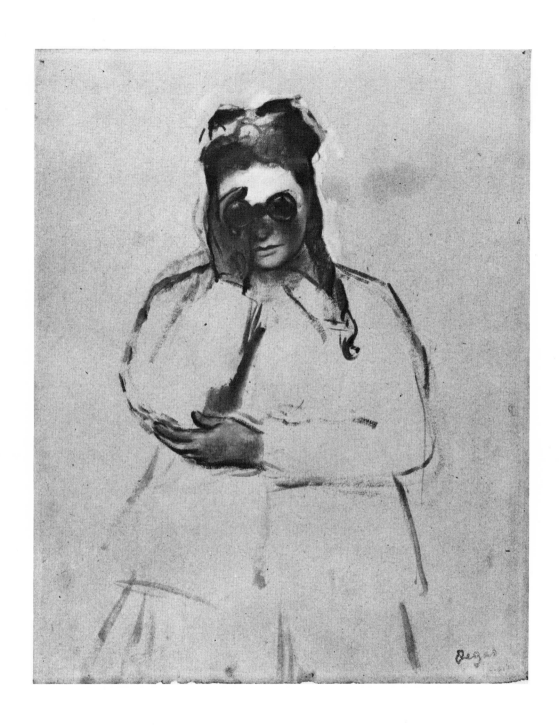

165 HILAIRE-GERMAIN-EDGAR DEGAS b 1834, d 1917
French (Paris; New Orleans)
Girl with Field-glasses, c 1868
Oil-color, thinned with turpentine, on pink paper.

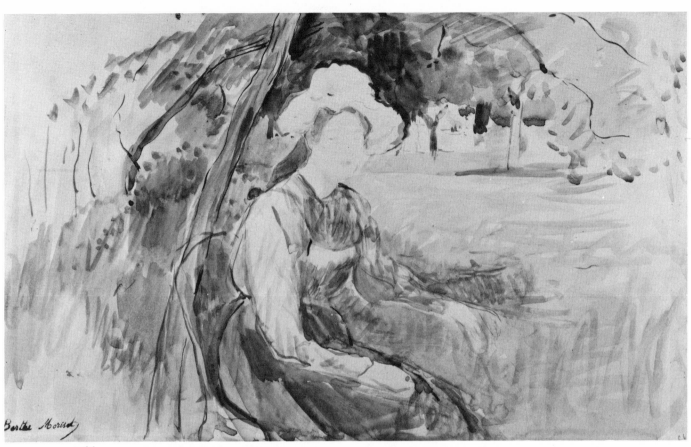

166

166 BERTHE-MARIE-PAULINE MORISOT b 1841, d 1895
French (Paris)
Study of a Girl seated beneath a Tree
Watercolor.

167 EDOUARD MANET b 1832, d 1883
French (Paris; Spain)
Study of Berthe Morisot, c 1880
Brush drawing in dark grey wash, over black lead.

168 VINCENT WILLEM VAN GOGH b 1853, d 1890
Dutch (The Hague; Paris; Arles; Auvers)
La Crau from Montmajour, 1888
Reed and fine pen with light and dark-brown ink, over black chalk (OVERLEAF).

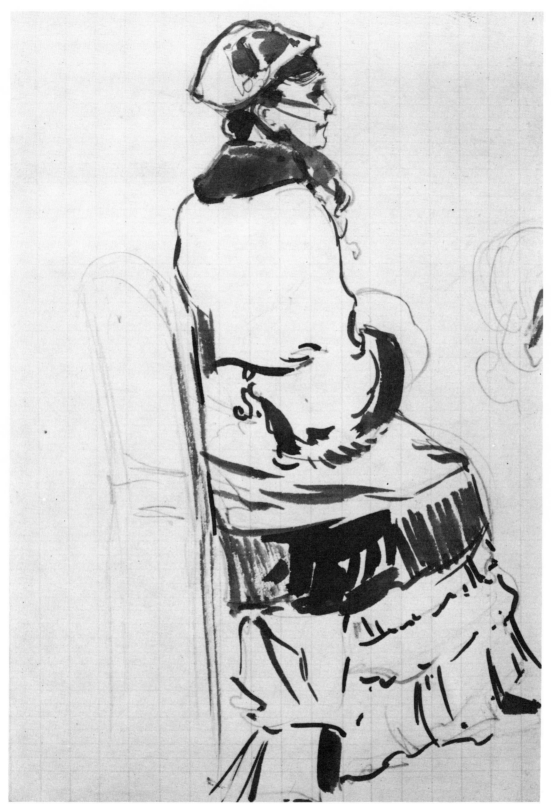

167

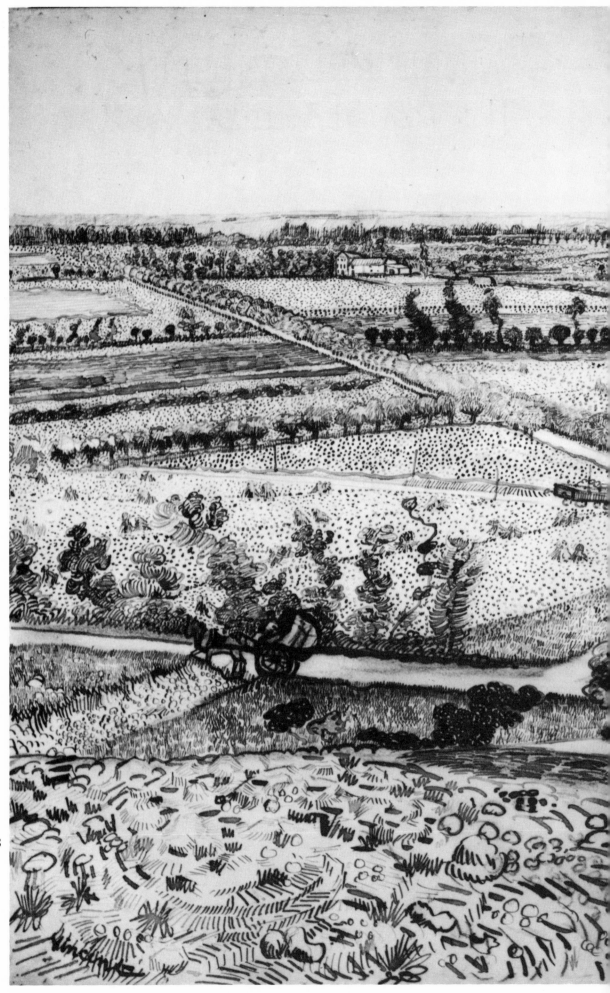

168

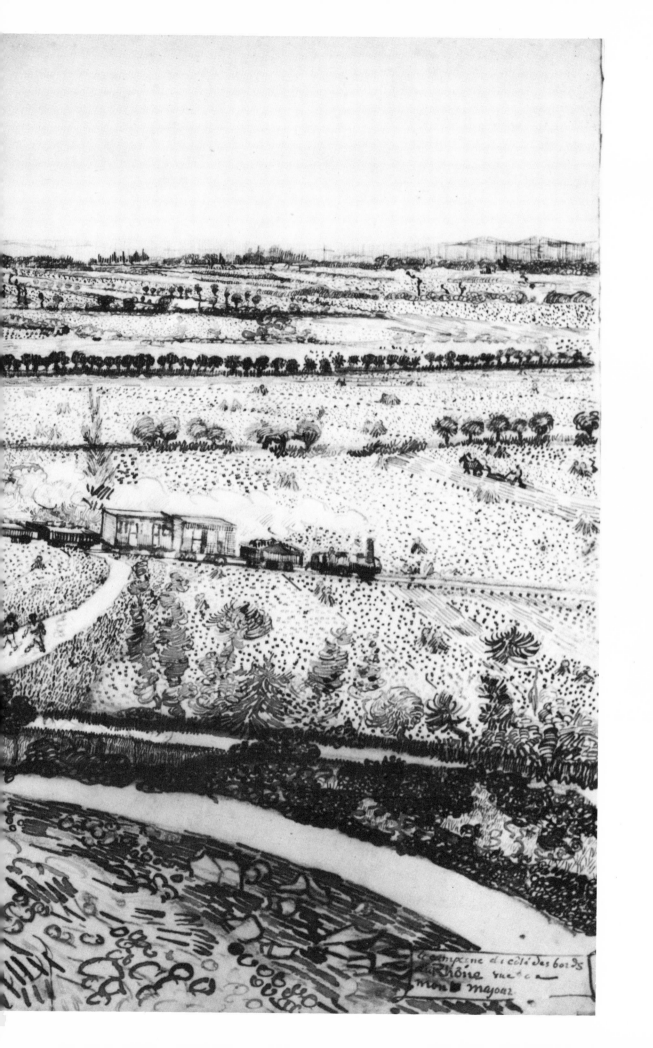

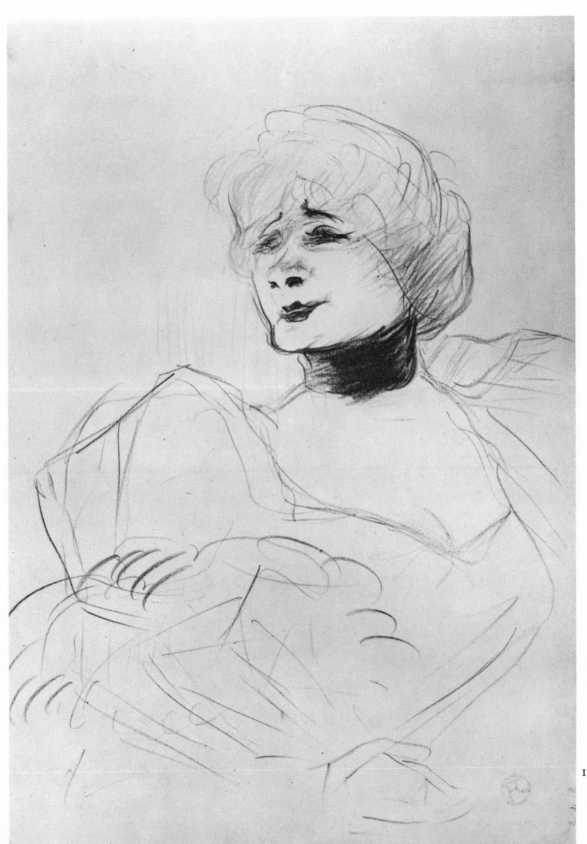

169

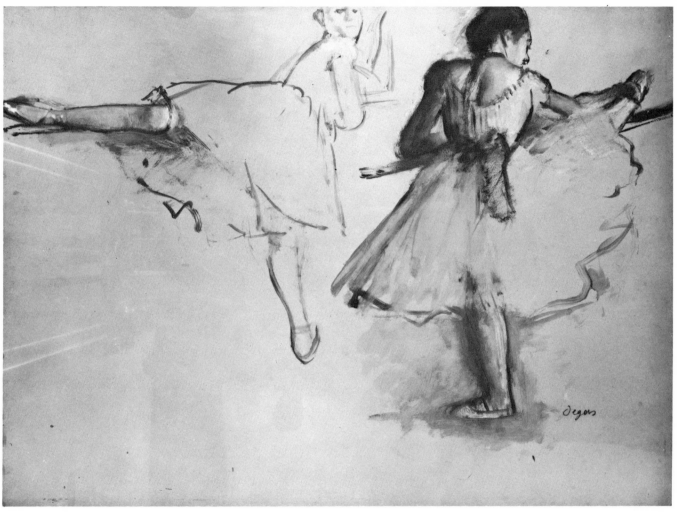

170

169 HENRI-MARIE-RAYMOND DE TOULOUSE-LAUTREC-MONFA b 1864, d 1901
French (Paris; Brussels; London)
Portrait of Marcelle Lender, before 1893
Black lead, and black chalk.

170 HILAIRE-GERMAINE-EDGAR DEGAS b 1834, d 1917
French (Paris; New Orleans)
Dancers exercising at the Bar, c 1876–7
Oil-color, thinned with turpentine, on green paper.

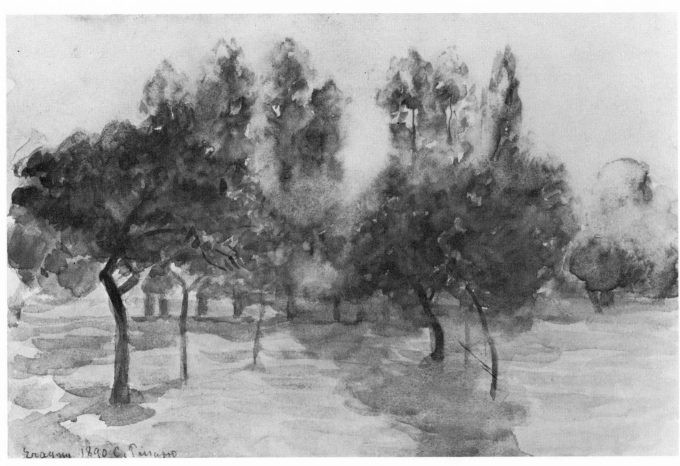

171

171 CAMILLE PISSARRO b 1830, d 1903
French (Paris; Pontoise; England)
Orchard at Eragny, 1890
Watercolor.

172 ODILON REDON b 1840, d 1916
French (Paris)
'La Cellule d'or', c 1894
Oil and gold, with pastel on paper.

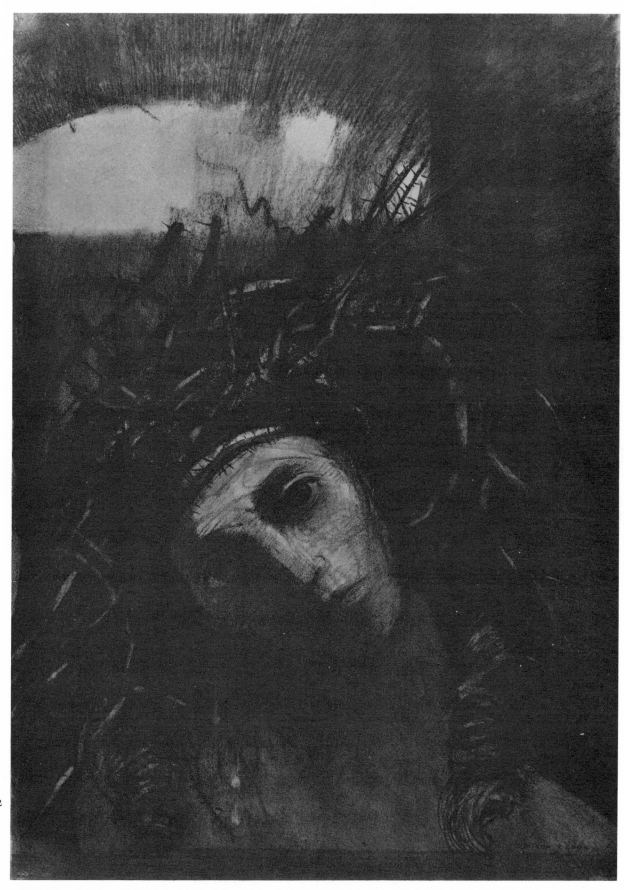

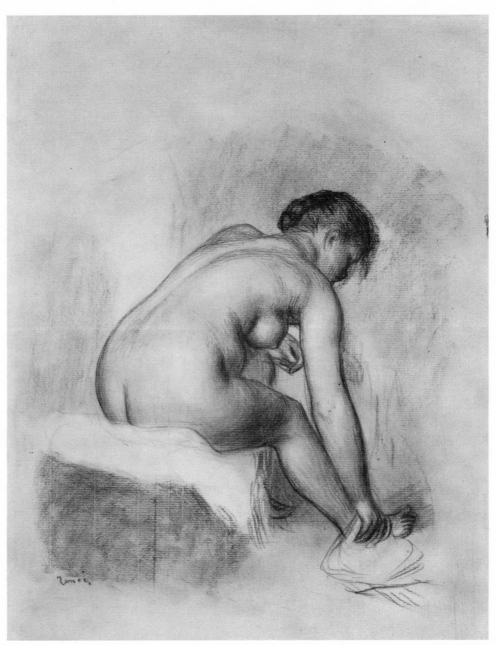

173

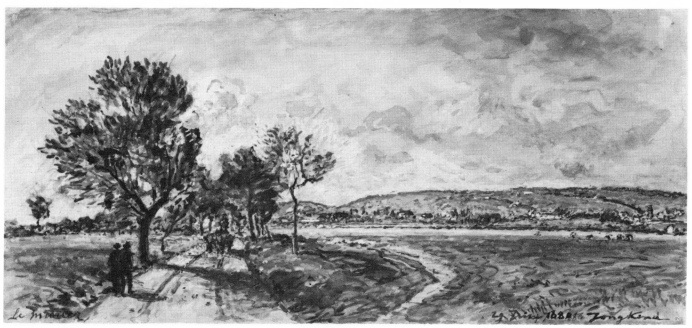

174

173 PIERRE-AUGUSTE RENOIR b 1841, d 1919
French (Paris; North Africa; Italy; England; Spain; Germany)
Nude Woman sitting drying her Foot, c 1885–1890
Red chalk heightened with white.

174 JOHAN BARTHOLD JONGKIND b 1819, d 1891
Dutch (Paris; Grenoble)
'Route au Printemps: Le Mûrier', 1880
Watercolor and bodycolor, over black chalk.

175 BERTHE-MARIE-PAULINE MORISOT b 1841, d 1895
French (Paris)
Study of Trees
Watercolor.